Modern Art in the Common Culture

Modern Art in the Common Culture

THOMAS CROW

YALE UNIVERSITY PRESS
New Haven and London

For Patrick Pleskunas
in memoriam

Designed by Gillian Malpass
Set in Linotron Sabon by Best-set Typesetter Ltd., Hong Kong
Printed in Hong Kong through World Print Ltd

Library of Congress Cataloging-in-Publication Data
Crow. Thomas E. 1948 –
Modern art in the common culture: essays/Thomas Crow.
Includes bibliographical references and index.
ISBN 0-300-06438-1 (hc)
1. Art, Modern – 19th century. 2. Art, Modern – 20th century.
I. Title.
N6450.C76 1995
709'.04 – dc20 95-17377
 CIP

A catalogue record for this book is available from
The British Library

Frontispiece: Annette Lemieux, *Portable World*, 1986.
Photo courtesy of the artist.

Contents

Preface

Practitioners of advanced art now must walk a delicate line. Disputes over cultural distinctions – high versus low, elite versus popular – have hardened to the point that room for maneuver between them is almost gone. In response, many historians of art have abandoned their youthful beliefs in the protocols of the Western canon, giving themselves over to a newly minted discipline of visual culture. Their position is that fine art, as it is traditionally understood, trades on elitist presumptions; a postmodern outlook can afford no exclusion of the Hollywood films, television productions, glossy advertisements, computer graphics, and all the other enticing visual products of the age. Likewise, the ancestors of these artifacts in the emerging popular media of previous centuries must be given equal standing to any received curriculum of masterworks.

There are certain facts, however, that fit awkwardly within this new orthodoxy. Museum exhibitions of uncompromisingly advanced and demanding art continue to draw large numbers of people. It would be an abuse of language to describe these audiences – swelled by curious and intrigued visitors of distinctly modest means – as an elite, even if their numbers do not approach those of a cinema blockbuster or runaway bestseller. Such people evidently find sustenance within the boundaries of fine art that is available nowhere else, and they would doubtless be dismayed to find their adventurousness swept aside by academic commentators whose notion of "the popular" is far more restricted and conventional.

Nor has awareness of the tension between classes of audience and levels of address ever been absent from serious artistic practice. The avant-garde in particular, from its origins in the nineteenth century, has defined its project by identifying with other marginal groups in urban society and with the ways in which their contemporaries consumed and transformed the commercialized culture of the day. While advanced artists must

acknowledge that their practice cannot exist without highly specialized learning and patient application, they have habitually recognized a pressing need to incorporate the expressions of vernacular culture: in effect, to admit to their creative endeavor a multitude of anonymous collaborators.

That crucial interchange provides the focus for the essays in this book, which range in their subject matter from Paris in the mid-nineteenth century to the latest revivals of Conceptual art in the 1990s. From this perspective, even the most esoteric forms of contemporary practice reveal themselves as bound to local and particular meanings, ones necessarily shaped by the common uses of shared social spaces over a long historical period. And one yield of this investigation is to show that the inheritance of Conceptualism, ignored if not derided by the majority of art historians, provides the field of art history with its best current resources of theoretical understanding.

Part 1

Kitsch

1

Modernism and Mass Culture
in the Visual Arts

What is to be made of the continuing involvement between modernist art and the materials of low or mass culture? From its beginnings, the artistic avant-garde has discovered, renewed, or re-invented itself by identifying with marginal, "non-artistic" forms of expressivity and display – forms improvised by other social groups out of the degraded materials of capitalist manufacture. Manet's *Olympia* offered a bewildered middle-class public the flattened pictorial economy of the cheap sign or carnival backdrop, the pose and allegories of contemporary pornography superimposed over those of Titian's *Venus of Urbino*. For both Manet and Baudelaire, can their invention of powerful models of modernist practice be separated from the seductive and nauseating image the capitalist city seemed to be constructing for itself? Similarly, can the Impressionist discovery of painting as a field of both particularized and diffuse sensual play be imagined separately from the new spaces of commercial pleasure the painters seem rarely to have left, spaces whose packaged diversions were themselves contrived in an analogous pattern? The identification with the social practices of mass diversion – whether uncritically reproduced, caricatured or transformed into abstract Arcadias – remains a durable constant in early modernism. The actual debris of that world makes its appearance in Cubist and Dada collage. And even the most austere and hermetic of twentieth-century abstractionists, Piet Mondrian, anchored the culmination of decades of formal research in a delighted discovery of American traffic, neon, and commercialized Black music. In recent history, this dialectic has repeated itself most vividly in the paintings, assemblages, and Happenings of the artists who arrived on the heels of the New York School: Jasper Johns, Robert Rauschenberg, Claes Oldenburg, and Andy Warhol.

How fundamental is this repeated pattern to the history of modernism? Yes, it has to be conceded, low-cultural forms are time and again called upon to displace and estrange the deadening givens of accepted practice, and some residuum of these forms is visible in many works of modernist art. But might not such gestures be little more than means to an end, weapons in a necessary, aggressive clearing of space, which are discarded when their work is done? This has indeed been the prevailing argument on those occasions when modernism's practitioners and apologists have addressed the problem, even in those instances where the inclusion of refractory material drawn from low culture was most conspicuous and provocative. In the early history of modernist painting, Manet's images of the 1860s represent one such episode, matched two decades later by Seurat's depiction of the cut-rate commercial diversions of Paris. And each of these confrontations between high and low culture was addressed in a key piece of writing by an artistic peer who assigned the popular component to a securely secondary position.

In the case of Manet (pl. 1), the argument came from Stéphane Mallarmé writing (in English) in 1876.[1] It was true, he wrote, that the painter began with Parisian lowlife: "Captivating and repulsive at the same time, eccentric, and new, such types as were needed in our ambient lives."[2] But the poet, in the most powerful reading of Manet's art produced in the nineteenth century, regarded these subjects as merely tactical and temporary. He was looking back at the work of the 1860s with relief that the absinthe drinkers, dissolute picnics, and upstart whores had faded from view. Left in their place was a cool, self-regarding formal precision, dispassionate technique as the principal site of meaning, behind which the social referent had retreated; the art of painting had overtaken its tactical arm and restored to itself the high-cultural autonomy it had momentarily abandoned. The avant-garde schism had, after all, been prompted in the first place by the surrender of the academy to the philistine demands of the modern marketplace – the call for finish, platitude, and trivial anecdote. The purpose of modernism was to save painting, not to sacrifice it to the degraded requirements of yet another market, this time one of common amusement and cheap spectacle. For Mallarmé, Manet's aim "was not to make a momentary escapade or sensation, but...to impress upon his work a natural and general law."[3] In the process, the rebarbative qualities of the early pictures – generated in an aggressive confrontation with perverse and alien imagery – were harmonized and resolved. His essay ends in the voice of an imaginary Impressionist painter who flatly states the modernist credo:

4

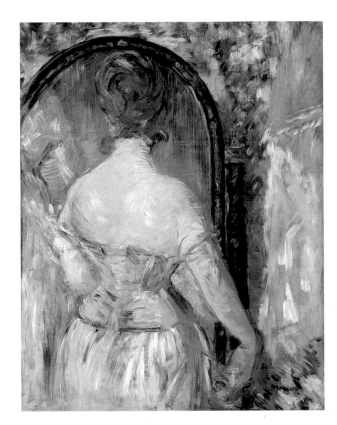

1 Edouard Manet, *Before the Mirror*, 1876. Oil on canvas, 92.1 × 71.4 cm. New York, Samuel R. Guggenheim Museum, Thannhauser Collection, Gift, Justin K. Thannhauser, 1978.

I content myself with reflecting on the clear and durable mirror of painting . . . when rudely thrown, at the close of an epoch of dreams, in the front of reality, I have taken from it only that which properly belongs to my art, an original and exact perception which distinguishes for itself the things it perceives with the steadfast gaze of a vision restored to its simplest perfection.[4]

Despite the distance that separated their politics, a parallel argument to Mallarmé's was made by "an Impressionist comrade" in 1891 in the pages of the journal *La Révolte*. Entitled "Impressionists and Revolutionaries," his text was intended as a political justification of the art of Seurat and his colleagues to an anarchist readership – and the anonymous Impressionist comrade has been identified as painter Paul Signac.[5] Like Mallarmé's 1876 essay, this was another account by an avant-garde initiate

that addressed the relationship between iconography drawn from cheapened urban experience and a subsequent art of resolute formal autonomy. And, similarly, it marked the former as expedient and temporary, the latter as essential and permanent. The Neo-Impressionists, he stated, had at first tried to draw attention to the class struggle through the visual discovery of industrial work as spectacle, and "above all" through portraying the kinds of proletarian pleasure that are only industrial work in another guise: in Seurat's *La Parade* for example, the joyless and sinister come-on for Ferdinand Corvi's down-at-heels circus, or in the Pavlovian smile of the music-hall patron who anchors the mechanical upward thrust of the dancers in *Le Chahut* (pl. 2).[6] As Signac expressed it:

> ... with their synthetic representation of the pleasures of decadence: dancing places, music halls, circuses, like those provided by the painter Seurat, who had such a vivid feeling for the degradation of our epoch of transition, they bear witness to the great social trial taking place between workers and Capital.[7]

But this tactic was to be no more permanent than the impulse that in 1890 sent optical theorist Charles Henry, armed with Signac's posters and charts, off to impart avant-garde ideas about color to the furniture workers of the Faubourg Saint-Antoine.[8] The continuing oppositional character of Neo-Impressionist painting does not derive, the artist was quick to say, from those earlier keen perceptions of the injuries of social class; instead, it consisted in an aesthetic developed in their making, one that now can be applied to any subject whatever. The liberated sensibility of the avant-gardist would stand as an implicit exemplar of revolutionary possibility, and the artist would most effectively perform this function by concentration on the self-contained demands of his medium. Signac refused any demand that his group continue

> a precise socialist direction in works of art, because this direction is encountered much more strongly among the pure aesthetes, revolutionaries by temperament, who, striking away from the beaten paths, paint what they see, as they feel it, and very often unconsciously supply a solid axe-blow to the creaking social edifice.[9]

Four years later, he summed up the progress of Neo-Impressionism in a pithy sentence: "We are emerging from the hard and useful period of analysis, where all our studies resembled one another, and entering that of varied and personal creation."[10] By this time Signac and his followers had

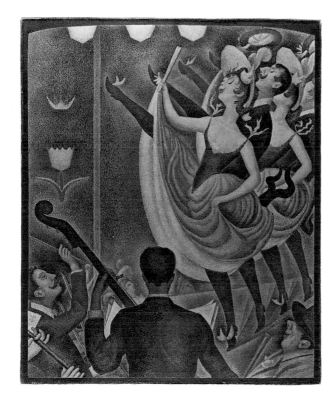

2 Georges Seurat, *Le Chahut*, 1890. Oil on canvas, 169 × 139 cm. Otterlo, Kröller-Müller Museum.

left behind the subjects and people of the Parisian industrial suburbs for the scenic pleasures of the Côte d'Azur.

For both these writers the relationship between painting and the ordinary diversions of urban life moved from wary identity to determined difference. At the beginning, "rudely thrown, at the close of an epoch of dreams, in the front of reality," as Mallarmé put it, vernacular culture provided by default the artist's only apparent grasp on modernity. Even this notoriously hermetic and withdrawn poet, like the anarchist-socialist Signac, held that the advanced artist was necessarily allied with the lower classes in their struggle for political recognition: "The multitude demands to see with its own eyes; . . . the transition from the old imaginative artist and dreamer to the energetic modern worker is found in Impressionism."[11] But it went without saying, for both, that emancipated vision would not come from imitating the degraded habits induced in the multitude by its currently favored amusements. Mass political emancipation occasioned a "parallel"

search in the arts – now, thanks to politics, rid of an oppressive, authoritarian tradition – for ideal origins and purified practice. The alliance between the avant-garde and popular experience remained in place but came to be expressed in negative terms.

The self-conscious theories of modernism formulated in the twentieth century ratified this position and made its terms explicit. In an essay that stands as one of Clement Greenberg's most complete statements of formal method, "Collage" of 1959, he put the "intruder objects" of Cubist *papiers collés* firmly in their place.[12] He belittled the view of some early commentators, like Guillaume Apollinaire and Daniel-Henry Kahnweiler, that the technique represented a renewed vision outward, its disruptions sparking attention to a "new world of beauty" dormant in the littered commercial landscape of wall posters, shop windows, and business signs:

> The writers who have tried to explain their intentions for them speak, with a unanimity that is suspect in itself, of the need for renewed contact with "reality" [but] even if these materials were more "real", the question would still be begged, for "reality" would still explain next to nothing about the actual appearance of Cubist collage.[13]

The word "reality" stands in this passage for any independent significance the bits of newspaper or woodgrain might retain once inserted into the Cubist pictorial matrix. Nowhere in the essay is this even admitted as an interpretative possibility. Collage is entirely subsumed within a self-sufficient dialogue between the flat plane and sculptural effect, the artist's worry over the problem of representation in general precluding representation in the particular. Thus, as the theory of modernism took on independent life, the dislodged bits of commercial culture came to appear, even more drastically, as the means to an end.

* * *

The testimony of the most articulate modernists would appear thoroughly to deny that debts to the vernacular in advanced art pose any particular problem – or perhaps to indicate that its solution must be pursued in another critical language entirely. Certainly, to the many partisans of a postmodernist present, who dismiss Greenberg's model as an arbitrary and arid teleology, it would appear foolish to look to the theory of modernism for any help whatsoever on this issue. Avant-garde borrowing from below necessarily involves questions of heterogeneous cultural practice, of trans-

8

gressing limits and boundaries. The postmodernists, who celebrate heterogeneity and transgression, find modernist self-understanding utterly closed to anything but purity and truth to media.[14]

The critique of Greenbergian modernism is now well advanced, and its defenders are scarce. His present-day detractors have found their best ammunition in the prescriptive outcome of his analysis as it congealed after 1950. But the later Greenberg has thereby come to obscure the earlier and more vital thinker, his eventual modernist triumphalism pushing aside the initial logic of his criticism and the particular urgency that prompted it. His first efforts as a critic in fact offered an explanation for the enforcement of cultural hierarchy as carried out by a Mallarmé or a Signac. At that point he was able to place the idealism of the former's mirror of painting and the latter's liberated consciousness in an historically analytical frame.

What worried Greenberg most in 1939 was not the picture plane. The founding essay of his enterprise as a critic, "Avant-Garde and Kitsch," begins with a flat rejection of the limited frame of formal aesthetics: "It appears to me it is necessary to examine more closely and with more originality than hitherto the relationship between aesthetic experience as met by the specific – not the generalized – individual, and the social and historical contexts in which that experience takes place."[15] This preamble was mildly stated but deeply meant; what was occupying his attention was nothing less than a material and social crisis which threatened the traditional forms of nineteenth-century culture with extinction. This crisis had resulted from the economic pressure of an industry devoted to the simulation of art in the form of reproducible cultural commodities, that is to say, the industry of mass culture. In search of raw material, mass culture had progessively stripped traditional art of its marketable qualities, and had left as the only remaining path to authenticity a ceaseless alertness against the stereotyped and pre-processed. By refusing any other demands but the most self-contained technical ones, the authentic artist could protect his or her work from the reproduction and rationalization that would process its usable bits and destroy its inner logic. From this resistance came the necessity for modernism's inwardness, self-reflexivity, "truth to media."

Greenberg made this plain in "Towards a Newer Laocoon," the essay in which he drew out the largely unstated aesthetic implications of "Avant-Garde and Kitsch." "The arts, then," he stated, "have been hunted back to their mediums, and there they have been isolated, concentrated and defined ... To restore the identity of an art, the opacity of the medium

9

must be emphasized.''[16] This conclusion was provisional and even reluctant, its tone far removed from the complacency of his later criticism. The formative theoretical moment in the history of modernism in the visual arts was inseparably an effort to come to terms with cultural production as a whole under the conditions of consumer capitalism. Because of this – and only because of this – it was able temporarily to surpass the idealism of the ideologies generated within the avant-garde, an idealism to which it soon tacitly succumbed. In Greenberg's early analysis, mass culture is never left behind in modernist practice, but persists as a constant pressure on the artist, which severely restricts creative "freedom." "Quality," it is true, remained in his eyes exclusively with the remnant of traditional high culture, but mass culture was prior and determining: modernism was its effect.

While interdependence between high and low lay at the heart of his theory, Greenberg nevertheless could admit no positive interdependence between the two spheres because of the rigid distinction he drew between popular culture and the modern phenomenon of kitsch. The former was for him inseparable from some integrated community comparable to the kind that sustained traditional high art; the latter was peculiarly modern, a product of rural migration to the cities and the immigrants' eager abandonment of the folk culture they brought with them. Expanded literacy and the demarcation of assigned leisure outside the hours of work, with the promise of heightened diversion and pleasure within that leisure time, set up pressure for a simulated culture adapted to the needs of this new clientele. Kitsch had emerged to fill a vacuum; the regimented urban worker, whether in factory or office, came to compensate for the surrender of personal autonomy through an intense development of the time left over, transferring the search for individual identity into the symbolic and affective experiences now defined as specific to leisure. But because the ultimate logic of this re-creation (the hyphen restoring the root meaning of the term) was the rationalized efficiency of the system as a whole, these needs were met by the same means as material ones: by culture recast as reproducible commodities. Among those of his contemporaries whose cultural horizons were limited to kitsch, Greenberg saw subjectivity as mirrored and trapped in the lifeless logic of mass production: imagining, thinking, feeling all performed by the machine long before the individual consumer encountered its products in the tabloids, pop tunes, pulp novels and melodramas of stage and film.

For this reason, the artist – in any genuine sense of the term – could expect no audience outside those cultivated members of the privileged

classes who maintain in their patronage a pre-modern independence of taste. He could state categorically,

> The masses have always remained more or less indifferent to culture in the process of development.... No culture can develop without a social basis, without a source of stable income. And in the case of the avant-garde, this was provided by an elite among the ruling class of that society from which it assumed itself to be cut off, but to which it has always remained attached by an umbilical cord of gold.[17]

In light of this analysis, it is not surprising that he should have posited the relationship between modernism and mass culture as one of relentless refusal. The problem remained, however, that the elite audience for modernism endorsed, in every respect but its art, the social order responsible for the crisis of culture. The implicit contention of early modernist theory – and the name of T.W. Adorno for modern music can be joined to that of Greenberg for the visual arts – was that the contradiction between an oppositional art and a public with appetite for no other kind of opposition could be bracketed off, if not transcended, in the rigor of austere, autonomous practice.

* * *

If the art of Manet is taken to mark the beginning of modernism, it would be hard not to admit the general accuracy of Greenberg's attachment to an elite. The impulse that moved Signac momentarily to make an audience of Parisian furniture workers stands out in its extreme rarity in the history of the avant-garde. The fleetingness of those efforts in Berlin, Cologne, or Vitebsk after World War I to redefine avant-garde liberation in working-class terms tells the same story. But oppositional art did not begin with Manet and did not, before him, always opt for detachment.

The two artists together most responsible for defining advanced art in terms of opposition to established convention, making painting a scene of dispute over the meaning of high culture, were Jacques-Louis David and Gustave Courbet; and the art of each, at least in the critical moments of 1785 and 1850, was about a re-definition of publics. The formal qualities that are rightly seen as anticipating fully fledged modernism – the dramatic defiance of academic compositional rules, technical parsimony and compressed dissonance in the *Oath of the Horatii* or the *Burial at Ornans* – were carried forward in the name of another public, excluded outsiders, whose characteristic means of expression these pictures managed to

11

address. In the process, "Rome" or "the countryside" as privileged symbols in a conflict of social values were turned over to the outsiders. The antagonistic character of these pictures can thus be read as duplicating real antagonisms present within the audience assembled at the public exhibitions. Already perceived oppositions of style and visual language, drawn from the world outside painting, were thrust into the space of art and put to work in a real interplay of publics. The appeal of each artist to the excluded group was validated by the hostility exhibited by the established, high-minded art public; that hostility was redoubled by the positive response of the illegitimate public; and so on in a self-reinforcing way.[18]

But with the installation of oppositional art within a permanent avant-garde, that group itself comes to replace the oppositional public precariously mobilized by David or Courbet; antagonism is abstracted and generalized; and only then does dependence on an elite audience and luxury-trade consumption become a given. One writer of Greenberg's generation, rather than bracketing off this dependence, made it central to his analysis: this was Meyer Schapiro. In his little-known but fundamental essay of 1936, "The Social Bases of Art," and in "The Nature of Abstract Art," published the following year in the independent *Marxist Quarterly*, he argued in an original and powerful way that the avant-garde had habitually based its model of artistic freedom on the aimlessness of the middle-class consumer of packaged diversion.[19] The complicity between modernism and the consumer society is clearly to be read, he maintained, in Impressionist painting:

> It is remarkable how many pictures we have in early Impressionism of informal and spontaneous sociability, of breakfasts, picnics, promenades, boating trips, holidays, and vacation travel. These urban idylls not only present the objective forms of bourgeois recreation in the 1860s and 1870s; they also reflect in the very choice of subjects and in the new aesthetic devices the conception of art solely as a field of individual enjoyment, without reference to ideas and motives, and they presuppose the cultivation of these pleasures as the highest field of freedom for an enlightened bourgeois detached from the official beliefs of his class. In enjoying realistic pictures of his surroundings as a spectacle of traffic and changing atmospheres, the cultivated rentier was experiencing in its phenomenal aspect that mobility of the environment, the market and of industry to which he owed his income and his freedom. And in the new Impressionist techniques which broke things up into finely discriminated

points of color, as well as in the "accidental" momentary vision, he found, in a degree hitherto unknown in art, conditions of sensibility closely related to those of the urban promenader and the refined consumer of luxury goods.[20]

Schapiro's contention was that the advanced artist, after 1860 or so, succumbed to the general division of labor as a full-time leisure specialist, an aesthetic technician picturing and prodding the sensual expectations of other, part-time consumers. The above passage is taken from the 1937 essay; in its predecessor Schapiro offered an extraordinary thematic summation of modernism in a single paragraph, one in which its progress is logically linked to Impressionism's initial alliance with the emerging forms of mass culture. In the hands of the avant-garde, he argued, the aesthetic itself became identified with habits of enjoyment and release produced quite concretely within the existing apparatus of commercial entertainment and tourism – even, and perhaps most of all, when art appeared entirely withdrawn into its own sphere, its own sensibility, its own medium. If only because of the undeserved obscurity of the text, it is worth quoting at length:

Although painters will say again and again that content doesn't matter, they are curiously selective in their subjects. They paint only certain themes and only in a certain aspect. . . . First, there are natural spectacles, landscapes or city scenes, regarded from the point of view of a relaxed spectator, a vacationist or sportsman, who values the landscape chiefly as a source of agreeable sensations or mood; artificial spectacles and entertainments – the theater, the circus, the horse-race, the athletic field, the music hall – or even works of painting, sculpture, architecture, or technology, experienced as spectacle or objects of art; . . . symbols of the artist's activity, individuals practicing other arts, rehearsing, or in their privacy; instruments of art, especially of music, which suggest an abstract art and improvisation; isolated intimate fields, like a table covered with private instruments of idle sensation, drinking glasses, a pipe, playing cards, books, all objects of manipulation, referring to an exclusive, private world in which the individual is immobile, but free to enjoy his own moods and self-stimulation. And finally, there are pictures in which the elements of professional artistic discrimination, present to some degree in all painting – the lines, spots of color, areas, textures, modelling – are disengaged from things and juxtaposed as "pure" aesthetic objects.[21]

Schapiro would one day become a renowned and powerful apologist for the avant-garde, but his initial contribution to the debate over modernism and mass culture squarely opposed Greenberg's conclusions of a few years later: the 1936 essay was, in fact, a forthright anti-modernist polemic, an effort to demonstrate that the avant-garde's claims to independence, to disengagement from the values of its patron class were a sham; "in a society where all men can be free individuals," he concluded, "individuality must lose its exclusiveness and its ruthless and perverse character."[22] The social analysis underlying that polemic, however, was almost identical to Greenberg's. Both saw the modern marketing of culture as the negation of the real thing, that is, the rich and coherent symbolic dimension of collective life in earlier times; both believed that the apparent variety and allure of the modern urban spectacle disguised the "ruthless and perverse" laws of capital; both posited modernist art as a direct response to that condition, one that would remain in force until a new, socialist society was achieved.[23] Given these basic points of agreement and the fact that both men were operating in the same intellectual and political milieu, how can the extent of their differences be explained?

One determining difference between the two theorists lay in the specificity of their respective understandings of mass culture: though the analysis of each was summary in character, Greenberg's was the more schematic. His use of the term "kitsch" encompassed practically the entire range of consumable culture, from the crassest proletarian entertainments to the genteel academicism of much "serious" art: "all kitsch is academic; and conversely, all that's academic is kitsch," was Greenberg's view in a pithy sentence.[24] Schapiro, on the other hand, was less interested in the congealed, inauthentic character of cultural commodities taken by themselves than he was in behavior: what, he asked, were the characteristic forms of experience induced by these commodities? In his discussion of Impressionism, this line of inquiry led him to the historically accurate perception that the people with the time and money able fully to occupy the new spaces of urban leisure were primarily middle class. The weekend resorts and *grands boulevards* were, at first, places given over to the conspicuous display of a brand of individual autonomy specific to that class. The correct clothes and accessories were required, as well as the correct poses and attitudes. The new department stores, like Boucicaut's Au Bon Marché, grew spectacularly by supplying the necessary material equipment and, by their practices of sales and promotion, effective instruction in the more intangible requirements of this sphere of life. The economic barriers were

enough, in the 1860s and 1870s, to ward off the incursion of other classes of consumer. Even such typically working-class diversions of the present day as soccer and bicycle racing (Manet planned a large canvas on the latter subject in 1870) began in this period as enthusiasms of the affluent.[25]

In Schapiro's eyes, the avant-garde merely followed a de-centering of individual life which overtook the middle class as a whole. It was, for him, entirely appropriate that the formation of Impressionism should coincide with the Second Empire, that is, the period when acquiescence to political authoritarianism was followed by the first spectacular flowering of the consumer society. The self-liquidation after 1848 of the classical form of middle-class political culture prompted a displacement of traditional ideals of individual autonomy into spaces outside the official institutions of society, spaces where conspicuous styles of "freedom" were made available. That shift was bound up with the increasingly sophisticated engineering of mass consumption, the internal conquest of markets, required for continuous economic expansion. The department store, which assumed a position somewhere between encyclopedia and ritual temple of consumption, is the appropriate symbol for the era. It served as one of the primary means by which a middle-class public, often deeply unsettled by the dislocations in its older patterns of life, was won over to the new order being wrought in its name.[26]

These early essays of Greenberg and Schapiro, which took as their common subject the sacrifice of the best elements in bourgeois culture to economic expediency, were both visibly marked by the classic interpretation of the 1848–51 crisis in France: that of Marx in the *Eighteenth Brumaire of Louis Bonaparte*.[27] There Marx described the way in which the forcible exclusion of oppositional groups from the political process necessitated a kind of cultural suicide on the part of the propertied republicans, a willed destruction of their own optimal institutions, values and expressive forms:

While the parliamentary party of Order, by its clamor for tranquillity, as I have shown, committed itself to quiescence, while it declared the political rule of the bourgeoisie to be incompatible with the safety and existence of the bourgeoisie, by destroying with its own hands in the struggle against other classes in society all the conditions for its own regime, the parliamentary regime, the extra-parliamentary mass of the bourgeoisie, on the other hand, by its servility toward the President, by its vilification of parliament, by its brutal treatment of its own press,

15

invited Bonaparte to suppress and annihilate its speaking and writing section, its politicians and its literati, its platform and its press, in order that it might be able to pursue its private affairs with full confidence in the protection of a strong and unrestricted government. It declared unequivocally that it longed to get rid of its own political rule in order to get rid of the troubles and dangers of ruling.[28]

When Schapiro spoke of the "enlightened bourgeois detached from the official beliefs of his class," he sought to go a step beyond Marx, to describe the concrete activities through which that detachment was manifested. Out of the desolation of early nineteenth-century forms of collective life, which affected all classes of the city, adventurous members of the privileged classes led the way in colonizing the one remaining domain of relative freedom: the spaces of public leisure. There suppressed community was displaced and dispersed into isolated acts of individual consumption; but those acts could in turn coalesce into characteristic group styles. Within leisure a sense of solidarity could be recaptured, at least temporarily, in which individuality was made to appear imbedded in group life: the community of fans, aficionados, supporters, sportsmen, experts. Lost possibilities of individual effectiveness within the larger social order were re-presented as a catalogue of leisure-time roles.

Another contributor to this extraordinary theoretical moment of the later 1930s, Walter Benjamin, made this point plainly in his study of Baudelaire and Second-Empire Paris. Speaking of the privileged class to which the poet belonged, he wrote:

> The very fact that their share could at best be enjoyment, but never power, made the period which history gave them a space for passing time. Anyone who sets out to while away time seeks enjoyment. It was self-evident, however, that the more this class wanted to have its enjoyment in this society, the more limited this enjoyment would be. The enjoyment promised to be less limited if this class found enjoyment of this society possible. If it wanted to achieve virtuosity in this kind of enjoyment, it could not spurn empathizing with commodities. It had to enjoy this identification with all the pleasure and uneasiness which derived from a presentiment of its destiny as a class. Finally, it had to approach this destiny with a sensitivity that perceives charm even in damaged and decaying goods. Baudelaire, who in a poem to a courtesan called her heart "bruised like a peach, ripe like her body, for the lore of love", possessed this sensitivity. To it he owed his enjoyment of this society as one who had already half withdrawn from it.[29]

16

* * *

In his draft introduction to the never-completed Baudelaire project, Benjamin wrote, "In point of fact, the theory of *l'art pour l'art* assumes decisive importance around 1852, at a time when the bourgeoisie sought to take its 'cause' from the hands of the writers and poets. In the *Eighteenth Brumaire* Marx recollects this moment...."[30] Modernism, in the conventional sense of the term, begins in the forced marginalization of the artistic vocation. And what Benjamin says of literature applies as well, if not better, to the visual arts. The avant-garde left behind the older concerns of official public art not out of any special rebelliousness on the part of its members, but because their political representatives had jettisoned as dangerous and obstructive the institutions and ideals for which official art was metaphorically to stand. David's public, to cite the obvious contrasting case, had found in his pictures of the 1780s a way imaginatively to align itself with novel and pressing demands of public life; his *Horatii* and *Brutus* resonated as vivid tracts on individual resolve, collective action, and their price. Oppositional art meant opposition on a broad social front. Until 1848, there was at least a latent potential for a middle-class political vanguard to act on its discontent, and an oppositional public painting maintained itself in reserve. This was literally the case with the most powerful attempt to duplicate David's early tactics, Géricault's *Raft of the Medusa*, which failed to find an oppositional public in the politically bleak atmosphere of 1819.[31] But when the Revolution of 1830 roused Delacroix from his obsession with individual victimization and sexual violence, he reached back to his mentor's great prototype. The barricade in his *Liberty Leading the People*, heaving up in the foreground, is the raft turned ninety degrees; the bodies tumble off its leading rather than trailing edge (Delacroix shifts the sprawling, bare-legged corpse more or less intact from the right corner to the left, precisely marking the way he has transposed his model); the straining pyramid of figures now pushes toward the viewer rather than away. In the first days of 1848 the republican Michelet employed the Géricault painting in his oratory as a rallying metaphor for national resistance. And after the February uprising, *Liberty* emerged briefly from its captivity in the storerooms.[32]

The events of 1851 ended all this, denying, as they did, any ambition Courbet had entertained to shift the address of history painting to a new outsider public, an opposition based in the working classes. For a middle-class audience, the idea of a combative and singular individuality, impatient with social confinement, remained fundamental to a generally internalized sense of self — as it still does. But that notion of individuality

would henceforth be realized in private acts of self-estrangement, distancing and blocking out the gray realities of administration and production in favor of a brighter world of sport, tourism, and spectacle. This process was redoubled in the fierce repression that followed the uprising of the Commune twenty years later; between 1871 and 1876, the heyday of Impressionist formal innovation, Paris remained under martial law.

If the subjective experience of freedom became a function of a supplied identity, one detached from the social mechanism and contemplating it from a distance, then the early modernist painters – as Schapiro trenchantly observed in 1936 – lived that role to the hilt. That observation might well have led to a dismissal of all avant-garde claims to a critical and independent stance as so much false consciousness (as it does for some today). But in his essay of the following year, Schapiro himself came to resist such a facile conclusion. The basic argument remained in place, but "The Nature of Abstract Art" deploys without irony terms like "implicit criticism" and "freedom" to describe modernist painting. Of the early avant-garde, he wrote,

> The very existence of Impressionism which transformed nature into a private, unformalized field of sensitive vision, shifting with the spectator, made painting an ideal domain of freedom; it attracted many who were tied unhappily to middle-class jobs and moral standards, now increasingly problematic and stultifying with the advance of monopoly capitalism. . . . in its discovery of a constantly changing phenomenal outdoor world of which the shapes depended on the momentary position of the casual or mobile spectator, there was an implicit criticism of symbolic and domestic formalities, or at least a norm opposed to these.[33]

Added here was a recognition of some degree of active, resistant consciousness within the avant-garde. And this extended to his valuation of middle-class leisure as well. He spoke of an Impressionist "discovery" of an implicitly critical, even moral, point of view. This critical art had not been secured through withdrawal into self-sufficiency, but had instead been grounded in existing social life outside the sphere of art.

Schapiro created a deliberate ambiguity in the second essay, in that it offered a qualified apology for modernism without renouncing his prior dismissal of the reigning modernist apologetics.[34] "The Nature of Abstract Art" is an inconclusive, "open" text, and it is just this quality, its unresolved oscillation between negative and affirmative positions, that makes it so valuable.[35] By 1937 Schapiro had ceased to identify the avant-garde with the outlook of a homogeneous "dominant" class. So, while

Impressionism did indeed belong to and figured a world of privilege, there was, nevertheless, disaffection and erosion of consensus within that world. The society of consumption as a means of engineering political consent and socially integrative codes is no simple or uncontested solution to the "problem of culture" under capitalism. As it displaces resistant impulses, it also gives them a refuge in a relatively unregulated social space where contrary social definitions can survive, and occasionally flourish. Much of this is, obviously, permitted disorder: managed consensus depends on a compensating balance between submission and negotiated resistance within leisure. But once that zone of permitted freedom exists, it can be seized by disaffected groups in order to articulate for themselves a counter-consensual identity, an implicit message of rupture and discontinuity. From the official point of view, these groups are defined as deviant or delinquent; following contemporary sociological usage, they can be called resistant subcultures.[36]

In one of the founding formulations of cultural studies, Stuart Hall and Tony Jefferson set out the traits of such subcultures in a way that can serve with little modification to characterize the early avant-garde as a social formation:

> They cluster around particular locations. They develop specific rhythms of interchange, structured relations between members: younger to older, experienced to novice, stylish to square. They explore "focal concerns" central to the inner life of the group: things always "done" or "never done", a set of social rituals which underpin their collective identity and define them as a "group" instead of a mere collection of individuals. They adopt and adapt material objects – goods and possessions – and reorganize them into distinctive "styles" which express the collectivity of their being-as-a-group. These concerns, activities, relationships, materials become embodied in rituals of relationship and occasion and movement. Sometimes, the world is marked out, linguistically, by names or an argot which classifies the social world exterior to them in terms meaningful only within their group perspective, and maintains its boundaries. This also helps them to develop, ahead of immediate activities, a perspective on the immediate future – plans, projects, things to do to fill out time, exploits. . . . They too are concrete, identifiable social formations constructed as a collective response to the material and situated experience of their class.[37]

To make the meaning of that last sentence more precise, the resistant subcultural response is a means by which certain members of a class

"handle" and attempt to resolve difficult and contradictory experience common to their class but felt more acutely by the subcultural recruits.

It was the work of community activist Phil Cohen (now scandalously unrecognized in the ascendancy of cultural studies as a field) that made the breakthrough, joining an empirical sociology of deviance to systematic visual aesthetics.[38] No one before him had seen past the stereotypes of adolescent deviance even to think that the menacing particulars of the original skinhead style in London's East End – the boots and braces, the shaved scalps and selective racial marauding – might reward the sort of interpretation practiced by art-historical iconographers. What he found was a precisely coded response to the changes in the city's economy and land use that had eroded beyond recovery the neighborhood life that the skinheads' parents had known. Where the mods of the 1960s had articulated – through sharp, Italian-style suits and gleaming Vespas – an imaginary relation to the closed option of upward mobility, the skinheads turned around and fashioned a similarly imaginary relation to the downward option of rough manual labor, an identity that had become equally inaccessible to them in the wake of the closing of the East End's docks and industries. An imaginary belonging to a lost local culture, a refusal to assent to fraudulent substitutes for community, were figured in the dress, speech, and rituals of enforced idleness that so alarmed outsiders.

Though this in no way redeemed the racism, ignorance, and apathy on view, what Cohen decoded at least amounted to an eloquence in choices of style and imagery. Battered and marginalized by economic rationalizations, working-class community could only be recovered as an imaginary solution in the realm of style, one limited further to the temporary, inherently ambiguous phase of "youth." Cohen's stress on the symbolic and compensatory rather than activist function of subcultures, along with the shift from blocked verbal facility to high competence in visual discrimination, fits the pattern of the early artistic avant-garde movements just as well. By the later nineteenth century, an artistic vocation, in the sense established by David, Goya, Géricault, Delacroix, or Courbet, had become so problematic as to require similar defense. With the emergence of a persistent avant-garde, a small, face-to-face group of artists and supporters became their own oppositional public, one socially grounded within structured leisure. The distinctive point of view and iconographic markers of the subculture came to be drawn from a repertoire of objects, locations and behaviors supplied by other colonists of the same social spaces; avant-garde opposition was and is drawn out of inarticulate and unresolved

dissatisfactions which those spaces, though designed to contain them, also put on display.

* * *

At this point, clearer distinctions need to be drawn between kinds of subcultural response. There are those that are no more than the temporary outlet of the ordinary citizen; there are those that are merely defensive, in that the group style they embody, though it may be central to the social life of its members, registers externally only as a harmless, perhaps colorful enthusiasm. But the stylistic and behavioral maneuvers of certain subcultures will transgress settled social boundaries. From the outside, these will be read as extreme, opaque, inexplicably evasive and, for that reason, hostile. The dependable negative reaction from figures in authority and the semi-official guardians of propriety and morality will then further sharpen the negative identity of the subculture, help cement group solidarity, and often stimulate new adherents and imitators.

The required boundary transgression can occur in several ways. Where different classes meet in leisure-time settings, objects, styles, and behaviors with an established significance for one class identity can be appropriated and re-positioned by another group to generate new, dissonant meanings. This shifting of signs can occur in both directions on the social scale (or scales). Another means to counter-consensual group statement is to isolate one element of the normal pattern of leisure consumption, and then exaggerate and intensify its use until it comes to signify the opposite of its intended meaning.

It is easy to think of examples of such semiotic tactics in present-day subcultures; our model of subversive consumption is derived from the analyis of these deviant groups. But the same tactics can just as easily be seen at work in the early avant-garde, where a dissonant mixing of class signifiers was central to the formation of the avant-garde sensibility. Courbet's prescient excursion into suburban pleasure for sale, the *Young Ladies on the Banks of the Seine* of 1856, showed two drowsing prostitutes in the intimate finery of their betters, piled on past all "correct" usage of fashionable underclothing.[39] And Manet would exploit similar kinds of dissonance in the next decade. It showed up in his own body; his friend and biographer Antonin Proust speaks of his habitual imitation of the speech patterns and peculiar gait of a Parisian street urchin.[40] The subject of both the *Déjeuner sur l'herbe* and *Olympia* is the pursuit of

21

commercial pleasure at a comparably early stage when it necessarily involved negotiation with older, illicit social networks at the frontier between legality and criminality.[41]

Establishing itself where Courbet and Manet had led, "classic" Impressionism, the sensually flooded depictions of weekend leisure in which Monet and Renoir specialized during the 1870s, opted for the second tactic. The life they portray was being lived entirely within the confines of real-estate development and entrepreneurial capitalism; these are images of provided pleasures. But they are images that alter, by the very exclusivity of their concentration on ease and uncoerced activity, the balance between the regulated and unregulated compartments of experience. They take leisure out of its place; instead of appearing as a controlled, compensatory feature of the modern social mechanism, securely framed by other institutions, it stands out in unrelieved difference from the denial of freedom that surrounds it.

It is in this sense that Schapiro could plausibly speak of Impressionism's "implicit criticism of symbolic and domestic formalities, or at least a norm opposed to these." But what Schapiro did not address was how this criticism came to be specifically articulated as criticism: a difference is not an opposition unless it is consistently legible as such. This raises once again the question of modernism in its conventional aesthetic sense – as autonomous, self-critical form. The "focal concern" of the avant-garde subculture was, obviously, painting conceived in the most ambitious terms available. It was in its particular opposition to the settled discourse of high art that the central avant-garde group style gained its cogency and its point. They were able to take their nearly total identification with the uses of leisure and make that move count in another, major arena, where official beliefs in cultural stability were particularly vulnerable. The *grands boulevards* and suburban regattas may have provided the solution, but the problem had been established elsewhere: in the hollowing out of artistic tradition by academic eclecticism, pastiche, the manipulative reaching for canned effects, all the played-out maneuvers of Salon kitsch. Almost every conventional order, technique and motif that had made painting possible in the past had, by this point, been fatally appropriated and compromised by a decayed academicism. And this presented immediate, practical difficulties for the fundamental process of making pictures: how do you compose, that is, construct a pictorial order of evident coherence, without resorting to any prefabricated solutions? The unavailability of those solutions inevitably placed the greatest emphasis – and burden – on those elements of picture-making that seemed unmediated and irreducible: the

single vivid gesture of the hand by which a single visual sensation is registered. As tonal relationships belonged to the rhetoric of the schools – rote procedures of drawing, modelling and chiaroscuro – these gestural notations would be of pure, saturated color.

The daunting formal problematic that resulted was this: how to build from the independent gesture or touch some stable, overarching structure which fulfilled two essential requirements: firstly, it had to be constructed only from an accumulation of single touches and could not appear to subordinate immediate sensation to another system of cognition; and, at the same time, it had to close off the internal system of the picture and invest each touch with consistent descriptive sense in relation to every other touch. Without the latter, painting would have remained literally pre-artistic, an arbitrary section out of an undifferentiated field of minute, equivalent, and competing stimuli. Impressionism, quite obviously, found ways around this impasse, discovered a number of improvised, ingenious devices for making its colored touches jell into a graspable order: disguised compositional grids, sophisticated play within the picture between kinds of notation and levels of descriptive specificity, motif selection in which the solidity of larger forms is inherently obscured, and, finally, the fabrication of the picture surface into a tangibly constructed wall or woven tissue of pigment. The persuasiveness of these solutions, however, depended to a great degree on the built-in orders of the places they painted. The aquatic resort or dazzling shopping street offered "reality" as a collection of uncomposed and disconnected surface sensations. The disjunction of sensation from judgment was not the invention of artists, but had been contrived by the emerging leisure industry to appear the more natural and liberated moment of individual life. The structural demarcation of leisure within the capitalist economy provided the invisible frame which made that distracted experience cohere as the image of pleasure.

The most provocative and distinctive pictorial qualities of early modernism were not only justified by formal homologies with its subject matter as an already created image, they also served to defend that image by preserving it from inappropriate kinds of attention. So that the promises of leisure would not be tested against too much contrary visual evidence – not only dissonant features of the landscape, like the prominent factories of Argenteuil, but also the all-too-frequent failure of the promise of happiness – the painters consistently fixed on optical phenomena that are virtually unrepresentable: rushing shoppers glimpsed from above and far away, the disorienting confusion of the crowded *café-concert*, smoke

and steam in the mottled light of the glass-roofed railway station, wind in foliage, flickering shadows, and, above all, reflections in moving water. These phenomena have become, thanks largely to Impressionism, conventional signs of the spaces of leisure and tourism, of their promised vividness and perpetual surprise, but as optical "facts" they are so changeable or indistinct that one cannot really hold them in mind and preserve them as a mental picture; and therefore one cannot securely test the painter's version against remembered visual experience. The inevitably approximate and unverifiable registration of these visual ephemera in painting makes large areas of the canvas less descriptive than celebratory of gesture, color, and shape – pictorial incidents attended to for their own sake.

The passage from deliberate evasiveness and opacity to insistence on material surface – to modernist abstraction, in short – has been admirably articulated in an essay on Monet by the novelist Michel Butor (in effect taking up the matter where Mallarmé had left it a century before). Speaking of *Regattas at Argenteuil* of 1872 (pl. 3), a picture dominated by broadly rendered reflections of sailboats and shoreline villas, he writes,

> It is impossible to interpret the reflected part as the simple notation of what lay before the painter's eyes. How can one suppose that Monet would have chosen any one of the millions of images that the camera might have registered? He constructed an image, animated by a certain rhythm, which we may imagine as conforming to that of the liquid surface (yet there is nothing to confirm even this), based on real objects.
>
> The semantic relation of above and below obviously works in both directions: a) the upper names the lower: this aggregate of blotches which means nothing to you is a tree, a house, a boat; b) the lower reveals the upper: this boat, this house, which may seem dull to you contains secret congruences of color, elementary images, expressive possibilities.
>
> The upper part corresponds to what one recognizes, the reality one is used to; the lower, which leads us toward the houses and boats, corresponds to the painter's act. The water becomes a metaphor for painting. The very broad strokes with which these reflections are indicated are vigorous assertions of material and means. The liquid surface provides an instance in nature of the painter's activity.[42]

Monet used the artifice of painting to make his scene better, more congruent and formally satisfying, than it could ever be in life. Impressionism's transformation of leisure into an obsessive and exclusive value, its inver-

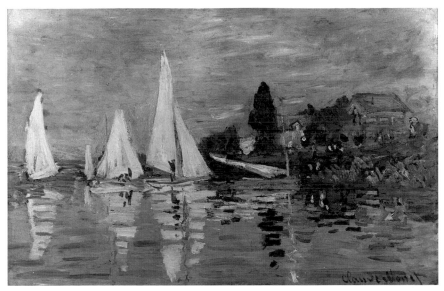

3 Claude Monet, *Regattas at Argenteuil*, c.1872. Oil on canvas, 48 × 75 cm. Paris, Musée d'Orsay.

sion of the intended social significance of its material, necessitated special painterly means, which in turn inverted the intended social significance of its medium.

Nineteenth-century high culture was nothing if it did not embody the permanent, indisputable and ideal; the avant-garde appropriated the form of high art in the name of the contingent, unstable, and material. To accept modernism's oppositional claims, one need not assume that it somehow transcended the culture of the commodity; it can rather be seen as having exploited to critical purpose contradictions within and between distinct sectors of that culture. Validated fine art, the art of the museums, is that special preserve where the commodity character of modern cultural production is sealed off from apprehension. There the aggressively reiterated pretense is that traditional forms have survived unaltered and remain available as an experience outside history. Marginal, leisure-time subcultures perform more or less the same denial of the commodity, using the objects at their disposal. Lacking legitimating institutions, their transformation of the commodity must be activist and improvisatory: thus, their continual inventiveness in displacing provided cultural goods into new constellations of meaning. The most powerful moments of modernist

negation have occurred when the two aesthetic orders, the high-cultural and subcultural, have been forced into scandalous identity, each being continuously dislocated by the other.

The repeated return to mass-cultural material on the part of the avant-garde can be understood as efforts to revive and relive this strategy – each time in a more marginal and refractory leisure location. Seurat, when he conceived *Sunday Afternoon on the Island of the Grande Jatte* as the outsize pendant to his *Bathers at Asnières* in the 1880s, pointedly placed an awkward and routinized bourgeois leisure in another context, that of exhausted but uncontrived working-class time off.[43] His subsequent figure painting, as Signac pointed out, drew upon the tawdriest fringes of Parisian commercial entertainment, the proletarianization of pleasure for both consumer and performer alike. This scene was dissected according to the putatively objective and analytic system of Charles Henry. But according to the first-hand testimony of Emile Verhaeren, Seurat was moved to the artifice and rigidity imposed by Henry's emotional mechanics through identifying an analogous process already at work in his subject.[44] Art historians have long noted the appearance in Seurat's later paintings of the exaggerated angular contours that were the trademark of the poster artist Jules Chéret.[45] As much as the circus or the *café-concert*, Seurat's material was the advertisement of pleasure, the seductive face it puts on; he spoke of that face in a deferential tone and pushed his formal means in an attempt to master it. As Verhaeren put it: "The poster artist Chéret, whose genius he greatly admired, had charmed him with the joy and gaiety of his designs. He had studied them, wanting to analyze their means of expression and uncover their aesthetic secrets."[46] These last words are significant for the present argument, indicating as they do that the artist begins with an already existing aesthetic developed in the undervalued fringes of culture. In its marginality is its secret allure, one which is not so much the promise of pleasure – from the evidence, Seurat was cool and critical in his attitude – as the simple existence of a corner of the city that has improvised an appropriate and vivid way to represent itself. The sophisticated and self-conscious artist, intent on controlling the artifice and abstraction that have irrevocably overtaken his art, on keeping it in contact with an appropriate descriptive task, finds subject matter in which this connection has already been made.

Cubism secured its critical character through a re-positioning of even more exotically low-brow goods and protocols within the preserve of high art. The iconography of café table and cheap cabaret mark out its milieu with significant precision. The correct brand name on a bottle label was as

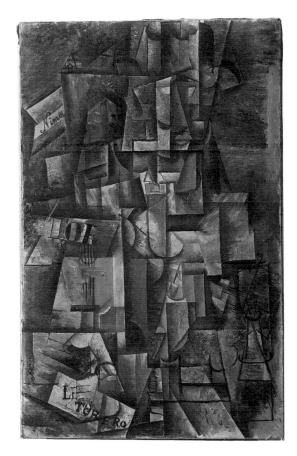

4 Pablo Picasso, *The Aficionado*, 1912. Oil on canvas, 135 × 82 cm. Basel, Kunstmuseum. Gift of Dr H.C. Raoul La Roche, 1952.

significant for Picasso and Braque as it had been to Manet in the *Bar at the Folies-Bergère*. The handbills, posters, packs of cigarette papers, department-store advertisements, are disposed in the pictures with conscious regard for the specific associations of each item and the interplay between them. The Cubists proceeded in the manner of mock conspirators, or Poe's sedentary detective Dupin, piecing together evidence of secret pleasures and crimes hidden beneath the apparently trivial surface of the popular media. Picasso for one could also take the measure of rival groups seeking identity in distraction. The provincial and chauvinist Midi displayed in his *Aficionado* of 1912 (pl. 4) stands in pointed contrast to the idyllic south of France embraced by the established avant-garde. Given the associations of French bullfighting, the figure in the painting – the stuffed

shirt in a Nîmes café, arrayed in his shoddy enthusiasm for the second-rate local bullring – stands as an enemy pleasure seeker. In addition to the comedy so apparent to an expert Spanish observer, there is a likely political subtext to the theme, the *corrida* being traditionally linked to parties of the extreme Right and having served as a rallying point for anti-Dreyfusard agitation in the south.[47]

The principle of collage construction – which entered Cubist practice around the same date as the *Aficionado* – further collapsed the distinction between the masterly and the burlesque, by turning pictorial invention into a fragmented consumption of manufactured images. Collage does its work within the problematic of pictorial modernism, dramatizing the literal support while preserving representation, but it is a solution discovered in a secretly coded world describable by means of these literal surfaces. And Cubism is readable as a message from the margins not only in the graphic content of the intruder objects, but in their substance and organization as well. The ersatz oilcloth and wallpaper substitutes for solid bourgeois surfaces, supplied originally by Braque from his provincial decorator's repertoire, are determinedly second-rate – in present-day terms, the equivalent of vinyl walnut veneers or petrochemical imitations of silk and suede. As such surfaces soon degrade, peel, flake, and fade, as newsprint and handbills turn brown and brittle, so collage disrupts the false harmonies of oil painting by reproducing the disposability of the most ordinary consumer goods.

<div align="center">* * *</div>

> Today, every phenomenon of culture, even if a model of
> integrity, is liable to be suffocated in the cultivation of kitsch.
> Yet paradoxically in the same epoch it is to works of art that
> has fallen the burden of wordlessly asserting what is barred to
> politics. . . . This is not a time for political art, but politics has
> migrated into autonomous art, and nowhere more so than
> where it seems to be politically dead. (T.W. Adorno, 1962)[48]

Of the surviving contributors to the theory of modernism and mass culture that coalesced in the 1930s, Adorno alone was able to preserve its original range of reference and intent. One purpose of the present discussion of the avant-garde as a resistant subculture has been to lend historical and sociological substance to Adorno's stance as it pertains to the visual arts. In that light, the formal autonomy achieved in early modernist painting should be understood as a mediated synthesis of possibilities

<div align="center">28</div>

derived from both the failures of existing artistic technique and a repertoire of potentially oppositional practices discovered in the world outside. From the beginning, the successes of modernism have been neither to affirm nor to refuse its concrete position in the social order, but to represent that position in its contradiction, and so act out the possibility of critical consciousness in general. Even Mallarmé, in the midst of his 1876 defense of Impressionism as a pure art of light and air, could speak of it also as an art "which the public, with rare prescience, dubbed, from its first appearance, Intransigeant, which in political language means radical and democratic."[49]

In the examples cited above, a regular rhythm emerges within the progress of the Parisian avant-garde. For early Impressionism, early Neo-Impressionism and Cubism before 1914, the provocative inclusion of materials from outside validated high culture was linked with a new rigor of formal organization, an articulate consistency of attention within the material fact of the picture surface; joining the two permitted the fine adjustment of this assertive abstraction to the demands of description – not description in the abstract, but of specific enclaves of the commercial city. The avant-garde group enacted this engagement itself, in an intensification of collective cooperation and interchange, individual works of art figuring in a concentrated group dialogue over means and criteria. But in each instance, this moment was followed by retreat – from specific description, from formal rigor, from group life, and from the fringes of commodity culture to its center. And this pattern marks the inherent limitations of the resistant subculture as a solution to the problematic experience of a marginalized and disaffected group.

Monet's painting after the early 1880s can be taken as emblematic of the fate of the Impressionist avant-garde. The problem of verifiable description was relaxed when the artist withdrew to remote or isolated locations to paint: the difficulty of improvising pictorial orders appropriate to a complex and sensually animated form of sociability was obviated by concentration on stable, simplified, and depopulated motifs (one knows this is a cathedral, a stack of grain, a row of poplars; the painting does not have to work to convince). In the process, the broad and definite touch of the 1870s, held between structure and description, was replaced by a precious, culinary surface, which largely gives up the job of dramatizing constructive logic. Not coincidentally, the 1880s was the period when Monet, thanks to Durand-Ruel's conquest of the American market, achieved secure financial success. Pissarro dismissed it all in 1887 as showy eccentricity of a familiar and marketable kind: "Monet plays his salesman's

29

game, and it serves him; but it is not in my character to do likewise, nor is it in my interest, and it would be in contradiction above all to my conception of art. I am not a romantic!"[50]

Pissarro had by this time thrown in his lot with the Neo-Impressionists, for whom Monet's "grimacing" spontaneity was precisely a point at issue. Monet had transformed Impressionism from a painting about play to a variety of play in itself (this is the sense in which modernist painting becomes its own subject matter in a regressive sense). The Neo-Impressionists moved back to the actual social locations of play – and once again put squarely in the foreground the formal problem of single touch/sensation versus larger governing order. The result of Seurat's laborious method was drawing and stately composition assertively made out of color alone. As the group carried on following his premature death, however, the pointillist touch expanded, became freer and more expressive in itself, worked with its neighbors less within finely adjusted relationships of color than as part of a relaxed, rhythmic animation of flat areas. This "varied and personal creation," as proclaimed by Signac in 1894, also entailed a retreat from hard urban subjects in favor of a repertoire of stock tourist vistas: sunsets, Côte d'Azur fishing villages, Mont Saint-Michel, Venice. As in the Impressionism of the 1880s, making the single gesture with the brush now advertised itself as a kind of play within an unproblematic playground, provided simultaneously by motif and picture surface alike.

This tendency was pushed even further in the hands of the younger painters soon to be called Fauves. Derain and Matisse, who came to artistic maturity in the late Neo-Impressionist milieu in southern France, used the liberated pointillist gesture as their point of departure. The result was painting built from loose sprays and spreading patches of saturated color, the descriptive function of which is casually loose and unsystematic. Conventionalized landscape motifs do much of that work and license the free abstraction of surface effects. Derain's dealer Ambroise Vollard knew his business when, having in mind the success of Monet's London pictures of the 1890s, he dispatched the young artist to England. Derain duly returned with a collection of postcard views: Big Ben, Westminster Abbey, Tower Bridge.[51] The Fauve "movement" was practically appropriated even before it gained its public identity in the exhibitions of the Indépendants and Salon d'Automne in 1906: collectors had spoken for major pictures; Vollard was buying out their studios; the critic Louis Vauxcelles, who supplied them with their supposedly derisive sobriquet, was in fact lyrically suppportive. The Fauves came close to being the first pre-sold avant-garde.[52]

But with that success came the sort of indeterminacy that Pissarro had decried in Monet. Derain, writing from L'Estaque in 1905, expressed his eloquent doubts to Maurice Vlaminck:

> Truly we've arrived at a very difficult stage of the problem. I'm so lost that I wonder what words I can use to explain it to you. If we reject decorative applications, the only direction we can take is to purify this transposition of nature. But we've only done this so far in terms of color. There is drawing as well, so many things lacking in our conception of art.
>
> In short, I see the future only in terms of composition, because in working in front of nature I am the slave of so many trivial things that I lose the excitement I need. I can't believe that the future will go on following our path: on the one hand we seek to disengage ourselves from objective things, and on the other we preserve them as the origin and end of our art. No, truly, taking a detached point of view, I cannot see what I must do to be logical.[53]

With assimilation into a more or less official modernism came the felt loss of a descriptive project and the corollary erosion of pictorial logic. A useful contrast can, in fact, be drawn between the work of Derain or Matisse at that moment, and the contemporaneous work of Vlaminck, who remained in the semi-industrialized suburban ring of Paris. In the latter's paintings of 1904–5, like *Houses at Chatou* (pl. 5), Fauve color and gesture work against their expected connotations of exuberance and ease; the deliberate instability of the technique is instead made to stand for the raw, unsettled quality of this particular landscape. In formal terms as well, this painting is one of the most uncompromising and unified Fauve works, and the artist's blunt confidence, his ability to use the brightest colors to convey bleakness and dereliction, may well have intensified Derain's anxieties about his own direction.

A child of the suburban working class, Vlaminck in these paintings was no tourist, and this set him apart from his colleagues. Braque, who had taken liberated gesture and color the furthest toward surface abstraction, made the most decisive break with the short-lived Fauve idyll a few years later; he withdrew with Picasso from the exhibition and gallery apparatus during the crucial years of Cubist experimentation, renewing the old avant-garde commitment to collaborative practice. Even if the collectivity was reduced to the minimum number of two, the effacement of creative personality was all the greater. And that combined withdrawal and

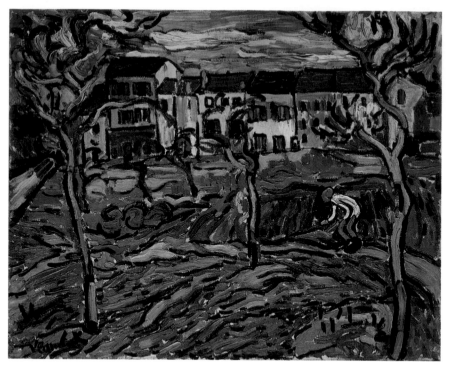

5 Maurice Vlaminck, *Houses at Chatou*, 1904–5. Oil on canvas, 81.9 × 100.3 cm.
Art Institute of Chicago, Gift of Mr. and Mrs. Maurice E. Culberg.

commitment to reasoned, shared investigation was tied down to specific
representation – and celebration – of a compact, marginalized form of life.

<p style="text-align:center">* * *</p>

Modernist practice sustains its claim to autonomy by standing, in its
evident formal coherence, against the empty diversity of the culture
industry, against market expediency, speculative targeting of consumers,
and hedging bets. But it has achieved this contrast most successfully by
figuring in detail the character of the manufactured culture it opposes.
Picasso's *Aficionado* twisted the south of France idyll into an embarrassing
leisure-time pose. The Dadaists of Berlin were most attentive to this
potential in Cubism, seeking in their own work to expose the debility of
life in thrall to industrial rationality. Raoul Haussmann wrote in 1918:

"In Dada, you will find your true state: wonderful constellations in real materials, wire, glass, cardboard, cloth, organically matching your own consummate, inherent unsoundness, your own shoddiness."[54] But the example of Berlin Dada serves to demonstrate that to make this kind of meaning unmistakable was to end all of art's claims to resolve and harmonize social experience. The Cubist precedent, by contrast, had been an effort to fend off that outcome, to articulate and defend a protected aesthetic space. And because it was so circumscribed, it was overtaken, like every other successful subcultural response.

Collage – the final outcome of Cubism's interleaving of high and low – became incorporated as a source of excitement and crisp simplification within an undeflected official modernism. In the movement's synthetic phase, translation of once-foreign materials into painted replications resolved the noisy and heterogeneous scene of fringe leisure into the sonority of museum painting. Critical distance was sacrificed further in 1915 when Picasso, in the wake of Braque's departure for the army, returned to conventional illusionism and art-historical pastiche while at the same time continuing to produce Cubist pictures. That move cancelled Cubism's claim to logical and descriptive necessity, and acknowledged that it had become a portable style, one ready-to-wear variety among many on offer. The critic Maurice Raynal, writing admiringly in 1924 of Picasso's *Three Musicians*, said more than he knew when he called it "rather like magnificent shop windows of Cubist inventions and discoveries."[55] The subject matter of that painting and others before it tells the same story: after 1914, virtually on cue, the raffish contemporary entertainers who populated previous Cubist painting gave way to Harlequins, Pierrots, and Punchinellos – sad clowns descended from Watteau and the pre-industrial past, the tritest metaphors for an alienated artistic vocation.

* * *

The basic argument of the present essay has been that modernist negation – which is modernism in its most powerful moments – proceeds from a productive confusion within the normal hierarchy of cultural prestige. Advanced artists repeatedly make unsettling equations between high and low which dislocate the apparently fixed terms of that hierarchy into new and persuasive configurations, thus calling it into question from within. But the pattern of alternating provocation and retreat indicates that these equations are, in the end, as productive for affirmative culture as they are for the articulation of critical consciousness. While traditionalists can be

depended upon to bewail the breakdown of past artistic authority, there will always be elite individuals who will welcome new values, new varieties and techniques of feeling. On the surface, this is easy to comprehend as an attraction to the glamor of marginality, to poses of risk and singularity. But there is a deeper, more systematic rationale for this acceptance, which has ended in the domestication of every modernist movement.

The context of subcultural life is the shift within a capitalist economy toward consumption as its own justification. The success of this shift – which is inseparably bound up with the developing management of political consent – depends on expanded desires and sensibilities, that is, the skills required for an ever more intense marketing of sensual gratification. In our image-saturated present, the culture industry has demonstrated the ability to package and sell nearly every variety of desire imaginable, but because its ultimate logic is the strictly rational and utilitarian one of profit maximization, it is not able to invent the desires and sensibilities it exploits. In fact, the emphasis on continual novelty basic to that industry runs counter to the need of every large enterprise for product standardization and economies of scale. This difficulty is solved by the very defensive and resistant subcultures that come into being as negotiated breathing spaces on the margins of controlled social life. These are the groups most committed to leisure, its pioneers, who for that reason come up with the most surprising, inventive and effective ways of using it. Their improvised forms are usually first made salable by the artisan-level entrepreneurs who spring up in and around any active subculture. Through their efforts, a wider circle of consumers gains access to an alluring subcultural pose, but in a more detached and shallow form, as the elements of the original style are removed from the context of subtle ritual that had first informed them. At this point it appears to the large fashion and entertainment concerns as a promising trend. Components of an already diluted stylistic complex are selected out, adapted to the demands of mass manufacture and pushed to the last job lot and bargain counter.

The translation of style from margin to center depletes the form of its original vividness and subtlety, but a sufficient residue of those qualities remains such that audience sensibilities expand roughly at the rate the various sectors of the culture industry require and can accommodate. What is more, the success of this translation guarantees its cyclical repetition. While it is true that the apparatus of spectacular consumption makes genuine human striving – even the resistance it meets – into saleable goods, this is no simple procedure. Exploitation by the culture industry serves at the same time to stimulate and complicate those strivings in such

a way that they continually outrun and surpass its programming. The expansion of the cultural economy continually creates new fringe areas, and young and more extreme members of assimilated subcultures will regroup with new recruits at still more marginal positions. So the process begins again.

Elements of this mechanism were in place by the mid-nineteenth century, and the rest of the century saw its coming to maturity in sport, fashion, and entertainment.[56] The artistic avant-garde provides an early, developed example of the process at work. In fact, because of its unique position between the upper and lower zones of commodity culture, this group performs a special and powerful function within the process. That service could be described as a necessary brokerage between high and low, in which the avant-garde serves as a kind of research and development arm of the culture industry.

To begin with its primary audience, the fact that the avant-garde depends on elite patronage — the "umbilical cord of gold" — cannot be written off as an inconsequential or regrettable circumstance. It must be assumed that so durable a form of social interchange is not based merely on the indulgence or charity of the affluent, but that the avant-garde serves the interests of its actual consumers in a way that goes beyond purely individual attraction to "quality" or the glamor of the forbidden. In their selective appropriation from fringe mass culture, advanced artists search out areas of social practice that retain some vivid life in an increasingly administered and rationalized society. These they refine and package, directing them to an elite, self-conscious audience. Certain played-out procedures within established high art are forcibly refused, but the category itself is preserved and renewed — renewed by the aesthetic discoveries of non-elite groups.

Nor, plainly, does the process of selective incorporation end there. Legitimated modernism is in turn re-packaged for consumption as chic and kitsch commodities. The work of the avant-garde is returned to the sphere of culture where much of its substantial material originated. It was only a matter of a few years before the Impressionist vision of commercial diversion became the advertisement of the thing itself, a functioning part of the imaginary enticement directed toward tourists and residents alike.[57] In the twentieth century this process of mass-cultural recuperation has operated on an ever-increasing scale. The Cubist vision of sensory flux and isolation in the city became in Art Deco a portable vocabulary for a whole modern "look" in fashion and design. Cubism's geometricization of organic form and its rendering of three-dimensional

illusion as animated patterns of overlapping planes were a principal means by which modernist architecture and interior design were transformed into a refined and precious high style. Advertised as such, now through the powerful medium of film costume and set decoration, the Art-Deco stamp was put on the whole range of Twenties and Depression-era commodities: office buildings, fabric, home appliances, furniture, crockery. (The Art-Deco style was also easily drawn into the imagery of the mechanized body characteristic of proto-fascist and fascist Utopianism.)

The case of Surrealism is perhaps the most notorious instance of this process. Breton and his companions had discovered in the sedimentary layers of an earlier, capitalist Paris something like the material unconscious of the city, the residue of forgotten repressions. But in retrieving marginal forms of consumption, in making that latent text manifest, they provided modern advertising with one of its most powerful visual tools: that now familiar terrain in which commodities behave autonomously and create an alluring dreamscape of their own.

* * *

This essay has not aimed to supply a verdict on modernism in the visual arts. Recent discussion of the issue has suffered from a surplus of verdicts. Typically, one moment of the series of transformations described above is chosen as the definitive one. The social iconographers of modernism (the most recent trend in art history) largely limit themselves to its raw material. The aesthetic dialecticians, Adorno holding out until the end, concentrate on the moment of negativity crystallized in form. The triumphalists of modernism – the later Greenberg and his followers, for example – celebrate the initial recuperation of that form into a continuous canon of value. Finally, that recuperation is the object of attack from two contradictory strains of postmodernist: the version offered by the Left sees in this moment a revelation that modernist negation was always a sham, never more than a way to refurbish elite commodities; that offered by the Right, advancing a relaxed and eclectic pluralism, sees this recuperation as insufficient and resents the retention of any negativity even if it is sublimated entirely into formal criteria.

The purpose of the present essay has been to widen discussion to include, or rather re-include, all the elements present in the original formulation of modernist theory. One motivation for writing came from reflection on the fact that the founding moments for subsequent discourses on both modernist art and mass culture were one and the same. Current

debates over both topics invariably begin with the same names – Adorno, Benjamin, Greenberg (less often Schapiro, but that should by now be changing). Very seldom, however, are these debates about both topics together. But at the beginning they always were: the theory of one was the theory of the other. And in that identity was the realization, occasionally manifest and always latent, that the two were in no fundamental way separable. Culture under conditions of developed capitalism displays both moments of negation and an ultimately overwhelming tendency toward accommodation. Modernism exists in the tension between these two opposed movements. And the avant-garde, the bearer of modernism, has been successful when it has found for itself a social location where this tension is visible and can be acted upon.

6 Cecil Beaton, test shot of fashion shoot for American *Vogue* at Pollock exhibition, Betty Parsons Gallery, 1951.

2

Fashioning the New York School

What difference does it make that some of Jackson Pollock's most commanding, fully realized paintings were used in 1951, when they were barely dry, as a backdrop for fashion models in the pages of *Vogue* (pl. 6)? Over the decades of adulatory writing on the New York School, the answer would plainly have been: none at all. But the critical and scholarly landscape has changed. No longer can such an accommodation between the requirements of commerce and the summit of modernist formal achievement be dismissed as a momentary, adventitious accident – certainly not since the publication in 1983 of Serge Guilbaut's *How New York Stole the Idea of Modern Art.*[1]

In that celebrated, castigated, and still-underestimated account, Guilbaut documented the workings of a prior convergence between modernist painting and the propagandistic requirements of post-war American hegemony. The basic story he had to tell was how large political and commercial interests, avid for symbols of cultural legitimacy, captured a strain of art that had been conceived in isolation and neglect. In the service of Cold War polemic, a body of paintings was seized upon and projected globally as an emblem of American freedom and of the benign power liberated by that freedom. Cultural domination in the field of visual art was orchestrated as an accompaniment to America's new role as dominant world power.

This had already been observed by others in a retrospective way, but Guilbaut was the first to examine in any detail the inner workings of the process by which it came about.[2] Taking his investigation back to the 1930s in New York, he traced the ways that the artists had gradually made themselves vulnerable to this appropriation. By the early 1940s, they found themselves in flight twice over: firstly, from the constraints of their own past commitments to politically engaged art; secondly, from

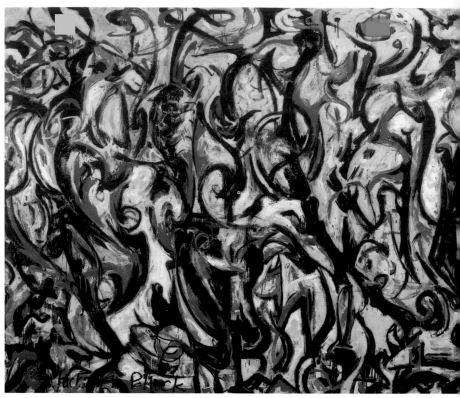

7 Jackson Pollock, *Mural*, 1944. Oil on canvas, 604.5 × 246 cm. University of Iowa Museum of Art, Gift of Peggy Guggenheim.

provincial dependency on the great Parisian modernists, many of whom were then living in American exile and available for direct comparison. The resulting momentum threw their art into the embrace of official Americanism, and this alliance was sealed in 1947 and 1948 when resurgent nativist hostility to modern art prompted the cultural establishment to put its weight behind a home-grown avant-garde.[3] One public face of that alliance was the positive – if arm's-length – endorsement of Pollock by Henry Luce's *Life* magazine, a primary corporate voice of American triumphalism.[4]

The attentions of *Vogue* and *Life* depended equally on the one trait fundamental to virtually all New York School painting: the sheer wall-filling size of the paintings. Of the two appropriations, however, only one

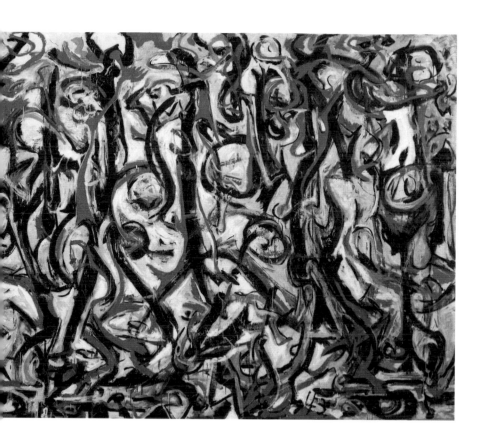

can offer any insight into the origins of the American fixation on the big canvas. The official ideological projection of this new art as an American symbol – the *Life* version – was certainly predicated on that expansive scale, but the artists in question were already moving in that direction well before the watershed years of 1947–48. It is more than doubtful that cultural managers outside the small avant-garde could even have imagined this development, still less could they have summoned it up on their own. By contrast, the *Vogue* use of the art as a backdrop for fashionable posing finds its source in the earliest genealogy of large-scale abstraction in New York.

* * *

The definitive move to the big abstract canvas came with the making of Pollock's *Mural* (pl. 7), a canvas completed in 1944 but commissioned the

41

previous year by his new patron Peggy Guggenheim. As is well known, in order to accommodate the enormous size of the stretched canvas, the artist was obliged illegally to knock out a wall between his own studio and that recently occupied by his brother Sande. At a time when a modernist painting was considered large if it was four or five feet on a side, this one was to measure roughly nine by twenty feet. Pollock wrote to their oldest brother, Charles, with understandable elation that it looked "pretty big, but exciting as all hell," adding with understandable pride that he was bound by "no strings as to what or how I paint it."[5] But there was one respect in which he was very much bound, and that was the key, enabling factor in the whole equation: its physical size had been decided for him. The painting came to be called *Mural*, of course, because that was what its patron originally conceived it to be. The marriage of Peggy Guggenheim and Max Ernst had just ended, and she had established a new liaison with a wealthy and dandyish Englishman named Kenneth McPherson.[6] She marked the change by taking a new apartment, which had one architectural oddity: at its entrance was a long, shallow vestibule from which one ascended by stairs to the apartment proper. Guggenheim was appalled by McPherson's ideas for decorating this awkward, but symbolically important space: in her words, he "didn't seem to realize that a certain highly luxurious pleasure-seeking life was over and no longer fits in with our times."[7] Her career, in both entrepreneurial and social terms, depended on being in touch with the latest turn in taste. The older Surrealists, with their preciously wrought cabinet pictures, were to be relegated to that "luxurious, pleasure-seeking life" Guggenheim had known before but now wished to reject (in appearance at least), as unsuitable to a time of general scarcity and sacrifice.

The break with Ernst had accompanied a general estrangement from the exiled Surrealists whom she had sponsored at her Art of this Century gallery. There was a new group around her: Howard Putzel, the francophile American dealer; James Johnson Sweeney, the francophile Irish poet and satellite of James Joyce, who had found a place on the staff of the Museum of Modern Art; Roberto Matta, the Chilean-born Surrealist painter who was unique within the group in seeking to make strategic alliances with younger Americans.[8] It was they who turned Guggenheim toward sponsoring Pollock, a move which resulted in his 1943 one-man show and the extraordinary contract that granted the artist a regular monthly income.[9] Lee Krasner has forthrightly testified to this:

> Howard Putzel really got Jackson his contract. Surely Peggy made the gesture, but the fact is I doubt that there would have ever been a

contract without Howard. Howard was at our house every night, and he told Jackson what to do and how to behave. Otherwise, I doubt it would have ever happened. The whole thing was based on our friendship with Putzel.[10]

No American artist – virtually no artist at all – was the object of such speculative financial investment.[11] Sweeney took on the task of providing verbal accompaniment to this orchestrated change in taste. In well-known words from his own catalogue introduction to the first show, he described Pollock's talent as "unpredictable . . . undisciplined . . . a mineral prodigality not yet crystallized . . . lavish, explosive, untidy."[12] The same rhetoric – "smoldering . . . coarse in his strength . . . fury of animal nature" – reappeared the following year when he used the 1943 painting *She-Wolf* to illustrate an article in *Harper's Bazaar*: "Harmony," Sweeney declared, "would never be a virtue in his work. An attempt to achieve it would necessitate toning down all his expression and lead to its final emasculation."[13]

Pollock, for his part, was deeply irritated at this characterization and its implicit dismissal of his intense efforts to impose discipline on his compositions.[14] But he was at the same time indebted to precisely this mythology for his discovery of the large canvas. Through these interventions by members of the Guggenheim circle, *Mural* had become the focus of the incipient Pollock cult. Its size – which far exceeded the largest formats on which he had yet worked – was part of their evolving notion of the scale that a quintessentially American painter ought to be using. The idea may first have come from Putzel, who is said to have wanted to see whether a larger scale would release the energies contained in the smaller paintings.[15] But it was none other than Marcel Duchamp who made perhaps the most decisive contribution by suggesting to Guggenheim that it be painted on stretched canvas rather than directly onto the apartment wall.[16] His ostensible reasoning was that she could then take it with her when she moved, but the century's most original thinker on the portability and disposability of works of art doubtless had ideas that extended beyond simple practicality. He bestowed on the work its objective ambiguity, inaugurating a series of (as Pollock himself would later put it) "large movable pictures which will function between the easel and the mural."[17] For Guggenheim, Pollock's past associations with the common-man muralism of Thomas Hart Benton, the Federal Arts Project, and the workshop of the Communist painter David Siqueiros underscored her seemly awareness of wartime realities (in other hands, such grandiosity of scale might have signified a careless, Baroque excess).

According to reports, Pollock stared at the blank stretched canvas for six months before suddenly covering the entire field in a single night's painting.[18] Everything that would make Pollock's project so exceptionally productive came together in that one moment. He himself would take three or four years to catch up with its full implications in the canonical series of poured paintings made between 1947 and 1952 (that lag generating the effect of coincidence with Cold War culture). With the 1944 painting, however, he had already discovered how liberating it could be to work on such a scale, how it could force a new gestural rapidity and a broadening of physical movement in the handling of paint. Its demands engendered his new compositional logic, based on repetition of calligraphic figural notations, dispersed and accumulated to the point that they made their own non-figural and non-hierarchical order, coextensive with but not identical to the rectangular support. Its innovativeness is all the more striking because it was achieved on an upright surface, with conventional brushes and un-thinned paint.[19] (If the painting remains underestimated in the literature, it may be because of its remote location at the University of Iowa.)

The apparent spontaneity with which Pollock covered the vast canvas further confirmed the American myth, though the patrons of the enterprise were the least Americanized group imaginable. They had projected Pollock expressly into a space that was, to them, exotically other and promised an art that was as different as possible from Surrealism, but one which did not reject the terms of that movement altogether. While Clement Greenberg is normally the focus of any discussion of Pollock's critical reception and promotion as the leading American artist of his generation, the original conception of the Guggenheim group dictated the decisive terms of his admiration. His brief review of the 1943 show had spoken disapprovingly of certain paintings veering between "the intensity of the easel picture and the blandness of the mural."[20] But by 1947 he had assimilated Putzel's and Duchamp's vision of Pollock and would write in celebration of the fact that the artist "points a way beyond the easel, beyond the mobile, framed picture, towards the mural perhaps – or perhaps not."[21]

The most interesting of Greenberg's immediate responses to the moment of 1943–44 came not in any direct commentary on Pollock, but in an extended diatribe against Surrealist painting, first printed in the *Nation* in 1944, and then republished for a British audience in *Horizon*. There he attacked the "nihilism of the Surrealists," a condition for him most clearly exposed in their easy alliance with fashion. Surrealism had become, he argued:

a blessing to the restless rich, the expatriates, and the aesthete-flâneurs in general who were repelled by the asceticisms of modern art. Surrealist subversiveness justifies their way of life, sanctioning the peace of conscience and the sense of chic with which they reject arduous disciplines.[22]

The object of this criticism was just such a person as Peggy Guggenheim, but it also reproduced exactly the terms of her rejection of the decadently luxurious associations which Surrealism had come to carry in New York. To say that something has become mere fashion is really to say that it has just passed out of fashion. And it is implicitly to declare that something else is now in fashion, even if one chooses to describe it as asceticism and arduous discipline.

Greenberg was here doing his part in the same interested management of taste initiated within the Peggy Guggenheim circle, even if he kept his distance from Sweeney's Natty-Bumppo clichés. What that group had already perceived and acted on was a realization that the exiled Surrealists were objectively out of their element in New York. André Breton and the painters around him could sneer all they liked; they could continue to trade on past prestige; but all that was camouflage over the reality that they had lost the resources of their practice. Huddling together like any defensive group of immigrants, clinging to bygone rituals of solidarity, they were in no position to exploit what America had to offer an innovative and ambitious artist (Mondrian being one of the only exceptions among the exiles). The really canny entrepreneurs like Putzel, Sweeney, and Guggenheim herself knew that the avant-gardism in which they had invested their lives was in jeopardy unless the perception of a European monopoly was broken and artists capable of functioning in an American environment were given room and an aura of their own.

* * *

There is a photograph of Peggy Guggenheim and Pollock standing in front of the installed *Mural* (pl. 8). It is a slightly angled, expressionist view, shot through a piece of abstract sculpture by David Hare.[23] Pollock is to one side in an ill-fitting suit, and it is tempting to say that he looks drunk. Guggenheim is near the center in a tightly contained pose, clutching a lapdog in each arm. The unkind question one can ask is, who is the poodle in this picture? The painting itself is Pollock's best reply to the unkind answer. She certainly knows that it is, and that knowledge is the source of her evident pride in the work.

45

8 Peggy Guggenheim and Pollock in front of *Mural*, 1944.

One can pair this photograph with any of the images in *Vogue* and see the latter as its late and accurate echo. The photographer sent out to Betty Parsons's gallery was, of course, Cecil Beaton. The dresses may have been American in origin but the allegiances of both photographer and journal remained firmly in the orbit of Paris and London. A famous English arbiter of high style, a considerable artist in his own right, was to determine how the art was to embellish the clothing.[24] Having discerned the unexpected elegance that Pollock conjured from his rude pourings and spatters, Beaton and his editors judged his colonial spontaneity exactly the right counter-

point to the refined flourishes of the gowns. A primitivizing fascination for native American art had helped Pollock and his contemporaries find their way to distinctive forms of abstraction, but the agents of Europeanized culture seem to have been allowed the last primitivist turn, deftly placing his paintings in a tradition of discriminating enthusiasm for American prodigies going back to the ecstasies of the French over Benjamin Franklin and James Fenimore Cooper: "dazzling and curious," wrote the copywriter, they "almost always cause an intensity of feeling."

The fashion photographs represented appropriation, even exploitation, if one wants to choose that kind of moralizing language: Beaton cropped his backdrops at will; for several shots he placed a hidden light behind the model, directed toward the painting, adding his own literal dazzle to the metaphorical one discerned by so many admiring critics.[25] But the 1944 photograph shows that a parallel appropriation in the realm of style and fashion was inseparable from the very origin of this kind of object: the large-scale abstract painting with its "all-over" composition.

A freedom to manipulate the art for purposes of display began with the first hanging of Pollock's *Mural*, Duchamp continuing his role as midwife to the enormous canvas by agreeing to supervise its installation in Guggenheim's apartment. When it was discovered that Pollock's measurements had been too long for the actual space by almost a foot, the French artist took the decision to cut off the excess, and no one complained that the work suffered any significant violence.[26] And no sooner was the painting in place than the posing-in-front-of-it began, this being the very activity for which it had been conceived. It was one in which the artist himself participated, the price for the opportunity offered to him by his patron and her advisers. A further step in the analysis proposed here would be to look at the most famous Pollock photographs of all, the studio pictures of Hans Namuth, in which yet another European (with his own interests) deployed the large canvas – in process on the floor below, or completed on the wall behind – as a framing device to define the American artist.

In analyzing the uses to which Pollock's capabilities have been put, it is important not to conflate those carried on at a distance – service in the cause of Cold War nationalism – with those which can be said to have constituted the effective conditions for his signature work. If one laments these prior uses, what exactly is the loss being mourned? If it is some deeper authenticity of experience, how does one know anything about it, except by hopeful conjecture from the stylized gesture and movement that are actually registered in Pollock's big paintings? The gestures and move-

ments were his, to be sure, but the conditions that lent them a style, and thereby a legibility, were imagined for him.

If one is puzzled about the meaning of a Renaissance painting, one turns eagerly to the stipulations of the contract between artist and patron in the lucky event that one survives. This approach to interpretation, straightforward in its logic, proceeds from the specified materials of a work of art and the implied uses to which it is to be put, the interests it is to serve. In the case of *Mural*, one knows the exact terms of agreement between artist and patron; there is further a rich body of commentary by the middlemen who brought it into being, actual modern counterparts to the shadowy "humanist advisers" so often conjured up in iconographical interpretations of Renaissance art. Far from being intrinsically an expression of up-to-date conditions of American capitalism, the large canvas owes its origins to the needs of an improvised, latter-day court, one modelled on traditional European conceptions of enlightened and self-flattering patronage. Nor was it, seemingly, one that could remain transplanted in the New World for long, as Guggenheim permanently removed herself and her collection to Italy when it became safe to do so. Her advancement of Pollock had been the principal gesture of accommodation by a courtly culture toward its temporary, democratic surroundings.

Having been born from such terms of exchange, the big canvas would always carry the meaning of stage and backdrop, nor was it, by any means, the first type of art meant to be faced away from by its principal users. The pathos of the situation for the artists who adopted the format was that they could not afford to acknowledge such originary meanings in their own practice. That implicit conflict led to resolute forms of denial and perhaps to certain acts of protest. Rothko's famous anxiety about the conditions in which his paintings would be seen – his desire for low lighting, isolation and a hushed, reverent atmosphere – can be taken as an instance of the former. Pollock may have registered an internal protest through physically violating the integrity of the canvas: Peggy Guggenheim had thought to cut a figure in front of her *Mural*; Pollock gave the expression a mockingly literal twist in *Cut Out* of 1948. But these efforts were relatively small and inescapably read as peripheral commentary in relation to the commanding presence of the large canvases. The automatic impressiveness of the grand format was an addiction from which none among this generation could break free, and Beaton was there to record the cruel bargain entailed in that dependence.

3

Saturday Disasters:
Trace and Reference in Early Warhol

The public Andy Warhol was not one but, at a minimum, three persons. The first, and by far the most prominent, was the self-created one: the product of his famous pronouncements, and of the allowed representations of his life and milieu. The second consists of the complex of interests, sentiments, skills, ambitions, and passions actually figured in paint on canvas or on film. The third was his persona as it sanctioned experiments in non-elite culture far beyond the world of art. Of these three, the latter two are of far greater importance than the first, though they were normally overshadowed by the man who said he wanted to be like a machine, that everyone would be famous for fifteen minutes, that he and his art were nothing but surface. The second Warhol is normally equated with the first; and the third, at least by historians and critics of art, has been largely ignored.[1]

This essay is primarily concerned with the second Warhol, though this will necessarily entail attention to the first. The conventional reading of his work turns upon a few circumscribed themes: the impersonality of his image choices and their presentation, his passivity in the face of a media-saturated reality, the suspension in his work of any clear authorial voice. His subject-matter choices are regarded as essentially indiscriminate. Little interest is displayed in them beyond the observation that, in their totality, they represent the random play of a consciousness at the mercy of the commonly available commercial culture. The debate over Warhol centers around the three rival verdicts on his art: (1) it fosters critical or subversive apprehension of mass culture and the power of the image as commodity; (2) it succumbs in an innocent but telling way to that numbing power; (3) it cynically and meretriciously exploits an endemic confusion between art and marketing.[2]

49

A relative lack of concentration on the evidence of the early pictures has made a notoriously elusive figure more elusive than he needs to be – or better, only as elusive as he intended to be. The authority normally cited for this observed effacement of the author's voice in Warhol's pictures is none other than that voice itself. It was the artist himself who told the world that he had no real point to make, that he intended no larger meaning in the choice of this or that subject, that his assistants did most of the physical work of producing his art. Indeed, it would be difficult to name an artist who has been as successful as Warhol in controlling the interpretation of his own work.

In the end, any critical account of Warhol's achievement as a painter will necessarily stand or fall on the visual evidence. But even within the public "text" provided by Warhol, there are some less calculated remarks that qualify the general understanding of his early art. One such moment occurred in direct proximity to two of his most frequently quoted pronouncements: "I want everybody to think alike" and "I think everybody should be a machine." In this section of his 1963 interview with G.R. Swenson, he is responding to more than the evident levelling effects of American consumer culture. Rather, his more specific concern is the meanings normally given to the difference between the abundant material satisfactions of the capitalist West and the relative deprivation and limited personal choices of the Communist East. The sentiment, though characterized by the prevailing American image of Soviet Communism, lies plainly outside the Cold War consensus: "Russia is doing it under strict government. It's happening here all by itself. . . . Everybody looks alike and acts alike, and we're getting more and more the same way."[3] These words were uttered only a year or so after the Cuban Missile Crisis and within months of Kennedy's dramatic, confrontational appearance at the Berlin Wall. It was a period marked by heightened ideological tension, in which the contrast of consumer cultures observable in Berlin was generalized into a primary moral distinction between the two economic and political orders. The bright lights and beckoning pleasures of the Kurfürstendam were cited over and over again as an unmistakable sign of Western superiority over a benighted Eastern bloc. One had only to look over the Wall to see the evidence for oneself in the dim and shabby thoroughfare that the once-glittering Unter den Linden had become.

In his own offhand way, Warhol was refusing that symbolism, a contrast of radiance and darkness that was no longer, as it had been in the 1950s, primarily theological, but consumerist. The spectacle of overwhelming Western affluence was the ideological weapon in which the

Kennedy administration had made its greatest investment, and it is striking to find Warhol seizing on that image and negating its received political meaning (affluence equals freedom and individualism) in an effort to explain his work. Reading that interview now, one is further struck by the barely suppressed anger present throughout his responses, as well as by its ironizing of the phrases that would later congeal into the clichés. Of course, to generalize from this in order to impute some specifically partisan intentions to the artist would be precisely to repeat the error in interpretation cited above, to use a convenient textual crutch to avoid the harder work of confronting the paintings directly. A closer look at such statements as these, however, can at least prepare the viewer for unexpected meanings in the images, meanings possibly more complex or critical than the received reading of Warhol's work would lead one to believe.

* * *

The thesis of the present essay is that Warhol, though he grounded his art in the ubiquity of the packaged commodity, produced his most powerful work by dramatizing the breakdown of commodity exchange. These were instances in which the mass-produced image as the bearer of desires was exposed in its inadequacy by the reality of suffering and death. Into this category, for example, falls his most famous portrait series, that of Marilyn Monroe. Complexity of thought or feeling in Warhol's *Marilyns* may be difficult to discern from our present vantage point. Not only does his myth stand in the way, but his apparent acceptance of a woman's reduction to a mass-commodity fetish can make the entire series seem a monument to a benighted past or an unrepentant present. Though Warhol obviously had little stake in the erotic fascination felt for her by the male intellectuals of the Fifties generation – Willem de Kooning and Norman Mailer, for example – he may indeed have failed to resist it sufficiently in his art.[4] It is far from the intention of this essay to redeem whatever contribution Warhol's pictures have made to perpetuating that mystique. But there are ways in which the majority of the Monroe paintings, when viewed apart from the Marilyn/Goddess cult, exhibit a degree of tact that withholds outright complicity with it.

This effect of ironic displacement began in the creation of the silkscreen stencil itself. His source was a black-and-white publicity still, taken for the 1953 film *Niagara* by Gene Koreman. (The print that the artist selected and marked for cropping exists in the archives of his estate [pl. 9].) A portrait in color from the same session, in which the actress reclines to one

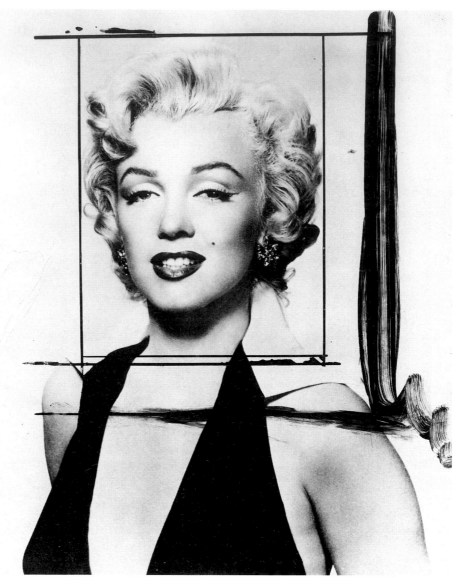

9 Gene Koreman, publicity still of Marilyn Monroe for film *Niagara*, 1953. Courtesy the Estate and Foundation of Andy Warhol.

side and tilts her head in the opposite direction, was and remains today one of the best-known images of the young actress, but Warhol preferred to use a segment of a different, squarely upright pose. His cropping underlined that difference, using the outer contours of her hair and shoulders to define a solid rectangle, a self-contained unit at odds with the illusions of enticing animation normally projected by her photographs. Its shape already prefigures the serial grid into which he inserted this and the rest of his borrowed imagery.[5]

Warhol began his pictures within weeks of Monroe's suicide in August 1962, and it is striking how consistently this simple fact goes unremarked in the literature.[6] Some of the artist's formal choices refer to a memorial or funeral function directly: most of all, the single impression of her face against the gold background of an icon, the traditional sign of an eternal other world. Once undertaken, however, the series raised issues that went beyond the artist's personal investment in the subject. How does one handle the fact of celebrity death? Where does one put the curiously intimate knowledge one possesses of an unknown figure, come to terms with the sense of loss, the absence of a richly imagined presence that was never really there; for some it might be Monroe, for others James Dean, Buddy Holly, or a Kennedy: the problem is the same.

The beginnings of the *Marilyn* series also coincided with Warhol's commitment to the photo-silkscreen technique, and a close link existed between technique and function.[7] The screened image, reproduced whole, has the character of an involuntary imprint. It is a memorial in the sense that it resembles memory – sometimes vividly present, sometimes elusive, always open to embellishment as well as loss. Each of the two *Marilyn Diptychs*, also painted in 1962, lays out a stark and unresolved dialectic of presence and absence, of life and death (pl. 10). The left-hand side is a monument; color and life are restored, but as a secondary and unchanging mask added to something far more fugitive. Against the quasi-official regularity and uniformity of the left panel, the right concedes the absence of its subject, openly displaying the elusive and uninformative trace underneath. The right panel nevertheless manages subtle shadings of meaning within its limited technical scope. There is a reference to the material of film that goes beyond the repetition of frames. Her memory is most vividly carried in the flickering passage of film exposures, no one of which is ever wholly present to perception. The heavy inking in one vertical register underscores this. The transition from life to death reverses itself; she is most present where her image is least permanent. In this way, the *Diptych*

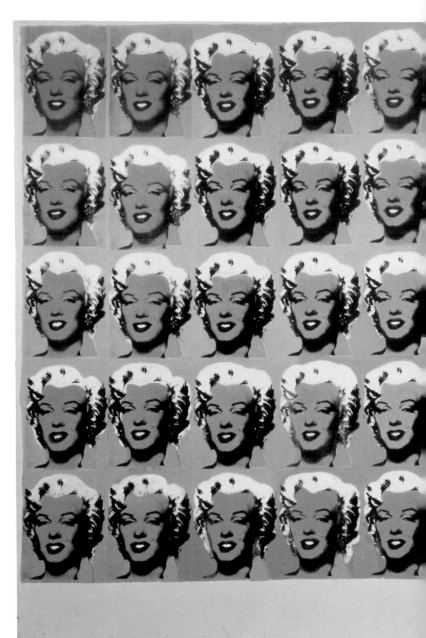

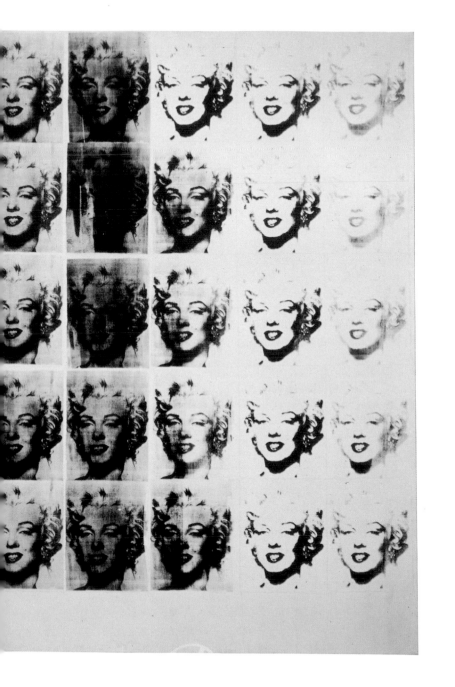

stands as a comment on and complication of the embalmed quality, the slightly repellent stasis, of the *Gold Marilyn*.

Having taken up the condition of the celebrity as trace and sign, it is not surprising that Warhol would soon afterwards move on to the image of Elizabeth Taylor. They were nearly equal and unchallenged as Hollywood divas with larger-than-life personal myths. Each was maintained in her respective position by a kind of negative symmetry; by representing what the other was not. Also in 1963, he completed a dominant triangle of female celebrity for the early Sixties with a picture of Jacqueline Kennedy, in the same basic format as the full-face portraits of Monroe and Taylor. The President's wife did not share film stardom with Monroe, but she did share the Kennedys. She also possessed the distinction of having established for the period a changed feminine ideal. Her slim, dark, aristocratic standard of beauty had made Monroe's style, and thus power as a symbol, seem out of date even before her death. (That new standard was mimicked within the Warhol circle by Edie Sedgewick, for a time his constant companion and seeming alter ego during the period.) The photograph of Monroe that Warhol chose was from the Fifties; through that simple choice he measured a historical distance between her life and her symbolic function, while avoiding the signs of ageing and mental collapse.

The semiotics of style that locked together Warhol's images of the three women represents, however, only one of the bonds between them. The other derived from the threat or actuality of death. The full-face portraits of the *Liz* series, though generated by a transformation of the *Marilyn* pictures, in fact had an earlier origin. Taylor's famous catastrophic illness in 1961 – the collapse that interrupted the filming of *Cleopatra* – had found its way into one of Warhol's early tabloid paintings, *Daily News* of 1962 (pl. 11). During that year, the rhythm of crises in the health of both women had joined them in the public mind (and doubtless Warhol's as well). In Jacqueline Kennedy's case, he ignored, for understandable reasons, the wide public sympathy over her failed pregnancy; but when the traumatic triangle was completed with a vengeance in November 1963, his response was immediate.

The Kennedy assassination pictures are often seen as an exception in the artist's output, exceptional in their open emotion and sincerity, but the continuity they represent with the best of his previous work seems just as compelling.[8] As with the *Marilyn*s, the loss of the real Kennedy referent galvanizes Warhol into a sustained act of remembrance. Here, however, he has a stand-in, the widow who had first attracted him as an instance of celebrity typology. Again, he limits himself to fragmentary materials, eight

11 Andy Warhol, *Daily News*, 1962. Acrylic on canvas, 183.5 × 254 cm. Frankfurt, Museum für Moderne Kunst.

grainy news stills out of the myriad representations available to him. These he shuffles and rearranges to organize his straightforward expressions of feeling (pl. 12). The emotional calculus is simple, the sentiment direct and uncomplicated. The pictures nevertheless recognize, by their impoverished vocabulary, the distance between public mourning and that of the principals in the drama. Out of his deliberately limited resources, the artist creates nuance and subtlety of response that is his alone, precisely because he has not sought technically to surpass his raw material. It is difficult not to share in this, however cynical one may have become about the Kennedy presidency or the Kennedy marriage. In his particular dramatization of the newsprint medium, Warhol found room for a dramatization of feeling and even a kind of history painting.

* * *

The account offered thus far has been grounded in the relationships between Warhol's early portraits. That line of interpretation can also be

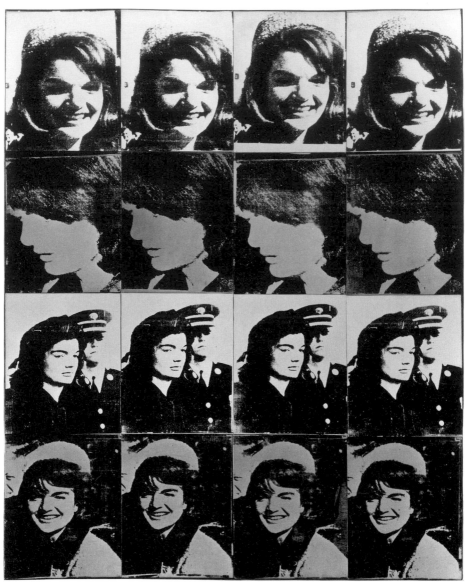

12 Andy Warhol, *16 Jackies*, 1964. Synthetic polymer paint and silkscreen ink on canvas, 203 × 162.5 cm. Private collection.

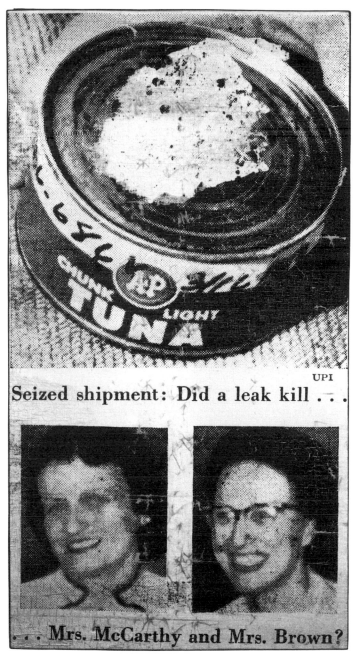

Seized shipment: Did a leak kill . . .

. . . Mrs. McCarthy and Mrs. Brown?

13 Warhol, *Tunafish Disaster*, 1963. Synthetic polymer paint and silkscreen ink on canvas, 104 × 55.9 cm. Private collection.

extended to include the apparently anodyne icons of consumer products for which the artist is most renowned. Even those familiar images take on unexpected meanings in the context of his other work of the period. For example, in 1963, the year after the Campbell's soup-can imagery had established his name, he did a series of pictures under the title *Tunafish Disaster* (pl. 13). These are, unsurprisingly, lesser known works, but they feature the repeated images of a directly analogous object, a supermarket-label can of tuna. In this instance, however, the contents of the can had killed two unsuspecting women in Detroit, and newspaper photographs of the victims are repeated below those of the deadly containers. The wary smile of Mrs. McCarthy, the broad grin of Mrs. Brown, as each posed with self-conscious sincerity for their snapshots, the look of their clothes, glasses, and hairstyles, speak the language of class in America. The women's workaday faces and the black codings penned on the cans transform the mass-produced commodity into anything but a neutral abstraction.

More than this, of course, the pictures commemorate a moment when the supermarket promise of safe and abundant packaged food was disastrously broken. Does Warhol's rendition of the disaster leave it safely neutralized? While the repetition of the crude images forces the spectator's attention onto the awful banality of the accident and the tawdry exploitation by which one comes to know the misfortunes of strangers, they do not mock attempts at empathy, however feeble. Nor do they insist upon some peculiarly twentieth-century estrangement between the event and its representation: the misfortunes of strangers have made up the primary content of the press since there has been a press. The *Tunafish Disasters* take an established feature of Pop imagery, established by others as well as by Warhol, and push it into a context decidedly other than that of consumption. The news of these deaths cannot be consumed in the same way as the safe (one hopes) contents of a can.

Along similar lines, a link can be made with the several Warhol series that use photographs of automobile accidents. These commemorate events in which the supreme symbol of consumer affluence, the American car of the 1950s, lost its aura of pleasure and freedom to become a concrete instrument of sudden and irreparable injury. (In only one picture of the period, *Cars*, does an automobile appear intact.) Does the repetition of *Five Deaths* or *Saturday Disaster* cancel attention to the visible anguish in the faces of the living or the horror of the limp bodies of the unconscious and dead? One cannot penetrate beneath the image to touch the true pain and grief, but their reality is sufficiently indicated in the photographs to expose one's limited ability to find an appropriate response. As for the

repetition, it might just as well be taken to register the grim predictability, day after day, of more events with an identical outcome, the levelling sameness with which real, not symbolic, death erupts into daily life.

In selecting his source material, Warhol was in no way acting as a passive conduit of mass-produced images that were universally available. Far from limiting himself to newspaper photographs that might have come his way by chance, he searched out prints from the press agencies themselves, which only journalistic professionals could normally have seen.[9] (Certain of these were apparently deemed too bizarre or horrific ever to be published; that is, they were barred from public distribution precisely because of their capacity to break though the complacency of jaded consumers.)

Not long after his first meditations on the Monroe death, Warhol took up the theme of anonymous suicide in several well-known and harrowing paintings. *Bellevue I* (1963) places the death within a context of institutional confinement. Again the result reinforces the idea that the repetition of the photographic image can increase rather than numb sensitivity to it, as the viewer works to draw the separate elements into a whole. The compositional choices are artful enough to invite that kind of attention. Take, for example, the way the heavily inked units in the upper left precisely balance and play off the void at the bottom. That ending to the chain of images has a metaphoric function akin to the play of presence and absence in the *Marilyn Diptych*; it stands in a plain and simple way for death and also for what lies beyond the possibility of figuration.[10] (This control, of course, could take the form of understanding the characteristic imperfections and distortions of the process, that is, of knowing just how little they had to intervene once the basic arrangement, screen pattern, and color choices had been decided.) In the *Suicide* of 1964, this orchestration of the void, all the fractures and markings generated from the silk-screen process, becomes almost pure expressionist invention (pl. 14).

The electric-chair pictures, as a group, present a stark dialectic of fullness and void. But the dramatic shifts between presence and absence are far from being the manifestation of a pure play of the signifier liberated from reference beyond the sign (pl. 15). They mark the point where the brutal fact of violent death entered the realm of contemporary politics. The early 1960s, following the recent execution of Caryl Chessman in California, had seen agitation against the death penalty grow to an unprecedented level of intensity.[11] The partisan character of Warhol's images is literal and straightforward, as the artist himself was wont to be,

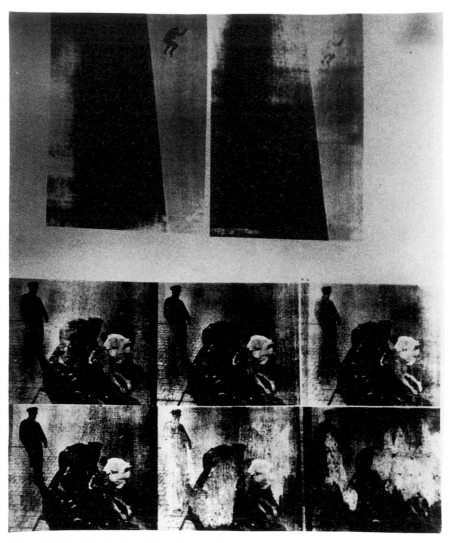

14 Warhol, *Suicide*, 1962. Synthetic polymer paint and silkscreen ink on canvas. Private collection.

and that is what saves them from mere morbidity. He gave them the collective title *Disaster*, and thus linked a political subject to the slaughter of innocents in the highway, airplane and supermarket accidents he memorialized elsewhere. He was attracted to the open sores in American political

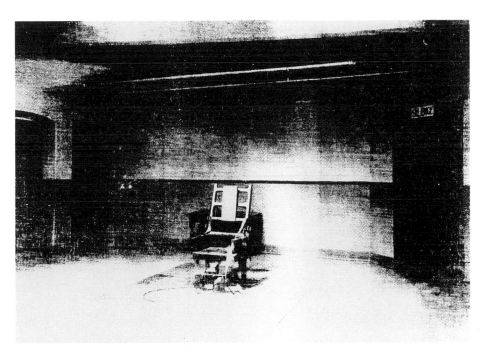

15 Warhol, *Little Electric Chair*, 1963. Synthetic polymer paint and silkscreen ink on canvas, 55.9 × 71.1 cm. Private collection.

life, the issues that were most problematic for liberal Democratic politicians such as Kennedy and the elder Edmund Brown, the California Governor who had allowed Chessman's execution to proceed. He also did a series in 1963 on the most violent phase of civil-rights demonstrations in the South; in his *Race Riot* paintings, political life takes on the same nightmare coloring that saturates so much of his other work.

Faced with these paintings, one might take seriously, if only for a moment, Warhol's dictum that in the future everyone will be famous for fifteen minutes, but conclude that in his eyes it was likely to be under fairly horrifying circumstances. What this body of paintings adds up to is a kind of *peinture noire* in the sense that the adjective is applied to the *film noir* genre of the Forties and early Fifties – a stark, disabused, pessimistic vision of American life, produced from the knowing rearrangement of pulp materials by an artist who did not opt for the easier paths of irony or condescension. A picture such as the 1963 *Gangster Funeral* (pl. 16) comes over like a dispatch of postcards from hell.

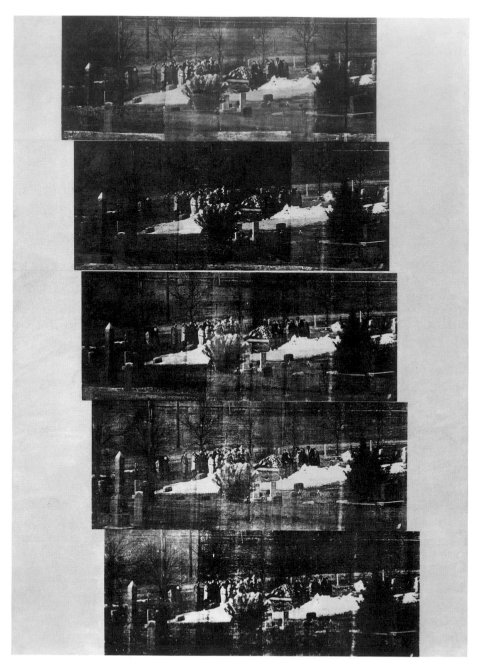

16 Warhol, *Gangster Funeral*, 1963. Synthetic polymer paint and silkscreen ink on canvas, 266.7 × 192.1 cm. New York, Dia Art Foundation.

By 1965, of course, this episode in his work was largely over; the *Flowers, Cow Wallpaper*, silver pillows, and the like have little to do with the imagery under discussion here. Then the clichés began to ring true. But there was a threat in this art to create a true "pop" art in the most positive sense of that term – a pulp-derived, bleakly monochrome vision that held, however tenuous the grip, to an all-but-buried tradition of truth-telling in American commercial culture. Very little of what is normally called Pop Art could make a similar claim. It remained, one could argue, a latency subsequently taken up by others, an international underground (soon to be overground), who created the third Warhol and the best one.

Part 2

Markets

4

The Return of Hank Herron:
Simulated Abstraction and the Service
Economy of Art

In the early 1970s the extreme insularity of late modernist painting and the large philosophical claims that surrounded it became the objects of a sly parody. Consistent with its deadpan self-effacement as satire, the text was published under the pseudonym of "Cheryl Bernstein" and included, with no indication as to its fraudulent status, in a widely consulted anthology of writings on Conceptual art.[1] An editor's introduction provided Cheryl Bernstein with a plausible biography appropriate to "one of New York's younger critics" ("born in Roslyn, New York...she attended Hofstra University before taking her MA in art history at Hunter"), including a promised monograph in progress. Her article is entitled "The Fake as More," and its ostensible subject is the first one-man show by "the New England artist Hank Herron," whose exhibited work consisted entirely of exact copies of works by Frank Stella.

Bernstein judges the exhibition a triumph. Herron, she argues, is, in the final analysis, superior to Stella, in that the copyist has faced up to the hollowness of originality as a concept in later modernism. Herron's replicas leave behind the fruitless and atavistic search for authenticity in artistic expression, accepting, as Stella himself cannot, that modern experience of the world is mediated by endlessly reduplicated simulations or "fakes". While their appearance exactly matches the originals, the replicater's canvases more powerfully manifest the material literalness and relentless visual logic for which Stella is celebrated. Because Herron removed the unfolding of that pictorial logic from any notion of bio-graphical development (he had duplicated ten years of Stella's work in one), he exploded the romantic vestiges still clinging to the formalist

69

readings of modern art history. Progress in art is closed off by this higher critical apprehension that the record of modernist painting now exists as another congealed image, one among the myriad manufactured simulacra that stand in for "the real" in our daily lives.

The thought experiment contained in "The Fake as More" has been rendered here with its terminology somewhat modified (Bernstein's philosophical references being the intellectual glamor figures of the 1950s and 1960s: Heidegger, Sartre, Wittgenstein, and Merleau-Ponty). Its language has been inflected – without betraying its ingenious invented logic – in the direction of what in today's art world is loosely called poststructuralism. The death of the author as it has been postulated by Roland Barthes and Michel Foucault, the triumph of the simulacrum as proclaimed by Jean Baudrillard, are ideas that enjoyed wide currency among younger artists and critics throughout the 1980s. Despite her older theoretical terminology and precocious date, these ideas are fully present in Cheryl Bernstein as well. One has only to juxtapose quotations to discover the closeness of fit between early-1970s satire and mid-1980s practice.

In the intervening period, for example, Sherrie Levine established a formidable reputation through her replication of canonical photographs, drawings, and paintings (pl. 17). The author of an admiring magazine profile wrote: "By literally *taking* the pictures she did, and then showing them as hers, she wanted it understood that she was flatly questioning – no, flatly undermining – those most hallowed principles of art in the modern era: originality, intention, expression."[2] This, by comparison, was Bernstein in 1973: "Mr. Herron's work, by reproducing the exact appearance of Frank Stella's entire *oeuvre*, nevertheless introduces new content and a new concept . . . that is precluded in the work of Mr. Stella, i.e., the denial of originality."[3] In 1984 Peter Halley, a painter and frequently published critic, expressed his high regard for Levine's copies by citing Baudrillard's enthusiasm for art in the state of "esthetic reduplication, this phase when, expelling all content and finality, it becomes somehow abstract and non-figurative."[4] Bernstein, for her part, had spoken of Herron's duplication of Stella's work as "resolving at one master stroke the problem of content without compromising the purity of the non-referential object as such."[5]

It was curious, in fact, how much the fictitious replicater for a time came to overshadow his genuine prototype in Elaine Sturtevant, who began replicating the works of all the dominant males in Pop as early as 1965, only to cease painting altogether in 1973 and show nothing for the next

17 Sherrie Levine, *After Walker Evans*, 1981. Gelatin silverprint, 11.8 × 9.8 cm. New York, The Metropolitan Museum of Art, Gift of the artist, 1995.

18 Sturtevant, *Flowers (after Warhol)*. Synthetic polymer paint and silkscreen ink on canvas.

dozen years (Warhol, for one, lent her his stencils for the *Flower* series [pl. 18], and in 1967 she mounted a full-scale facsimile of Oldenburg's *Store*).[6] The dead-pan conceit involved in "The Fake as More" was less than fair to Sturtevant, who has, in fact, included Stella among her other objects of imitation since the mid-1960s (pls. 19, 20). That historical occlusion meant that the invented Hank Herron, having lain virtually unnoticed in the pages of Gregory Battcock's anthology *Idea Art* for more than a decade, suddenly in 1984 became the one being talked about as if he had actually existed. While his creators planted some clues to the

19 Sturtevant, *Getty Tomb (after Frank Stella)*. Black enamel on canvas.

20 Sturtevant, *La Paloma (after Frank Stella)*. Alkyd on canvas, 76.2 × 152.4 cm.

21　Peter Halley, *Twin Cells with Circulating Conduits*, 1985. Acrylic and roll-a-tex on canvas, 160 × 274.3 cm. Private collection.

deception (starting with the common three-syllable names, rhymed first names, and a further rhyme with the name of baseball player Hank Aaron), many who heard the story were unaware of its exact source and had no awareness at all of the fictitious Bernstein. The mysterious artist was understood to have exhibited his purloined Frank Stellas just once and then disappeared.[7]

The article's exclusive stress on Stella may have accounted for much of its belated pertinence and for the temporary currency of the fake artist over the real Sturtevant. Its premise converged with 1980s practice not only because of its theme of replication but also because of renewed attention to the historical record of modernist abstraction on the part of younger artists. By 1985 Levine had moved on from replication of modern masters to small paintings of geometric motifs; Halley invoked Stella in print while more closely rehearsing the early work of the English modernist Robyn Denny (pls. 21, 22); Philip Taaffe produced obsessively crafted homages to Barnett Newman and Bridget Riley; while Ross Bleckner likewise trafficked in "Responsive Eye" devices of the 1960s (pl. 23). By the ironic means of duplication and simulation, young artists who wished to return to abstract forms, to reject the overheated subjectivism of Neo-

22 Robyn Denny, *Baby Is Three*, 1960. Oil on canvas, 213.4 × 365.6 cm. London, Tate Gallery.

Expressionist styles, found a way to connect their work to the last important episode in that kind of art. And out of this convergence between replicating procedure and geometric motif came Herron's dim, momentary glory; a mockery of mainstream art's perceived sterility in the early 1970s found itself transformed, through these artists' words and works, into a kind of celebration.

Behind the original parody had been the assumption that painting had been shamefully debilitated, deprived of its larger tasks of representation in the social world (there was, in fact, an unstated link between Cheryl Bernstein and the mid-Seventies activist group Artists Meeting for Cultural Change). "The Fake as More" was a thoroughly unsympathetic attack, displaying a certain measure of willful philistinism, on the inwardness of contemporary abstract painting and on its claims to pose serious ontological and epistemological questions. One might as well elevate to equivalent stature the (for them) mindless act of replicating Stellas. Plug in the standard language of furrowed-brow criticism and it worked as well as the average encomium in the *Artforum* of the day. When self-reflexivity could be persuasively imagined, and half-persuasively justified, as the deadening trap of identity, the modernist project was surely over. A decade later, artists like Levine and Halley agreed: the enterprise of modernism

23 Ross Bleckner, *The Oceans*, 1984. Oil and wax on canvas, 304.8 × 865.8 cm. Private collection.

had demonstrably failed to attain the purity and fullness of presence that it had promised, becoming instead one more set of cultural signs in a continuum that extended to the realms of electronic media and information technology. To grasp this reality (as they saw it), the artist had somehow to manifest the same originless, depthless repeatability in his or her own practice.

In 1939 Clement Greenberg, then at the height of his powers as a theorist if not as a visual critic, argued that an art resolutely founded on the problems generated by its own particular medium would escape exploitation either by commerce, or by the terrifying mass politics of the day.[8] Through the sacrifice of narrative and eventually figuration of any kind, he maintained, the visual arts would be strengthened in the areas

that remained exclusively theirs. The new art of simulation took that argument and turned it on its head: art was to survive by virtue of being weak. Weakness was the gift both of 1960s reductivism and of the assaults of the Conceptual artists on the hallowed status of the object itself. So debilitated, the art of late modernism had been freed from its own history and made available, like the liberated signifiers of advertising and commercial entertainment, to endless rearrangement and repackaging.

* * *

Levine has described her paintings of stripes and grids as being about "the uneasy death of modernism."[9] One is grateful for the qualifier "uneasy" in that remark, and her work seems the most worried and complex in reference of those under discussion here. Especially successful are the framed plywood panels with the knot-hole plugs painted gold or white (pl. 24), pictures that refer deftly both to Max Ernst's natural-history

24 Sherrie Levine, *Small Gold Knot no. 3*, 1985. Metallic paint on plywood, 50.8 × 40.6 cm. Private collection.

variant of Surrealism and to Gothic painting on wood. She rejects oil and uses casein, a binder related to egg tempera. Thus her reflections on the extinction of the easel painting involve a gesture back to pre-Renaissance traditions of devotional imagery, to a time when painting was able confidently to articulate a culture's shared beliefs.

The line of argument associated with the new abstraction has rested on the assumption that painting in our time has largely lost that power. Where Levine made the comparison with the past by means of subtle visual associations, Halley pursued the point explicitly in his writing.[10] The large scale and aggressive figuration of Neo-Expressionist painting were to him a mistaken attempt to restore the traditional forms of power in art, mistaken because that restoration inevitably produces an art of nostalgia for the traditional forms of power in society. Doubtless there was a kernel of truth in this perception, but it also contained an unexamined contradiction: while Halley and like-minded artists were asserting a condition of non-difference between high art and the general economy of sign production, art was being increasingly distinguished as an extraordinary and privileged marker by the actual behavior of that economy. "Serious" painting and sculpture – racked though they have been by inner doubt, loss of vocation, painful self-consciousness, the nearly complete erosion of their old representational purposes by photographic and electronic media – became ever more valued, patronized by an ever larger, more aggressive and more sophisticated clientele.

Art may have been overtaken by the universal commodity form, but it was (and remains) clearly a commodity with a difference that makes all the difference. Disembodied information about the smallest event in a studio in a Brooklyn backstreet or a Venice Beach alleyway can mobilize human energies, financial transfers, and intellectual attention on a global scale. That sort of cultural leverage – in material terms – would have to be measured in multiple orders of magnitude. Contrast this extraordinary efficiency with that of the film industry, so often seen as the quintessential medium of our historical moment: there massive investments are required to return even a minimum level of profit; the same can be said of professional sports, which demand elaborate forms of concentration, monopoly and state intervention in order to secure the enormous financial commitments involved. While governments and large corporations have plainly acquired a stake in contemporary art, the financial risks are minuscule by comparison. With their low costs of entry and potential for exponential returns, the fine arts seem closer in this respect to computer software, our era's most potent form of intellectual property. Art seems similarly well

adapted to a world in which markets are completely internationalized, politics are subordinated to them, and economic exchanges, unconstrained by time and space, are expressed in disembodied, quasi-fictional forms of information transfer.

By almost any objective measure, the art world gained in intensity of activity, cultural visibility, and power over the ten years that preceded the emergence of simulated abstraction in the mid-1980s. The number of New York galleries showing new art increased exponentially. Corporate collecting grew immensely, adding its weight to the heated competition among individuals to acquire substantial accumulations of the newest art (often the stimulus being the fear that it might soon be priced beyond reach). Art consultants and other forms of middlemen proliferated. Certain schools, such as California Institute of the Arts, began to function as efficient academies for the new scene, equipping students with both expectations and realizable plans for success while still in their twenties. Those with a stake in the latest art lamented, some with undisguised satisfaction, that the museums and old-line galleries had been superseded as arbiters of success by a network of newer collectors, corporate consultants and artist-dealers: the size and dynamics of the new art economy had outgrown the old institutional channels.[11]

If art had lost certain kinds of power, it had gained others and in larger measure. The younger artists of the 1980s enjoyed a climate of opinion in which they needed to give form to no narrative or idea of shared importance in order to be regarded with the utmost seriousness by an international audience of thousands (the economic power of which is far out of proportion to its numbers). The displacement of subjectivity in simulated abstraction, its evasions of the burdens of originality, was one response to circumstances in which efficient reproduction of the category "art" was sufficient to command attention. Neo-Expressionism, by comparison, had looked backwards to older artistic habits. It tugged at your sleeve; it begged to be noticed, while its traffic with vernacular forms, unvarnished private fantasies, and plain ugliness always gave it the capacity to offend – despite its evident international success.

Neither motive was evident in the smooth, clean surfaces and crisply defined motifs, the manufactured look, the eclecticly borrowed geometric motifs of simulated abstraction. In narrowing artistic mimesis to the realm of already existing signs, these artists simply accepted, with a much cooler kind of confidence, the distinction between what the modern cultural economy defines as art and what it does not. The self-sufficient validity of the art object was no longer, as it had been in the best moments of

79

modernism, wrested from an "encroachment on the territory of the non-aesthetic and a continual skirmishing with its power" (the phrasing is Charles Harrison's).[12] Even the Neo-Expressionists still believed that this struggle remained the central task of modern painting. By contrast, the sheer, unquestioned difference in coding between art and non-art became the primary meaning of the new abstraction.

* * *

Almost at its first appearance, this art was dismissed as market-driven, and its detractors could take ironic satisfaction in the rapidity with which major galleries, museums and collectors (pre-eminently the Saatchis) competed for a share of its instant glamor. In one important respect, however, such dismissals missed the point. Their mistake lay in a failure to recognize that successful manipulation of the codes of the art system cannot be verified in the responses of any individual viewer; that verification can take place only in the observable behavior of the larger economy in which works of art circulate. The economy was in fact the true medium of the new abstraction: without the ratification of the marketplace, this art could never have been completed. Simulated abstraction turned the trick of making cognitive value and careerism into one and the same thing – a very 1980s concept, but difficult to deny.

This fact posed particular difficulties for certain prominent writers on art, those who had pioneered the critical postmodernism of the 1970s. Prompted by anti-formalist art practices that had contested the hegemony of autonomous objects in traditional materials, this group – gathered in New York around the journal *October* – had taken on the institutions, ideologies and gender biases that had framed the modernist gaze.[13] They drew their vocabulary largely from the French structuralist and semiotic tradition in cultural interpretation, in which the fundamental meaning of a work was relocated to immaterial systems of signs. Reference to the world or to the inner experience of the creator was to be understood as a secondary effect of the operations of socially determined codes that escape introspective consciousness – codes in which the exchange of signs is its own justification.

It seems increasingly clear, however, that a good deal of the advanced practice of the late 1960s and after – in both art and its criticism – was trapped by its antipathy to modernism into fighting the last war and misunderstanding the stakes in the battle before it. The subversive enthusiasm of the period was eventually undermined by a blindness to

what the determining economy of its practice was actually becoming. The framework provided by semiotics and poststructuralism was to lend a cleaner, more modern method to the Marxian critique of the commodity-fetish, even (or most of all) for artists and critics who were Marxists in no other respect. But this theoretical marriage of the old and the new entailed a basic error concerning the nature of the contemporary market in art, one marked by confusion between its two very distinct sectors.

For convenience these can be labelled – in New York terms – 57th Street/Madison Avenue (uptown) on one hand and SoHo (downtown) on the other. The "uptown" trade in old and modern masters, like the market in relics and antiquities, would approximate the model of commodity-fetishism. What most buyers are after is not the specific use-value of one particular painting, but the generic exchange-value represented by magic words like Van Gogh or Picasso, or even Jasper Johns. Their connotation of unique forms of embodied consciousness, focused inwardness, and consummate mastery serve to justify a competition for prizes that frequently turns the reality signified by those phrases into lifeless slogans. Yet without those slogans, without the belief that unique value is embedded in each distinct object, the trade could not go on. The objects of trade are taken to preexist their incorporation into a market; their making must be authenticated as having taken place elsewhere, in the isolated creative imagination of the artist and the closed confines of the studio. A belief in the distinction between making and trading is crucial to the maintenance of value.

In order to understand how anti-commodity art helped entrench a commercial apparatus of distribution, it is essential to grasp that the market in contemporary art – the "downtown" market – is, to a great extent, an economy of services more than of goods. A primary value that the well-placed client receives from a gallery and its stable of artists is participation, insider status and recognition. Look ready to buy and the velvet rope is lifted; the first reward is separation from the common visitors out front. A few purchases from stock may lead to the chance to buy the sort of piece that is held in reserve for privileged clients. Along the way, there is the acquired sense of access: introductions to the artists, flattering chat with the gallery owner, who may be a celebrity him/herself. Other entrepreneurs, the freelance art consultants, offer yet greater degrees of intimacy and even a sense of power with their services: studio visits to the artists who are just about to take off, the promise that one might build a truly "important" collection, that one's decisions will begin to be taken into account in the way artists' reputations are made.

The expansion of this side of the art economy was in fact stimulated rather than impeded by artists who challenged modernist complicity with the marketplace. Minimalism and the Conceptual art that followed it, while disdaining the trade in art objects, had the paradoxical effect of embedding the practice of art more fully into its existing system of distribution. In the installation or performance work, the site of practice shifted from the hidden studio to the gallery; increasingly, it was there that the work of art was assembled or performed. The making of non-commodity art involved intense curatorial activity, and artists became more like commercial curators, middlemen for themselves. Though couched as a protest against a division of labor in which the producer was subordinated to the demands of a commercial apparatus, the cost was a more complete identification of the producer with that apparatus.[14] Installation art ceded what subversive potential it had possessed to the degree that it has lately become the main attraction in the venues of art tourism for the wealthy and well-placed, from Documenta to Biennale to SoHo and points between. And having sampled the event and the satisfying social interchange it occasions, the collector turns to the artist's dealer for a suitably portable souvenir.

An apparatus of theory fixated on the circulation of arbitrary signs in an effort to outwit the commodity fetish unwittingly came to rehearse the requirements of this system at the level of thought, thus playing a not unimportant part in sustaining its growth.[15] The art world's continual circulation of information and services has become a primary source of profit in itself. If one were to measure the monetary volume passing through the support system – the museum donations, building programs, travel and tourism, publishing, salaries and fees to curators and consultants, property gains in gallery districts, shipping and insurance, facilitation of business transactions in other sectors – the actual purchase costs of works of contemporary art would be small by comparison.

What was more, the loss of modernist truth-to-medium as a critical value, that is the loss of deference to the autonomy of the artist's professional culture, gradually undid the professional autonomy of the critic as well. His or her exclusive role had been based on the command of theory, abstract concepts, and specialized languages of interpretation. By the end of the 1970s, however, that command was being widely disseminated. Much to the dismay of some established figures in academia, the generalizing abstraction of high theory was transformed into a kind of folk wisdom in the streets of lower Manhattan (and Chicago, Los Angeles, London, Glasgow, Cologne, Tokyo...).[16] Young artists were turning the

idea of art-making as sign-manipulation into a powerful form of cultural machinery that ceased to be obedient to the critical ambitions of its authors: theory led artists to these highly rationalized strategies of appropriation and replication, in which the requirement of original, synthetic creation no longer stood in the way of matching supply to market demand. Those critics who had helped overthrow the modernist canon have since had to stand by and helplessly watch their own speech turned into more marketable products.

That predicament in the end exposes the limits of the Hank Herron fiction as a metaphor for sophisticated art practice during the 1980s. His creators imagined that his Stella facsimiles could be effectively ratified by a critic's ingenuity, and that assumption firmly locates their parody within the outdated assumptions of an earlier era. The invention of Cheryl Bernstein, on the other hand, is the closer anticipation of the 1980s, her unreality corresponding to the eroding ground under the critic's feet. Young artists may have overreached themselves when they ventured their theoretical competence in print, and they could in that venue open themselves to ridicule from seasoned professionals in the game.[17] But the practitioners of simulation and reduplication had the advantage of being able to induce certain observable behaviors in the wider art economy, and this has proved to be one way of taking its measure. In their hands, the unacknowledged complicity of the critical postmodernists assumed some intentional value.

On that score the work of Levine once again commands particular attention, as she has deliberately used her allusive abstract painting to move away from the Hank Herron play of mirrors. When she was faithfully rephotographing Edward Weston and Walker Evans (pl. 17), she was a favorite of the theorists, who praised her deft undercutting of all pretention to creative originality, a value itself appropriated for so long as an exclusively male prerogative.[18] The resulting images were taken to embody the idea, so powerfully advanced by Barthes and Foucault, that the myth of unique authorship represses the tissue of voices and quotations that constitutes any text. But much of that support slipped away when she moved from a strict regime of rephotography to a loose citation of modernist precedents in her ingratiating casein panels. Her reception then began to resemble that accorded Halley, Taaffe or Bleckner, who were suspiciously regarded as instruments in an orchestrated shift in art-world fashion for the benefit of the market, and with whom she was quickly categorized under the ugly promotional terms "Neo-Geo" and "Simulationist."[19]

Much of the animosity in that critical reaction appears in retrospect as a predictable response to having a past mistake disagreeably called to one's attention. Without drastically altering her premises, Levine had begun to produce eminently marketable work – a significant change in financial fortunes for her from the slow-selling rephotography.[20] Her photographs had advanced the proposition that the contemporary art system could be kept in motion with objects that needed only to resemble those which had held the same place in the past; but that proposition remained safely at the level of ideas, of critics' dicta. Her paintings went one step further and actually introduced a shift in the functioning of that system. Not only were they a conceptual advance on the immovable identity relations embodied in her photography, their significant diagnostic value lay in having isolated the minimal degree of visual difference, the precise degree of residual originality, required to prompt the art economy into efficient action. Witnessing an artist induce a measured change, however small, in anything so large put the diminished powers of criticism into dismaying perspective.

5

Art Criticism in the Age of
Incommensurate Values:
On the Thirtieth Anniversary of *Artforum*

Historical understanding of recent art will not begin to be satisfactory until the role of the art press is fully taken into account. Magazines and journals have been the vehicles for more than the musings of critics and opinions on new work; they have equally been responsible for disseminating basic information to artists about what their colleagues and competitors are doing. The work of art-world journalists has been, in an almost classically Enlightenment sense, to create and hold together a community of shared cognitive interests.

The relative difficulty of that enterprise varies over time and has become significantly more difficult and obscure in recent years. The task of writing to mark a symbolic milestone in the history of *Artforum* underscores that realization. Because the work necessarily involves going back over the past volumes of the magazine, particularly the decade from 1965 to 1975, it is nearly impossible to stop reading and return to the job in hand. Single issues from that period maintain a level of informativeness and intensity that put to shame whole books of recent critical writing. And that level is all the more impressive when one takes into account how frequently regular contributors appear and how quickly the work had to be done. But that fact may only be surprising from the perspective of the present, when the monthly article has been, to a great extent, replaced by laborious essays in academic quarterlies and hard-cover anthologies from scholarly presses. The time frame from conception to publication now has to be measured in years rather than weeks, and the writing tends to become thick with second-guessing in advance, the careful touching of theoretical bases, and worried anticipation of criticism.

In making this sort of comparison, the dangers of nostalgia are enormous, and one's autobiography and selective memory irresistibly intrude. The founding editors of the journal *October* were quick to defend themselves from this charge as they framed their ambitions in 1976: "We do not wish to share," they announced, "in that self-authenticating pathos which produces, with monotonous regularity, testimonies to the fact that 'things are not as good as they were' in 1967, '57 – or in 1917."[1] Yet to acknowledge that pathos in any form is to share in it, and the *October* project would have had far less justification if things had been as good with art publishing then as they had been in 1967. That first date was of course the one most present in their minds, the year when – to cite the most legendary instance – one issue of *Artforum* could throw together Michael Fried's "Art and Objecthood," its diametric opposite in Robert Morris's "Notes on Sculpture," and for good measure Sol LeWitt's "Paragraphs on Conceptual Art," which attempted entirely to transcend the terms of that epic disagreement. Other issues of the magazine were only somewhat less consequential, and running through them all were the letters: the flamboyant sarcasm that Robert Smithson directed toward Fried holds perhaps the greatest documentary interest today, but his was just one shot in a continual ricochet of commentary and disagreement from the magazine's community of readers; even the editors allowed themselves the extracurricular opportunity to be heard in the letters pages. Impressive as the verbal fireworks could be, however, perhaps the most arresting intervention of the era came in a few lines from Donald Judd in 1967: "Sirs: The piece reproduced on p. 38 of the summer issue was put together wrong and isn't anything."[2] The corollary of this objection was that, had it appeared in correct form, it would have been *something*, bespeaking a moment when the visual information provided by an art magazine could be expected by its community to go beyond embellishment to meet some standard of cognitive precision: the reproduction could not replace the thing itself, but was nonetheless a workable stand-in adequate for purposes of advancing the discussion.

If *Artforum* today cannot be the magazine one rediscovers in those old bound volumes, that is because no magazine is or can be: the entire economy of writing about art has changed because the economy of art has changed in its scale and fundamental character. An essentially local community linked by open cognitive interests was no match for an emerging global service economy in the luxury sector laying claim to the name of Art. The feeling of engagement in a common pursuit, as manifested in the *Artforum* letters column, always contains a healthy

element of fiction, and that useful illusion could not survive too much testing by reality. Basic issues of access and survival made fine discriminations of form seem a mocking luxury, indeed the province of institutional apologists. By the early 1970s, the definition of community had hardened into one of left-wing political opposition, acted out in groups like the Art Workers Coalition and Artists Meeting for Cultural Change. The magazine, under John Coplans and Max Kozloff, made a brave effort to stay with this direction in the life of its core constituency, but found itself caught by the very disparity of forces that had driven artists to these defensive maneuvers against the institutions of the art world. The crunch came between 1975 and 1976, orchestrated in the *New York Times* by a triumphant Hilton Kramer – no friend to critical voices differing from his own – and Coplans was dismissed as editor. With his departure went the magazine's last personal link to its Californian origins and to its early history of fostering the climate for advanced art in America.

Of course substitutes soon emerged as vehicles for the writing Kramer and his allies wanted suppressed in the mainstream. From the midst of the dissenting political milieu, the *Fox* flared and sputtered. *Art-Language* continued as a disputatious British outrider (with a tangled role in the rise and fall of the former). *October*, with better funding and a secure arrangement in academic publishing, settled in for the long haul. Its implicit diagnosis of the impasse that had defeated the old *Artforum* was that serious art writing could go on as before if it could call in sufficient reinforcements. Paris, for some time secondary in the practice of art, would come to the rescue on the plane of theory, the amalgam of semiotics, psychoanalysis, and deconstructive skepticism that went under the name of poststructuralism.

Greatly reduced circulation was not the only thing that set these journals apart from the existing model of the art magazine: economy demanded that an abstemious parsimony with the visual be the new order of the day. The *October* editors made a measured iconoclasm into policy, declaring in a Quaker-like way that its look would "be plain of aspect, and its illustrations determined by considerations of textual clarity," in order to emphasize "the primacy of text and the writer's freedom of discourse."[3] Conforming to ancient rhetorical formulae, illustration itself came under suspicion as an inherently "lavish" embellishment, and an elegantly austere graphic style was put forward as the outward sign of the gravity appropriate to the historical occasion. That quality was all the more appropriate in that the journal's component of explicit theorizing came largely from writers whose main commitment was to the word.

On a more polemical level (in rhetoric one would say forensic), visual austerity stood as an indictment of the complicity of the mainstream art magazine with the corrupting commerce in art objects, the irredeemable enemy of "intellectual autonomy." As someone who has happily contributed to *October*, I can say that the restraint and balance of its design, with its crisp monochrome illustrations, can be admirably effective from the writer's point of view. But what is lost in that approach is the opportunity for the text and the visual reproduction to function on anything like equal terms. That equality may indeed entail an infringement on the freedom of writing when non-cognitive values of publicity and display govern editorial decisions. But the strength of the best art criticism is its inner understanding that the visual confronts the act of writing with the un-thought of language; in the absence of the assertive, large-scale illustration provided by a magazine like *Artforum*, it can be too easy to speak *of* the visual without speaking *to* it.

Having fled from the oppressive priorities of commerce, serious art writing then finds itself vulnerable to another external regime of power: that of the literary academy. By "power," I mean less an abstraction in the manner of Foucault than the competition for concrete and relatively scarce rewards. Visual-art studies in the American university involve relatively small numbers; the combined disciplines of literary studies involve an enormous population of students and faculty. Over-production of new holders of doctoral degrees in turn generates a need for a continually inflating quantity of publication. In the face of these linked problems, simplified lessons from French theory have provided a neat solution: to the extent that everything can be construed as "a text", anything can become part of "English" or "Comparative Literature," or what have you. In a 1987 interview, published posthumously in 1991, Craig Owens reflected on one lesson he had learned from his experience as an *October* editor:

> Because we are now over-producing comp-lit PhD's, here is now a field (the visual arts community) that can be *colonized*. So we get the phenomenon of people moving into this field. The problem is not that they haven't studied art history. So what? It is that they really haven't got much identification with, or many connections within, this particular community.[4]

Despite the great disparity in visibility and power between the few specialists in the image and the many specialists in the word, the credibility of the latter's expansionism requires willing cooperation on the part of the former. Owens was evidently growing tired of providing that assistance,

but many others have been more willing. As a result, the expectation remains that art journals will gratefully solicit the opinions of literary critics, philosophers, and social theorists for the pretended novelty of hearing serious ideas introduced into their sleepy field. Such openness and generosity is ideal in principle and would be entirely to be applauded except for the fact that these gestures are hardly ever reciprocated. It is the rarest of art historians who is ever invited to speak to literary critics – or philosophers or social scientists – on their own ground about their core subject matter. Such enforced deference to other fields is no valid verdict on the relative advancement of the best art writing, but is merely one artifact of a developing medium of interdisciplinary dialogue which permits – for reasons of the relative power of disciplines – traffic in one direction only. Anxiety to secure a hearing in the literary academy accounts for a great deal of the over-managed, over-qualified prose that currently afflicts the field.

The strategy of restrained journal design proved open to another form of cooptation when it was aped by none other than Kramer in the launch of in his own journal, the *New Criterion*. As a prim declaration of high-mindedness, he entirely eschewed illustration and limited advertising to decorous typography. A neo-conservative journal can easily afford a show of fastidiousness about the demands of commerce when this stance implies no actual objection to the marketplace being run in the way its participants – major collectors, curators, and dealers – see fit. While it may occasionally object to certain outcomes (the Museum of Modern Art's 1990 *High and Low* exhibition, for example), the system that generates an occasional embarrassment remains beyond scrutiny or reproach. But if colorless clothing entirely suits the disingenuous probity of the neo-conservatives, there is a real price to be paid by those who would subject the system to critical scrutiny from a position of competence in matters of visual form. The latter are increasingly obliged to work in a publishing format that allows little participation in the way non-textual information is transmitted within the art world generally. That transmission then floats free into an incorrigible network where any effect – visual or verbal – is permitted.

The foregoing discussion, largely for reasons of focus and brevity, has been framed almost entirely in American terms. But the forces that ended the first phase of *Artforum* after 1976 were international in scope. As the boom that took hold in the late 1970s was to prove, the scale of commerce in art was generating a qualitatively different system, beyond anything that a local community of cognitive interests could readily comprehend. The

25 Anselm Kiefer, *Women of the Revolution*, 1992. Mixed media installation, London, Anthony d'Offay Gallery.

New York critics of the 1970s were right to enlist an international response on the level of theory to hold their own against the rapid globalization of the marketplace, though the forces in play were bound to be mismatched. Buyers, dealers, curators, and artists could operate halfway across the globe from one another; enthusiasm in Germany for certain artists from the American West Coast caused New York to be by-passed as a center of intellectual mediation, and this is just one example among many. There came an enormously expanded demand for exposure of works of art, for transfer of information, but this demand was more and more met by the luxury catalogue and by the international exhibition circuit followed by art-world insiders (discussed above in "The Return of Hank Herron").

The fate of context-specific art points up the importance of the new art tourism over more accessible, democratic forms of information transfer. A decade ago, when international round-up exhibitions like *Zeitgeist* and *New Spirit in Painting* aggressively promoted painting's return to dominance, it was decried as a threat to the critical potential of installation art. But in the end, the same institutions that once gave room to Neo-Expressionism and its variants have been just as happy to abandon them. Traditional media have proven to be too limited for the most effective projection of signature personalities and celebrity status.

Anselm Kiefer, whose name virtually stands for the return to painting, took to the stage in 1992 with an ensemble of bed sculptures indexed to the names, scrawled in paint on the walls of the gallery, of women of the French Revolutionary era (pl. 25). During the early 1990s, every effort to mount up-to-date surveys put installations – with heavy use of texts and photography – forcefully to the fore in their representation of global art activity.[5] The London exhibition *Double Take* of 1992 exposed the nature of the new, domesticated installation aesthetic in its internal architecture. The spaces of the unloved Hayward Gallery were almost entirely filled by a new, parasitical interior designed by Aldo Rossi. Its effect was to make the gallery into a warren of isolated, four-walled spaces, the passages between them being often awkward and narrow, closing off vision and easy movement between one exhibit and the next. Exhibit is the apt term, more accurate than installation, because each space resembled a named pigeon hole or office cubicle, designed to isolate the expression of a single artist in the way that a fairground attraction is given its individual stall. And just as a picture frame forces the viewer's attention to a painting back onto its internal relations, these compartments – obligingly provided by the institution – made each work into a framed piece of unique environ-

mental sculpture. The whole arrangement might well have been kept in place for an endless set of new pieces designed to be showcased in them.

The parallel demand for a vivid language of promotion and enthusiasm has been readily met by the European star curators – the likes of Achille Bonita Oliva, Rudi Fuchs, Jan Hoet, and Norman Rosenthal – who operate across borders with ease and who have revived the windy subjectivism and mystical excesses that hard-nosed American critics of the 1960s had thought banished forever. The result is the same body of art being talked about in entirely incommensurable vocabularies. Certain artists – though not the current stars of the scatter installation – have begun to confront the anomalies of this new global network in their practice; it is up to critics to address it as well, to try to hold it in mind even when engaged in detailed examination of individual artists and works.

Given the crucial role of Joseph Beuys in authorizing the new curatorial subjectivism, one strong precedent for such critical intervention exists in Benjamin H.D. Buchloh's trenchant dismantling of the Beuys mythology, "The Twilight of the Idol," which appeared in *Artforum* in 1980 and was all the more compelling for being there.[6] This activity can and should take place in any venue for writing, but it gains a particular effectiveness, an added measure of realism, when surrounded by the actual matter being addressed: the clutter of advertisements, the page-filling color. The critical force of the old *Artforum* was never anything but a lived contradiction between thought and commerce. We have passed through a period when commerce has displayed the superior intelligence and outrun the theoreticians: simply getting back to a state of effective contradiction is the task of the moment.

Part 3

Photographs

26 Jeff Koons, *French Coach Couple*, 1986. Cast stainless steel, height 43.2 cm.
Courtesy of Sonnabend Gallery, New York.

6

Handmade Photographs and
Homeless Representation

The debate around cultural distinctions – high and low, elite and mass, cultivated and vernacular – has largely descended into unproductive exchanges between hardened, warring positions. A point has been reached where it will not be easy to recover, for purposes of dispassionate examination, what has been the key question in the art and criticism of this century. One significant limitation of established media and cultural studies has been a reluctance to look beyond the expensive and intensively marketed products of large-scale entertainment industries. That concentration brings with it an almost automatic assumption that the finished products of those industries – "what Ice Cube is rapping about or whatever new kind of cyborg Arnold Schwarzenegger is impersonating" – are transparent to the feelings and states of mind of individuals within their intended audience.[1] In the British beginnings of cultural studies during the 1970s, the emphasis was different: the dominant concern then was with the way excluded and disadvantaged groups creatively adapted and recoded the commercial cultural products that came their way.[2] But even then, by concentrating on flamboyant youth subcultures and highly visible metropolitan ethnic groups, the founders of the field tended to single out those appropriations most likely to be fed directly back into the cultural machinery and promoted as new and glamorous styles for a mass market.[3]

But there remains a whole continent of vernacular culture that these approaches miss. This may be because so much of it is positively unexciting: dowdy, boring, provincial. To a large extent it consists of discards from the realm of cultivated fine art, which have come to be treasured in other quarters. Jeff Koons's stainless-steel casts (pl. 26) made their impact

in the mid-1980s because of the genuine strangeness to a cultivated art world of his selected tokens of small-town life, of its versions of masculine conviviality (the drinking accessories) and feminine gentility (the ceramic figurines).[4] In the case of the china objects, Koons's casts of casts fixed one's attention on Rococo fantasies of an Ancien Régime aristocracy persisting from generation to generation through networks of unheralded craft industries, retailers, and hobbyist or merely house-proud collectors.

In choosing these remnants of historical forms of art – devalued among sophisticates but cherished in some wider, inarticulate world – Koons was operating where Warhol had explicitly been before him, and in some of the most acute of the early paintings. Warhol's *Do It Yourself* paint-by-number pieces of 1962 (pl. 27) imitate the imitation of outdated naturalism which flourishes in amateur production (its second-order character signalled by the fact that the numbers sometimes remain visible in the completed segments). These programmed kits are obviously just one small part of an enormous output of non-professional painting: one only has to look at the number of practical guides to technique on sale in any art-supply shop. The authors of these books take their readers through set exercises in which the aspiring amateur mimics prescribed compositions and illusionistic effects. Once again, the models – like Warhol's – come from, and form, a virtual catalogue of bypassed conventions from nineteenth-century art.

When self-taught painters turn to their own subject matter, their commitment to naturalistic conventions often requires another guide, and that is the photograph. The subjects they are interested in are frequently inaccessible or simply will not sit still long enough to be captured by an untrained hand. Traced and laboriously rendered portraits of pop stars, athletes, pin-ups, children, cars, and pets represent the genuine underground of art. What their makers are generally after is a detailed fidelity to appearances which they associate with celebrity illustrators like Andrew Wyeth, or Salvador Dalí in his later career; fantasy and inventiveness frequently manifest themselves in incongruities modelled on hyper-illusionistic Surrealism.

The notion of the "handmade photograph" has had a minor career in avant-garde theory, from Picabia and early Dalí up to Gerhard Richter, but it is to this sort of production that it best applies. The idea that one can make that same illusion happen again, by one's own unaided manual powers, possesses a magical fascination. The accumulation of small errors in the transcription of the photographic data will invariably undo the effect to a more demanding eye, as the artist usually lacks the alternative

27 Andy Warhol, *Do It Yourself* (*Landscape*), 1962. Synthetic polymer paint and presstype on canvas, 178 × 137 cm. Cologne, Museum Ludwig.

28 Anonymous, "Thrift Store Painting" collected by Jim Shaw. Oil on board, 39.6 × 35.56 cm.

conceptual grid of competent drawing necessary to check and recover the coherence of the subject by other means. But the results plainly remain captivating to their makers.

Such paintings belong with the discarded amateur efforts collected and exhibited by Los Angeles artist Jim Shaw under the rubric of "Thrift-Store Paintings" (pl. 28). The nervous responses to Shaw's exhibition are a sign that this territory may be the last one toward which safe feelings of superiority are possible and that it may therefore possess the last potential for scandal. In an art world that claims to take "the death of the author" for granted, the impenetrable anonymity of Shaw's discoveries from the lumpen-suburban hinterland, the absence of reassuring subcultural or ethnic markers, seem to make that concept all too real. *Art in America*'s reviewer (who did not dislike the show) felt empowered to term the paintings "essentially worthless . . . dreadful, abject, and shabby."[5] It is difficult to imagine an aware critic taking this line about an item of Bronx subway graffiti or airport sculpture from the developing world, but these little canvases were fair game. Brian d'Amato, taking a more

thoughtful line in *Flash Art*, observed that their anonymous character, the mystery of their makers, only highlighted evidence of an indomitable "spirit of originality and self-expression."[6] The viewer had nowhere to hide from that lately forbidden desire.

Actual anonymity and self-effacement have not, in fact, been much encouraged in recent artistic practice. The sort of photographic and appropriation procedures that promise an effacement of the authorial self are invariably recouped through other media of publicity and critical attention, so that daring gestures can always be linked to a well-known individual. The sheer efficiency of these moves, the way that an artist's minimal interventions can garner substantial attention and rewards, inspire fascinated admiration for the unique creative personality behind them.

The less self-expression has been valued, the more the self of the artist – from Warhol to Kruger to Koons to Hirst – has come to loom over the work. There is, however, one tendency in cultivated fine art, persisting from the 1960s, which has achieved a condition of near-anonymous production. This is so-called Photo-Realism. Within this body of work, the suburban landscape has been mined not just for its blandly characteristic appearances, but also for the vernacular approach to picture-making pursued by large numbers of its inhabitants, practices which these professional artists have transposed to a high level of technical competence. While a great deal of work is still being done in this mode, it has largely lost the critical attention and legitimacy it briefly possessed at the outset, when its cool impersonality briefly seemed of a piece with Minimalism and Pop.[7] But the vernacular-based nature of its means of representation (which distinguished it from most Pop painting), meant that it could not remain securely within a fine-art context. Its brief prominence provided a license for certain forms of out-and-out kitsch (the California pin-ups of one Hilo Chen, for example), which had the effect of dragging the meaning of the whole practice back into the realm of the uncultivated and naive.[8] This by no means implies that photography-based illusionism has lost any useful place within the specialized concerns of accredited art practices; but its uses will derive from its deep affinity with the unconstrained and unsupervised drive to represent by hand.

* * *

London, in late autumn 1992, offered an opportunity to consider two such uses by serious artists. One was on view in the Gerhard Richter retrospective at the Tate Gallery, the other in a less heralded show of recent work

by Andrew Holmes, arguably the most important British producer of manually transformed photographs.[9] Finding one's way to Holmes required considerably greater effort than following the familiar paths to the Tate. An Underground journey out to the depressed peripheral neighborhood of Finsbury Park in north London deposited the visitor in the midst of the area's noisy transportation hub; to reach the exhibition one followed run-down streets lined with small Asian clothing businesses; the gallery was an adjunct to a framing company housed with meat wholesalers and such like in a new trading estate surrounded by barbed wire. In England the phenomenon of art entrepreneurs actively colonizing semi-derelict commercial districts is still new. For the London art scene, this was edge of the earth.

For all its obstacles to easy accessibility, the raw commercial edge of the setting was precisely appropriate to the vision on display inside. Holmes's most favored subject matter has always been Los Angeles, or rather the lines of transportation that artificially sustain the city across the harsh surrounding desert. He is an architect by vocation and a teacher at the Architectural Association; the concatenations of mobile structures on the American highway (trucks, trailers, tanks) with their permanent industrial armature (which channels, fills, fuels, unloads, washes) is for him the great architecture of America. Its configurations exist in recurrent process rather than stasis, and some of his work exploits video, filmstrips, and Polaroid assemblage to open up time within the work. But the core of the exhibition was a series of large drawings in seamless layers of Derwent color pencil, works in which time unfolds retrospectively through the viewer's awakening to the sustained intensity of labor and feeling that gave rise to them.

With these pictures, vividness is achieved through density of application and concentration of effect, this being just one aspect that distinguishes them from the superficially similar American Photo-Realism of the 1960s and 1970s. Deliberately casual, snap-shot arrangements are entirely missing from the work, as is the reiteration of merely at-hand suburban exteriors. His characteristic compression of meaning results in compositions like *Tanks* (pl. 29), a drawing which literally figures the necessary effacement of authorial presence implicit in its technique. The subject matter is two polished tank-trailers positioned beneath a gantry from which they are being filled with milk. The artist/viewer is so positioned between the two tanks as to have a close-up view of the one in front, the other being reflected from behind in its immaculate curving surface.[10] This is, of course, an impossible vision, one that no photograph could provide, in

29 Andrew Holmes, *Tanks*, 1991. Color pencil on paper. Private collection.

that the viewer's image would necessarily be caught in that same play of reflection. Careful, meditated extrapolation from the visual data is required to preserve a crucial cognitive distinction between the independent life of the working apparatus and the presence of the temporary observer – and one can feel the force of the exclusion.

Much theorizing about mechanical reproduction in recent art has suffered from the assumption that "the photograph" is a pre-existing, unitary object. The source, after all, of any photography-based illusionism is the negative or transparency – usually tiny, absent, and unavailable for inspection. Consequently any enlarged, opaque print is already a reproduction, one in which information is distorted and lost. There will be kinds of information in the source better mediated and fixed by a slow, manual process of synthesizing intelligence and accumulated feeling. And the result can be put to different sorts of uses, encountered and contemplated in ways that a photographic print cannot be. Large-scale and intense color saturation, for example, can be achieved by means that are not indelibly associated with advertising display. This removes the otherwise automatic requirement of irony and in turn expands the range of possible subjects. The technique also allows the work to issue, where appropriate, a less insistent invitation to the viewer's attention.

Tanks is an attempt to get down the feelings of an architect encountering a momentary vision of an anonymous architecture which is beyond the powers of his profession to produce. Its anonymity derives in part from mass-produced industrial components, and thus has something in common with the earlier work of Richard Rogers (for whom Holmes worked at one time). But Holmes's conception proceeds from a paradox inherent in the cerebral design and effect of buildings such as Rogers's. In that the tolerances involved call for expertise in custom manufacture that no architect could individually command, their construction has depended upon practical wisdom provided by contractors and skilled workmen. And such structures are subject to rapid decay if not rigorously and sensitively maintained by other hands (the deterioration of the Centre Pompidou being the proof). The building is, therefore, not a fixed thing, but exists along a trajectory in time of purposeful social activity.

Once architecture is reconceived in this way, there is no reason not to expand the term to cover the entire system of supply by road in which the urban oasis of Los Angeles is suspended. Complex industrial structures of remarkable scale and intricacy are in continual motion through this system, maneuvered and maintained by highly skilled individuals (and here Holmes's conception would be in diametric contrast to Bernd and Hilla

Becher's static codifications of factory architecture). As architecture it cannot be encompassed by plan or rendering; merely to conceive its extent is to grasp one's inability to do more than glimpse temporary fragments, and it will be only through these that it can be represented. The process of drawing is the process of investing a photographic trace of the fragment with the sense of its sublime, ungraspable whole. That investment is effected through all the small decisions over emphasis, contrast, and simplification taken through time. The self-denying discipline involved yields a palpable tension in the works, particularly in the achingly sustained areas of unbroken color.

* * *

The ambiguous, semi-vernacular status of the American Photo-Realists likewise hovers over Gerhard Richter's illusionistic painting of the 1980s. If his work were exclusively in the vein of *Betty* (pl. 30), the 1988 portrait of his daughter, he would not easily escape being labelled as a soft-focus European outrider of that tendency. But he has in common with Holmes the use of photography-based naturalism to signal the limits of some other practice, to map the territory outside its competences. In Richter's case, that other practice is emphatically that of fine art at its highest degree of cultivation.

This he signals most obviously by his simultaneous production of large abstract paintings in which all the resources of expressive paint handling and grand pictorial gesture seem to be on display (pl. 31). Superficially, this is a restoration of the sort of hierarchy that prevailed in the official exhibitions of the eighteenth and nineteenth centuries. In the top rank of any hanging would be the large historical canvases, seeking to impose complex demands on the intellect and erudition of the visitor, on his or her capacity to discern generalized, abstract truth from the exemplary narrative on display; lower down on the wall were the portraits, the picturesque scenes of anonymous types, landscapes and still-lifes presumed to indulge the more modest imaginative needs of the audience. The supporting presence of the lower genres confirmed the priority of the highest, the superiority of which was taken to rest on the ability of history painting to subsume their particular virtues in a grand conceptual synthesis.

The most prestigious painting of our own time has sought to confirm its superiority by exactly opposite means, that is, by purging the lower genres both from within itself and from its vicinity. Clement Greenberg coined the term "homeless representation" to register his irritation with the

30 Gerhard Richter, *Betty*, 1988. Oil on canvas, 102 × 72 cm. The Saint Louis Art Museum. Purchase: Mr. and Mrs. R. Crosby Kemper, Jr., through the Crosby Kemper Foundation, Mr. John Weil and Mr. and Mrs. Gary Wolff; Museum Purchase, Dr. and Mrs. Harold Joseph and Mrs. Edward Mallinckrodt, by exchange.

figurative residues present in the painting of Jasper Johns and Willem de Kooning.[11] But it can serve more broadly to designate the general condition of the lower genres in the later twentieth century. Set adrift, they have come to rest in a series of new contexts, from the sub-artistic markets for decorative kitsch to the ad hoc impulses of Shaw's thrift-store underground.[12]

Richter's more recent figurative painting is distinguished from his photography-based works of the 1960s by its elevation of *technique* derived from vernacular practices over a more commonplace recourse to *imagery* mined from mass-media sources. While he still uses the latter, the technique remains consistent whether the model comes from a newspaper or from a personal photograph. It has allowed him latitude to introduce strong sentiment into the habitually ironized realm of contemporary art. By itself, the image of *Betty* on the poster for the Tate retrospective bids fair to become a popular icon of the order of Wyeth's *Christina's World*. What Richter was seeking in the portrait of his daughter will plainly remain beyond one's full understanding, but one does know that he painted *Betty* in 1988 at about the same time that he was producing the highly mediated portraits of Gudrun Ensslin and Ulrike Meinhof, the dead young women of the terrorist Baader-Meinhof group, in *18 October 1977* (and he has not painted anything like it since). The remarkable use of selective focus, apparently derived from the wide aperture used for the photograph, displays the mechanical origin of the image, but the device is used to acute emotive effect: the sense of removal traditionally associated with the *profil perdu* (exploited equally by Wyeth) is deepened by the sharper definition of the near shoulder in a way that has nothing to do with normal seeing. The same mechanical contrast gives the hair its halo-like aura. But the painting keeps its distance from the likes of Wyeth to the degree that it recovers its affective potential from its mechanically objectifying means. *Betty* demonstrates that the degree of simplification necessarily involved in a manual process, combined with the vividness of presence imparted by the paint, can be a revelatory tool of analysis.

The presence of Richter's abstract paintings further guarantees that his naturalistic work need not be tied to the provincial, Wyeth-like assumption that such paintings can adequately fulfil the demands of art. At the same time, however, the former are anything but confirmed in their conventional superiority. Close examination of any of his most recent abstract work reveals the rich and apparently spontaneous surfaces, bursting with the promise of expressive revelations, to have been generated through gross mechanical stresses on the layers of congealed paint. These prior layers of

paint have, in certain cases, amounted to fully realized pictures in their own right: one such canvas (the magnificent *Abstract Painting [726]* of 1990) began its life as a finished work in the illusionistic mode of abstraction that had characterized his work of a decade before, only to be erased and transformed in the drying stages. An enormous triptych (*Forest*, also of 1990) improbably began as a trompe-l'oeil geometric fantasy in the manner of Vasarely's optical poster art, which was likewise obliterated beyond recognition by scrapers and squeegee mops. From a catalogue of earlier attempts to manifest emotive or cognitive depth in abstract form, Richter generates effects that rivet one's attention by the splendid intensity of promises never to be kept.

Paul Wood has recently and with accuracy described Anselm Kiefer as:

> the artist who has aspired most overtly to retake the high ground of the avant-garde, only to achieve something more akin to a contemporary Salon machine: the site, that is to say, where serious culture rehearses its characteristic concerns, its fears, its humanity, and its sense of its own profundity.[13]

Kiefer tries literally to re-integrate the devalued genres of portraiture, landscape, and still-life into the matrix of grandiose history painting. Richter, on the other hand, replicates the logic of the old Salon exhibitions by returning the homeless genres to their former accompanying role. But their everyday connection to individual thoughts and feelings is plainly no longer available to the big machines in any form. The mark of photography on painting – the great vernacular expedient – is there as an unmistakable sign that high abstraction has surrendered control over its necessary limiting terms, a condition that renders it equally contingent and equally homeless.

31 (previous pages) Gerhard Richter, *Abstract Painting (726)*, 1990. Oil on canvas, 250 × 350 cm. London, Tate Gallery.

7

Ross Bleckner, or the Conditions of Painting's Reincarnation

The uncanny aspect of Ross Bleckner's paintings begins in their confounding two elements thought for so long to be categorically distinct: the material surface and the picture plane. One was literal, the other virtual: an ideal viewer of a modernist work engaged in a constantly oscillating form of attention, shuttling between the actual pattern of pigment within the frame and that fictional screen behind which played the "optical" mirage. The two were utterly interdependent but just as rigorously non-identical in conceptual terms.

For a painter wanting to sustain this interplay, the trick has been to make the technical means as matter of fact and unmysterious as possible. This applies most of all to those artists who have created the most fascinating optical effects in modernist art. The shimmer of Seurat's seascapes or the layered currents under Monet's water lilies are mental events issuing from dry, corrugated surfaces of pigment. And that disparity was just as marked in later, non-figurative work within the same broad tradition. The behavior of hardware-store enamel will surprise no one inspecting a Jackson Pollock at close quarters. For all of Mark Rothko's secrecy about technique, his success came from a precise tuning of unassertive painterly means.[1] The same can also be said of Morris Louis, whose "unfurled" series use marginal rivulets of stain to conjure a compelling central image from nothing but a large expanse of raw cotton duck (pl. 32). The claim was advanced at the time that the stain technique had achieved complete integration of color with the picture plane, but the outcome in these paintings was to push the prosaic fact of surface and its spectacular fiction as far apart as they had ever been.

Bleckner's paintings, with a scale and presence to rival these later exemplars of high modernism, display a markedly different conception of

32 Morris Louis, *Alpha Tau*, 1960. Acrylic on canvas, 258 × 594.4 cm. The Saint
Louis Art Museum. Purchase: Funds given by the Shoenberg Foundation, Inc.

the boundary between physical world and mental image. They treat the
flat plane of the picture as possessing a substance of its own, like a
thickened film or skin. The matt, woven, porous surface that characterizes
virtually all canonical painting over the last century gives way in his work
to a continuous, sealed sheet of suspended pigment that signals its presence
through an unorthodox degree of reflectivity. That sheen suggests a
perpetual wetness, all the more when interrupted by scored marks or
indistinct shapes, dark against equal dark, which absorb the greater
measure of light. Bleckner's much-discussed imagery – the spectral phos-
phorescences and reflections, the dizzying Op-art devices, the antiquated
memorial objects, the vertiginous spaces traced in light (pls. 33–6) –
gains its consistency and force by being so evidently absorbed and com-
pressed inside these translucent membranes of congealed oils. There is little
of the normal illusionism, figurative or abstract, that posits the picture
surface as the forward point beyond which fiction no longer holds; nor is
there a resistant support upon which collage elements can be affixed.
Postmodern approaches to painting contemporary with Bleckner's – that
of Anselm Kiefer or virtually any other ascendant painter of the 1980s –
might mix these modes in time-honored, avant-garde fashion, but few, if
any, have managed to set both aside.
 Bleckner's success in this can perhaps best be gauged by the disturbance
he can create in the normal patterns of critical judgment. The best case in
point is the 1984 review by Brooks Adams, which many credit with

33 Ross Bleckner, *God Won't Come*, 1983. Oil on canvas, 213.4 × 152.4 cm. Private collection.

34 Ross Bleckner, *Delaware*, 1983. Oil on linen, 228.6 × 182.9 cm. Private collection.

35 Ross Bleckner, *Architecture of the Sky*, 1990. Oil on canvas, 269.2 × 233.7 cm.
Private collection.

36 Ross Bleckner, *Fallen Summer*, 1988. Oil on canvas, 274.3 × 182.9 cm.
Private collection.

bringing the artist to a new level of recognition. Adams accomplished this, however, with the grand indignation of one of those famous critical attacks on the nineteenth-century avant-garde: "Light glances off the oil slicks of these works making them slick and sleazy," he complained, "Light also sticks in the mountains and crevices of their paint texture making them feel a little tacky."[2] That "a little" comes across as a belated concession to critical balance, though the reader searching in vain for anything like mountains and crevices in the surface of a Bleckner will have already concluded that Adams had dismissed balance from the start. Facing these "Edgar Allan Poes without plots" with "some vague sense of foreboding, of something gone wrong," he is overcome with Gothic anxiety at their absence of normal painterly markers: "At times we can make landscapes out of them, at others only interior space. At moments we can see shadow play and think of Warhol's shadow paintings: then we see only self-portraits of all of us groping around in the dark."[3]

It required groping indeed for an Adams to find the phrase "goyische Goyas" to describe the work of a Bleckner. When he concluded by calling the paintings "fretful, steamy, leisurely, churlish, and to what avail?" many readers would have instantly shifted these adjectives onto the critic himself. But these excerpts from a much longer bout of free association indicate why it was more valuable to Bleckner's career than the most flattering puff would have been. Written at a time when "the return of painting" had polarized opinion between uncritical acceptance and outraged dismissal of the entire phenomenon, Bleckner was able to elicit a genuine response from a knowing observer, one that mixed equal measures of fascination and repulsion, hard scrutiny and unhinged fantasy. To declare that the paintings were "self-portraits of all of us groping around in the dark" was, on one level, a good metaphor for their refusal of programmed responses and, on another, a literal pointing to what most disturbs: the dull mirror presented by their reflective surfaces.

What fundamental rule or rules does this quality of surface violate? The beginning of an answer – and a point missing, so far, from commentary on the artist – is its resemblance to the coating on a photographic print. Any competent consumer of photography is habituated to look past the gloss or sheen of the paper; like the sealed evenness of texture across the image, indifferent to any illusion that may be transpiring in the thin chemical layer, reflection is a defining trait of the medium and gives off no contrary signals. The transposition of analogous effects to painting on the scale of New York School abstraction may well be to violate some deep settlement that the culture has reached concerning the permitted

spheres of the two media, perhaps to a greater degree than has been achieved by those pushing the boundaries from within photography itself.

The same qualities that can be ignored when looking at a photograph become, at least for some, an unsightly interruption in the delicate business of contemplating a painting. But that particular transgression, if this analysis holds good, would be only the most visible form of a more far-reaching abrogation of an ancient social pact concerning the signs of value on the surface of a picture. During the mid-1980s, Sherrie Levine produced some small pieces of plywood, on which the ovoid knothole plugs were painted gold (pl. 24). That minimal gesture deftly conjured up a more ancient history of painting, of religious images painted on panel, in which surfaces of precious matter – gold or lapis lazuli – were signs of a supernatural presence. Over the course of the fifteenth century in Italy, agreements between painters and patrons gradually (and unevenly) began to specify displays of the artist's skill for dictated expenditure of expensive pigments.[4] The old expanses of gold leaf were smooth and highly reflective; the new surfaces of conspicuous invention were heavily inflected and tended toward a dulled finish. In that substitution, it could be argued, a modern artistic self-consciousness began to take shape. The former techniques survived, but migrated to luxury crafts or popular devotional objects, which were pushed further and further away from the emerging category of fine art. Even within oil painting, conspicuous polish in technique and overall surface reflection became the province of the cabinet picture: small-scale still-lifes and scenes of ordinary life which gratified or amused more than edified the spectator.

The appearance of such works was taken to be part and parcel of their "mechanical" transcription of superficial visual experience. The same charge, of course, was levelled at photography, the reception of the new medium having readily fallen within these long-standing categories. It follows that the idea of photography as mechanical can be explained only in part by its technological modernity: photochemical transcription and an industrially produced apparatus. Painters have engendered the same response through manual techniques, though to transfer them from an intimate to a large scale demands an unorthodox approach to the medium.

Bleckner's highly individual approach to the technical side of painting is well known: his old-masterish reliance on ground pigments rather than prepared paint; his improvised and unusual mixtures of wax and linseed oils heated in fine cooking pots. He is not the first painter to have undertaken idiosyncratic experiments with his binding agents in order to

break away from the norms of surface appearance in ambitious painting; in doing so he has linked himself with an alternative tradition that has appeared only fitfully and in the margins of the mainstream over the last two hundred years. To trace that tradition from its earlier manifestations can help in clarifying the link between his striking technique and the particular themes and desires that dominate his work.

* * *

In the summer of 1791, a young French painter in Rome, Anne-Louis Girodet, had shut himself away in his studio, believing that his career depended on what he could make of the painting on his easel (pl. 37). Its subject was a reclining male nude, an *académie*, such as all winners of the Grand Prix de Rome had to produce as a demonstration piece. He had chosen as his subject the mythical shepherd Endymion, sent into eternal sleep by the infatuated moon goddess Selene. The story demanded a

37 Anne-Louis Girodet, *The Sleep of Endymion*, 1791. Oil on canvas, 197 × 261. Paris, Musée du Louvre.

nocturne, itself an unusual and challenging effect in such a painting. Girodet intended to go one step further, integrating the lunar illumination with the sexual narrative: the coupling between divinity and mortal is made visible as a fall of moonlight on the radiantly charged body of Endymion, which is offered up to the male viewer with no female intermediary in sight. The only other personage is the god Eros who, in the guise of the wind Zephyr, parts the overhanging branches to let Selene's light reach the object of her desire.

Girodet became preoccupied with rendering the light of the painting with the greatest possible truth to optical experience, avoiding the tricks used by painters of conventional night-time scenes. To that end, he had to exert the most precise control over the slightest modulations of hue within the narrowest of tonal ranges, in both the darkened and illuminated sections of his composition. But his obsession with animating light went further, to the point that he undertook to alter the reflective qualities of the actual painted surface – not with varnish after the fact, but in the quality of his binding medium. In the middle of that summer he wrote to his friend, the painter François Gérard, that his figures had been irreparably spoiled by a heedless technical experiment:

> It occurred to me to mix into my colors enough olive oil so that my large figure, which I finished six weeks ago, and the small one, finished for a fortnight, are as wet as if I had just completed them yesterday, the upshot being that both of them have to be completely repainted from head to toe. What's more, none of the background, which I'm changing everyday, is settled. . . . I have no idea whether I can continue to the end of it.[5]

He does not say precisely what he was after in this (to say the least) unorthodox procedure: perhaps he imagined that the olive oil would offer a certain desired degree of translucence while lending to the finish a useful overall cast of color; he might well have been seeking to encode the thematics of eternal youth into the very matter of the thing, building a permanent appearance of freshness into the surface so that it might always appear to have just left the easel. In the end, as he reports, he was left with no option but to scrape his sodden handiwork from the canvas, leaving himself with little more than a month to redo the painting, with its life-size figure, virtually in its entirety.[6]

Whether despite or because of the pressure, he found a way to fashion an astonishingly seamless skin of paint, one in which virtually no evidence of correction or indecision can be seen. The layering of who knows how

many tinted glazes transformed hue into a crepuscular twilight of tonal painting. This gay artist, only twenty-four years old, then saw his success ratified in scores of canvases created by other painters, who transformed the type of male beauty that he had synthesized into an endlessly repeatable model. But that influence did not remove him from the outsider status in which he had begun his experiment. The languishing ephebes that appear so frequently in late Neo-Classicism are by comparison cookie-cutter figures, strangers to the embedded atmospherics in which Girodet's beautiful shepherd is suspended. As such, they lack any deepened sense of suspension – that Endymion's state of ecstatic excitation entails a living death, a sleep from which he can never awaken – an effect that depends upon the stilled, amber-like medium through which the body is made visible.

Bleckner has made two remarks about his own work that are apposite to Girodet's painting as well. In one interview, he mentions a preoccupation with "breaks in how representation is coded," which prompts him to add, "I think things shine with their maximum brilliance just at that point that they're about to die."[7] That could as well be said of the idealist premises of Neo-Classicism faced with the test of the French Revolution; from Girodet's drive to resemble no one came a final burst of confidence in the perfected male nude as the fundamental law of art. And the formula applies equally within the thematics of the painting, to the shine on the face and torso of Endymion, which is both the aspect of the ravishing goddess and a glowing aura that radiates outward from the body. The figure, suffused as it is with narcissistic identification between painter and work, was not only a bid for recognition but patently a bid for love, a crystallized desire for desire. Again Bleckner can speak for his predecessor: "If these paintings one day bring me love it will have been what they mean. If it doesn't they will have failed me at the deepest level."[8] Or, as he later glossed this statement in a way that leavens its solemnity, "When I'm with someone I think of my paintings as love letters. When I'm single, I think of them as Personals ads."[9]

* * *

Picasso spent the better part of his career producing pictures that commanded love from those around him; to implore and to hope has not in the past been a recipe for success. The *Endymion* is an early, if not the first instance of a failed modernism. Like the austere and stringent Classicism of his teacher Jacques-Louis David, the painting was born from a moment

of social revolution and anxious self-consciousness, which forced critical questioning and emboldened individual talents to manifest new qualities of feeling in their work. But its technical and conceptual density made it unrepeatable by others; it sacrificed breadth of thematic and expressive possibilities for depth in a certain emotional and sexual register; its quality of finish was too heterodox amid more conventionally prosaic approaches to paint handling, too redolent of the luxury object and private gratification. To begin to catalogue subsequent failures of a similar kind – or better, lines never followed – would be to build up an alternative history of modernity in painting. And a rough survey of that emerging field highlights how frequently the surface of the painting figures as an insistent, unsettling third party in the contract between image and viewer.

There are many ways, for example, that Goya might belong to such a history, but the most unclassifiable of his paintings are perhaps the series he produced on tin plate in the early 1790s, almost contemporaneously with Girodet's *Endymion*. These were the first outcome of the famous crisis that overcame him in 1792: the fall of the French monarchy turned Spain sharply to the Right and threatened his patrons in the liberal intelligentsia, while he suffered the nearly fatal illness that left him permanently deaf. During his recovery, he took up painting from his imagination on metal, a medium that belongs to a cheap, vernacular tradition. In his own state of fear and isolation from regular communication, he used its smooth and resistant surface to create shadowy allegories of catastrophe and desperation; the flattened pentagon of brilliantly white light that flares above the wall in his *Yard with Lunatics* (pl. 38) belongs only to that surface and sheds next to no illumination on the human misery below.

The archaism of the metallic would find its late reflected glory in the rebellion of the Vienna Secession at the close of the next century. Gustav Klimt, his soaring official career in ruins after the outraged rejection of his university murals, turned to the patterned gold embellishment of Byzantium. His subsequent allegories from myth and the Bible, with an indifference to the boundary separating fine art from luxury craft, returned painting to the status of ritual object in a modern cult of subjectivity divided between erotic and aggressive compulsions (pl. 39). His project – and his paying career as a portraitist – found support largely among a Jewish elite, whose members were themselves being forced more and more to the outside in a political culture misshapen by demagogic anti-Semitism.

At the same time in America, in a movement that borrowed the name Secession, similar boundaries between fine and applied art were likewise being confounded in photography. The pictorialism of Edward Steichen

122

38 Francisco Goya, *Yard with Lunatics*, 1793–4. Oil on tinplate, 43.5 × 32.4 cm. Dallas, Meadows Museum, Southern Methodist University, Algur H. Meadows Collection.

and others deployed processes that turned the surface of the print into a malleable coating that could be built up manually by brushing on layer on layer of pigmented, photosensitive gums. These methods obscured depth and clarity in the service of suggestive nocturnes, the floating lights against dark silhouettes with which they turned their subjects into occasions for reverie and emotional projection (pl. 40). No modernism is now more discredited than this one, with its ambition to encompass and surpass painting, particularly Symbolist abstraction, preserving a refined pictorial sensibility through the glamor of up-to-date technology. And none, therefore, has probably been more worthy of Bleckner's generous embrace.

Just to list these cases of discarded modernisms is to grasp how much his art has gathered up their persistent features after the collapse of the old

39 Gustav Klimt, *Judith and Holofernes*, 1901. Oil on canvas in integral metal frame, 84 × 42 cm. Vienna, Oester-reichische Galerie.

40 Edward Steichen, *Nocturne, Orangerie Staircase, Versailles*, 1910. Pigment photographic print, 31.75 × 40 cm. Buffalo, New York, Albright-Knox Gallery. General Purchase Funds, 1911.

mainstream. It is also to see how regularly an insistent surface skin recurs in this fitfully appearing, alternative history of the last two hundred years: the third element that, as he himself puts it, "had to be constructed within the relationship of the spectator to the painting because it wasn't in the painting and it wasn't in the spectator."[10] It would be right to say that it is through his surfaces that this history has come to him rather than the other way around. They will tend by themselves, as in the past, to prompt an artist toward such motifs and themes as lunar reflections (*God Won't Come* [pl. 33]), disembodied flares in the dark (*Delaware* [pl. 34]), Byzantine domes of metallic tesserae (*Architecture of the Sky* [pl. 35]), or decayed beaux-arts nocturnes (*Fallen Summer* [pl. 36]).

* * *

125

Two factors nevertheless bind Bleckner to his own time. From within the realm of art, a once-dominant progressive consensus has given way to an historical consciousness that makes all these marginalized possibilities simultaneously available. From outside, and with an incomparable gravity, has come in the early 1980s the eruption of death as a daily fact of existence among young and middle-aged gay men. The morbidity, dread, erotic danger and compensatory aspiration, all encoded in the history of bypassed modernisms, suddenly possessed a public contemporaneity that spoke to the failure of the progressive project in science and politics when confronted with the new plague. In terms of the fragility of the body, that was enough to erase the interval separating the painter of postmodern New York from the pictorialist photographers of the city at the turn of the century, to return to conditions that prevailed before antibiotics, strict hospital sanitation, and most vaccines; when the mass killing of the Civil War was a fresh memory; when a general, unpredictable peril to life was assumed in the culture, and the black of Victorian widow's weeds was an everyday sight.

Bleckner directly evokes that era in the ornamental emblems that figure in his paintings: the chandeliers, candelabra, trophies, urns, statuettes, brocades, and flowers. Their prototypes were of a piece with the somber current in vernacular culture at the end of the last century: spiritualism, melodramas, the laments and ghost ballads of popular song, with which people came to terms with the familiarity of death at any age (archaicizing vernaculars like traditional country music preserve some of this). These were motifs with which the photographers were equally at home. Steichen's 1910 *Nocturne, Orangerie Staircase, Versailles* (pl. 40) reduces the north wing of the palace to a distant celestial vision (bearing the simultaneous overtone of a floating wedding-cake), guarded by a sentinel urn in black silhouette against the gloom, a ghostly set of steps hovering in the void to the right. In light of such comparisons, the general affinities broached above between Bleckner's art and the material character of the photographic print acquires some greater specificity. The Pictorialist gum print was a hybrid, thickened variant of the normal microscopic layer of metallic deposits on paper: the image expands and hardens within the layer of pigment between paper and finish. If it were invented today, it might well be classified as painting, but it would be a mode capable of absorbing a wide variety of imagery without hackneyed sculptural effects or collage appropriations.

It was the changing circle of Alfred Stieglitz, after having transformed European Pictorialist approaches for an American audience, that then

went on to do the same for European avant-garde painting and Dada provocation. Stieglitz's 291 Gallery prepared the ground for the impact of the 1913 Armory Show. His second initiative eclipsed his first; painting took over as the pre-eminent medium in advanced American art and enjoyed a run of fifty years, before losing coherence and confidence in the mid-1960s. To recover key terms of the practice of the Pictorialists, in the wake of that collapse, is in effect to return to the state of a nascent American abstractionism before the Armory Show, when the permitted range of serious practice had not been so narrowed and codified.

Over the last thirty years, nearly every major turn in advanced art – from the Minimalist object to the abject scatter piece – has announced itself as a defiance of demands for wholeness and integrity of form; each therefore required a strong precursor against whose claims to coherence and self-sufficiency the new might be measured. No mode of art was more easily cast in this role than painting, which has passed from being a term of technical description into a shorthand code for an entire edifice of insti-tutional domination exerted through the collector's marketplace and the modern museum.

Interests of drama and publicity have best been served when that arrogant strength imagined in the precursor has simply been asserted and never actually probed and tested. The aesthetic idealist perceives a grand continuity "from Altamira to Pollock";[12] the postmodernist critic counters by declaring that "painting" was an invention of bourgeois hegemony, the pretensions of which now collapse in the face of mechanical reproduc-tion.[13] The effect of such confidently sweeping pronouncements has been to inflate temporary uses of the medium – limitations as well as competences – into an invariable definition of the art form.

Temporary, when dealing with a practice of so ancient a lineage, may signify a century or more of its mainstream development. If painting has seemed to fall into eclipse, it may, in fact, be only one contingent set of possibilities that has failed. It follows that a subsequent return to the medium need not have resumed where the previous episode came to an end. Advanced painting in the West has left behind a secret, disconnected shadow of a history, a recoverable account of outsiders' predicaments and feelings, entirely sympathetic to the concerns of the critical postmodernism that has most disdained the medium.[13] Unless they are found through concrete practice in the studio, they run the danger of being again devalued and discarded just when they may be most necessary.

Part 4

Cities

41　Gordon Matta-Clark, *Day's End (Pier 52, Gansevoort and West Streets, New York)*, 1975. Cut in west wall in process.

8

Site-Specific Art:
The Strong and the Weak

The young sculptor Gordon Matta-Clark was invited in 1976 to contribute to an exhibition at a New York architectural think-tank, the Institute for Architecture and Urban Studies. The title of the show was *Idea as Model*; among the participants were three high-profile architects from the so-called New York Five: Richard Meier, Michael Graves, and Peter Eisenman (who also served as director of the Institute), for whom highly refined drawings were then the most prominent vehicles for their work and reputations.[1] Matta-Clark, a student in architecture in the late 1960s, had established himself in the first wave of artistic occupation of the SoHo district in downtown Manhattan, where he became one of the key personalities in the initial formation of that artists' enclave. The values of the two communities – neo-modernist architects and process-oriented artists – clashed violently as his contribution took shape.

Matta-Clark's characteristic way of working was to cut away sections of walls and floors in existing buildings. This subtractive activity had in the main been unauthorized: Matta-Clark and his friends would scour the city for abandoned buildings in which to experiment, and he conjured from them a melancholic poetry of disgrace. The year before, he had carried out the most spectacular of his clandestine and dangerous operations, *Day's End*, in which he transformed a mammoth abandoned pier into a radiant and perilous cathedral for the few who managed to see it before the police arrived (pls. 41–3).

There were strong overtones of Surrealism in these works, which suggest a sentimental, though not unwarranted, link with his absent father, the second-generation Surrealist painter Roberto Matta. At the same time, however, he was attacking some highly current problems in sculpture, in particular how to defeat the effect of ornamenting a space, either in a

42 Gordon Matta-Clark, *Day's End (Pier 52, Gansevoort and West Streets, New York)*, 1975. Main cut in west wall, corner cut at top of photograph, floor cut below.

43 Gordon Matta-Clark, *Day's End (Pier 52, Gansevoort and West Streets, New York)*, 1975. View toward west wall.

gallery or a public setting. This preoccupation had led the older cohort of Minimalists to various heroic exertions, either of Zen-like renunciation, domineering scale, or defiant incoherence. Matta-Clark's procedure allowed him the liberty of a complex improvisation in composing his pieces, largely because he had defeated the need for sculpture to consist of any additional matter at all.

The *Idea as Model* installation was to be one of his first works in this

mode to enjoy the sanction of an institution, and would have been a relatively tame affair had it gone ahead as planned. His announced project, developed with the curator's approval, was to expose a limited, existing space by cutting out square sections of a seminar room clad in windowless sheetrock, opening it up to the rest of the building; the removed pieces were to be stacked inside the room. His cutting would have taken its place alongside a variety of architect's models, some of them already highly conceptual and subversive of normal structural coherence. But late in the process of installing the show, he arrived armed – literally – with another conception, one which put in the foreground his own activist concerns with housing conditions for the city's poor. In each available window casement of the Institute, he placed a photograph of a new housing project in the Bronx in which the windows had already been broken out, vandalism being for him the damning imprint of social reality on all such managerial schemes advanced by the architectural profession. Presumably alert to the trap of the photographs amounting to one more discovery of the picturesque in a decaying cityscape, he secured the worried permission of the organizer to break a few windows that were already cracked. But in the event he shot out every single one with a borrowed air rifle.

The destruction took place at 3 a.m. The organizer confesses to having been as shattered as the glass; the fellows of the Institute were outraged when they arrived some hours later; Eisenman was said to have been incensed enough to liken Matta-Clark's action to the Nazi Storm Troopers on Kristallnacht;[2] the glaziers were called in and the piece eradicated by the end of the day.

If Eisenman indeed did say this, he was himself guilty of a disagreeable slander and an unearned presumption of absolute innocence, and one hopes that he repented it later. This is not to say that Matta-Clark's action was less than reckless with the safety of other people in the vicinity; and the results were plainly intolerable, as he would have known, from the point of view of safeguarding the visitors and exhibits in the show. Nor did the action escape from a certain urban picturesque, in that the shooting simply mimicked the despairing delinquency behind the endemic vandalism in the city while perpetuating a hackneyed notion of the artist as romantic outlaw. But because Matta-Clark would have known that the imprint of his action would be extremely short-lived, one should not repeat Eisenman's mistake and consider the piece only in the sudden violence of its inception. The eradication of the piece, which amounted to an instantaneous summoning of resources to repair the damage, actually completed it. The critical point was neatly made, with greater power than any

polemic, because its immediate object was made to act it out in a state of unreasoning panic: if this deterioration was intolerable for even a moment at the Institute for Architecture and Urban Studies, why was it tolerable day in and day out in the Bronx?

Alongside this unanswerable query, *Window Blowout* posed some lasting questions concerning the practice of site-specific sculpture. The champions of Minimalism in the mid-1960s had put forward the idea that the spectator's experience of sculpture should entail awareness both of the real time of the encounter and of the physical and institutional spaces in which it had been installed. But no actual trajectory of time was built into the installation of a Dan Flavin or a Carl Andre, in that their conception did not presuppose any necessary ending. For that reason, the experience of the work remained a matter of voluntary introspection and self-awareness on the part of the sensitive, well-prepared spectator, just as it had been under modernism's regime; the philosophical terms of phenomenology simply replaced those of modernist metaphysics.[3] The beholder's traditional role remained as central as it had ever been.

Matta-Clark's work, on the other hand, proposed an altogether stronger conception of the site-specific piece, one that finally threatened to depose the imperious beholder, however physically energetic or full of interpretative ingenuity. His sculpture tended to leave so minimal an imprint on the world that it precluded fixation on formal particulars by the simple measure of barring most of its interested audience from ever seeing it. As the choreographer Trisha Brown said about his key site interventions of the 1970s, "I can't remember the difference between the pieces I saw and what I heard about. . . . I didn't ever see the house split in half [pls. 44, 45]. The pier – it was covered in security guards by the time I got there."[4] This is a consummate insider of the SoHo scene speaking, someone who at times staged her own pieces in settings provided by his sculpture, and she is evoking what are among the handful of his truly major works. If she cannot claim the beholder's share, who can?

* * *

From these considerations emerges a definition of strongly site-specific art as opposed to the weaker variant that perpetuates the half-measures of Minimalism. The actual duration of the strong work is limited because its presence is in terminal contradiction to the nature of the space it occupies. Contradiction is the source of its articulateness, so brief duration is a condition of meaning and is presupposed in its founding stipulations. If the

44 Gordon Matta-Clark, *Splitting*, 1974.

piece could persist indefinitely, the contradiction is illusory. The overt
confrontation of *Window Blowout* is only one way to bring this about
(what might have been a further disciplining of Matta-Clark's project was
sadly cut short by his unexpected death from cancer in 1978). Among
sculptors of the same generation, no one has accepted and worked within
those terms more completely than Michael Asher, who has developed his
project in a way that has been free from virtually any hint of romantic
posturing.

Among his early works, the installation that perhaps bears the closest
resemblance to Matta-Clark's assault on the Institute of Architecture and
Urban Studies was a relatively quiet affair constructed in 1970 in the
gallery of a small private college in southern California (Pomona in
Claremont).[5] It took the form of a complete alteration of its interior
architecture with temporary walls of studs and sheetrock and a lowered
ceiling (pls. 46, 47). Two connected rooms of conventionally rectangular
shape were occupied by a parasitic interior in the configuration of a
slanted hourglass. The only light in this new interior came from the door,

45 Gordon Matta-Clark, *Splitting*, 1974. Interior detail.

46 Michael Asher, untitled installation, 1970. Claremont, California, Pomona College, Gladys K. Montgomery Art Center Gallery. Entrance.

which was overlaid with a new woodwork frame that kept the gallery entrance open around the clock; it could not be locked or even closed.

Asher reproduced the classically pristine, white-walled gallery to the point of fetishism, but the very being of the gallery was cancelled by its space being perpetually exposed to the outside world. An infinitely larger space invaded and absorbed the volume of the gallery; the narrow waist and the darkness of the second room dramatized the fact that all its light was provided by the external environment. In its simple gestalt, the installation was like a Minimalist object turned inside out, but the open door interrupted phenomenological inquiry into space, perception, and bodily presence, that is, the activity that had so intrigued the admirers of Minimal sculpture. Asher disrupted that investigation with a *picture*, because, framed by the entrance, was an idyllic landscape, a well-watered lawn in the desert, studded with palms and eucalyptus, adjoining the house of the college president (pl. 48). For this picture to work, within the terms of the

47 Michael Asher, untitled installation, 1970. Claremont, California, Pomona College, Gladys K. Montgomery Art Center Gallery. View from outer compartment toward inner one with axonometric drawing showing artist's structure in light lines.

48 Michael Asher, untitled installation, 1970. Claremont, California, Pomona College, Gladys K. Montgomery Art Center Gallery. View outward toward street.

piece, it had to have been produced by a method that was impeccably abstract and anti-illusionistic; and so it was. But its figurative vividness was just as intense. It hovered before the visitor as an enclosed synecdoche of all the conditions that made it possible for such a work to exist, most of all the unreal safety and privilege of the environment, so unlike the threatening outside world to which Matta-Clark would later seek to expose the admirers of advanced architecture in New York.

Asher's sculpture of course no longer exists, and the expectation of non-permanence was built into its conception. As long as his installation was in place, the space could not function in any other way; all of its residual spaces were sealed off and enclosed in darkness; no normal security was possible in Asher's version of public space. If it had been given a permanent place out of the way somewhere, if it were no longer disfiguring anything, it would no longer be the work it was. A useful point of comparison exists in Walter De Maria's *Earth Room* of 1968, preserved in perpetuity by the

Dia Foundation in a SoHo loft with opening hours and an attendant sitting at a desk to admit the infrequent visitor. That installation serves as a monument to phenomenological preoccupations – it will be available indefinitely to make its claims on the beholding subject – but its lack of any knowable ending, the absence of any other, impinging claim on the space, makes it seem dead, a leftover from another, irretrievable time. The significance of the original act dissipates if one need not imagine its conclusion.

Asher, for his part, has kept to the premises he established in 1970 and has ventured beyond such protective surroundings. In 1979 he used an invitation from the Chicago Art Institute to address a heavily used urban space.[6] Again the piece functioned around an incident of old-fashioned figuration at the entrance to the space, in this case the main entrance to the museum itself. At the top of the steps leading up from Michigan Avenue (the extended artery of Chicago's commercial center) facing down Adams towards the heart of the financial district, stood a bronze replica of Houdon's standing portrait of George Washington (pl. 49). Asher's intervention, if conducted clandestinely, would have been a more serious act of vandalism than *Window Blowout*. He directed that the statue be removed from its normal location and planted inside the building in the Institute's eighteenth-century French gallery (pl. 50).

This simple remapping of the museum's holdings had the effect of instantaneously altering the nature of the sculpture. In the midst of major paintings from the canon of art history, by artists of the order of David, Greuze, and Hubert Robert, it assumed a comfortable appropriateness, lending the museum the major Houdon it lacked – or so it would have seemed to the ordinary visitor. Yet the object was an impostor by every real criteria of belonging in this context; it is a copy in another medium, made in 1917, of a marble original dating from 1788. The statue concentrates in concrete form an entire history of American civic culture fashioning itself on borrowed European models, dating to Houdon's own trip to Virginia to model the likeness of the first president. That itself had been an actualization of Enlightenment dreams of patriotic heroism in the mode of antiquity. By virtue of the installation of the replica inside the museum, the visitor was invited to contemplate the history of the ground on which he or she stood in the same moment as contemplating the history entailed in the wealthy Madame Pastoret depicted by David wearing a simple gown in the antique manner as a mark of sympathy with the Revolution. As in the Pomona College piece, Asher contrived to fold the exterior of the institution into its interior, using the coincidence of form

49 Michael Asher, untitled installation, 1979. Art Institute of Chicago. Bronze copy of *George Washington* by Jean-Antoine Houdon at entrance.

50 Michael Asher, untitled installation, 1979. Art Institute of Chicago. Postcard available to visitors showing new placement of *George Washington* by Jean-Antoine Houdon in gallery of eighteenth-century French art. Caption reads:

THE ART INSTITUTE OF CHICAGO, Gallery 219

The replica in bronze of George Washington, 1788, by Jean-Antoine Houdon originally in front of the Michigan Avenue Entrance, can be seen in the foreground of this gallery. It was installed in an 18th century context by Michael Asher as his work in the *73rd American Exhibition* (June 9–August 5, 1979).

photo by Rusty Culp

between the replica and the absent original as the anchoring point to secure that reversal.

That anchoring remained subject to an unendurable strain: the weight of institutional habits and interests would always want to pry the replica away from the ghost of the original, whose place it had temporarily usurped. After a certain amount of time, despite the enlightened curating by James Speyer and Anne Rorimer which permitted the transposition, its presence in the gallery would gradually have become intolerable. Asher was able to make art out of the civic monument only at the price of its cancellation and therefore inevitably brief duration.

* * *

The phrase "site-specific," for so long restricted to the vocabulary of specialized criticism, finally achieved general currency during the 1980s in connection with a work of very different temporal ambition. This was Richard Serra's public sculpture in lower Manhattan, *Tilted Arc* (pl. 52). Serra had achieved his first prominence at around the same time as Asher with his "propped" sculptures in rolled and sheet lead. These used the sheer mass of the material to achieve a temporary stasis, their elements leaning against the walls of whatever gallery they were installed in (or, as in *One-Ton Prop* of 1969, supporting one another in a free-standing arrangement [pl. 51]). From these beginnings he went on to forge a flamboyant career as a sculptor in public spaces, adapting his practice to monumental sheets of Cor-Ten steel, anchored in concrete but often composed in such a way as to mimic the provisional appearance of his earlier pieces in propped lead.

Tilted Arc represented something of a culmination of this direction in his work. In a generous program of support for sculpture begun by the American federal government in 1972, entitled "Art-in-Architecture," its building projects were allowed to set aside one half of one per cent of their budgets for public art. In 1979, under the Democratic presidency of Jimmy Carter, Serra was awarded a commission for a work of monumental dimensions at the center of Federal Plaza in New York, a space enclosed within a complex of court and government office buildings occupying Foley Square. The location was one of conspicuous visibility and symbolic importance; not only was it the principal site of federal authority in the city, it was hard by the nerve centers of downtown artistic culture in SoHo and Tribeca and therefore a local monument to artists and other opinion leaders in that community.[7] The work would thus be guaranteed to come under extraordinary scrutiny in both its civic and aesthetic manifestations. Serra responded to the challenge with a gently curving sheet of Cor-Ten (which develops a patina of rust as protection against further corrosion), 120 ft long by 12 ft high, slanted slightly inward, with its convex face toward the street. Workers and visitors to the courthouse and office buildings on the plaza found their normal approaches blocked by the full length of the work.

Serra's first experiments with sculpture on this scale had, in fact, taken place in close proximity to Asher's Pomona College site in the months just before that piece was conceived. In 1969 Serra had been working just down the road at the works of the Kaiser Steel Corporation at Fontana, California. In the preparations for the *Art and Technology* exhibition at the Los Angeles County Museum, he had been invited to use the facilities of the

plant to make art. The level of technology was not in this case particularly high: by refusing to modernize its equipment, Kaiser was already losing out to more competitive manufacturers in Japan (to whom it was suicidally selling raw materials at the same time).[8] The "technology" component of Serra's pieces comprised nothing more complex than the magnetic cranes used to shift large pieces of metal around the plant. In this series, collec-

51 Richard Serra, *One-Ton Prop*, 1969. Lead antinomy, each piece 121.9 × 121.9 cm. Bochum, Germany, Galerie *m*.

tively entitled *Skullcracker*, Serra transferred the precarious structural principles of leaning and propping from the scale of a gallery to a monumental one, by stacking up slabs of unused iron and steel. He has since cited these temporary arrangements as the beginning of his thinking about sculpture on an urban scale.[9]

His initial efforts in the *Skullcracker* sequence were almost immediately destroyed by workers on the later shifts, and none of them could, in the end, be permanent. But this curtailed duration did not arise from the sort of considered site-specific character exemplified in Asher's or Matta-Clark's work; that is, it does not seem to have entailed any effort to clarify the site or the circumstance of the art occurring within it (for example, that a plant working to full capacity would probably not have afforded him the room he was using, so the occasion itself was an aspect of decline). The impermanence of the various pieces has, in fact, led him to disqualify them as public, judging their setting to have been "basically a studio situation which happened to be in a steelyard."[10]

In his subsequent career as a sculptor in outdoor, urban spaces, Serra has sought the same sort of continuous, unchanging visibility that characterizes his museum installations.[11] In what must have been a deliberate reference to Matta-Clark, he once declared, "I wouldn't go to a leftover, picturesque pier."[12] Such a location would be difficult to find or approach, and Serra has increasingly sought sites for his work where it would not – could not – be missed.[13] Further, he has been concerned to frustrate any search for links between the piece of sculpture and the given character of its setting, thus achieving a precise and unrelieved *non*-relation to the site, as the only means by which sculpture can be salvaged as a meaningful activity. Otherwise sculpture falls into what he regards as the intolerable position of "being subordinated to/accommodated to/adapted to/subservient to/ required to/useful to . . ." something other than itself.[14] Instead, his ambition has been that each public piece cause its surrounding space to "be understood primarily as a function of the sculpture," and not the other way around.[15]

Serra's moves into outdoor urban spaces have not then entailed any fundamental change in the demands his sculptures make inside a gallery; the overbearing scale and intrusive placement of a *Tilted Arc* was planned to enforce the same concentrated attention in a passing, non-committal audience as that habitually exercised by informed gallery visitors. What was new in his public work was the vastly enlarged perceptual space that sculpture has tried to govern. Rosalind Krauss, the artist's ablest explicator,

52 Serra, *Tilted Arc*, 1981. Cor-Tcn steel, 3.66 × 36.6 × 0.064 meters. New York, Federal Plaza. Destroyed 15 March 1989.

gave this account of how *Tilted Arc* prompted in the spectator a recognition of "vision's intentionality":

> ... this sculpture is constantly mapping a kind of projectile of the gaze that starts at one end of Federal Plaza and, like the embodiment of the concept of visual perspective, maps the path across the plaza that the spectator will take. In this sweep which is simultaneously visual and corporeal, *Tilted Arc* describes the body's relation to forward motion, to the fact that if we move ahead it is because our eyes have already reached out in order to connect us with the place to which we intend to go. Like vision, its sweep exists simultaneously here and there – here where I am sited and there where I already imagine myself to be.[16]

This passage of specialized phenomenological interpretation comes, however, from no learned article or seminar but instead formed part of Krauss's expert testimony to the special judicial hearing called in 1985 to decide the future of the work. The result of Serra's desire indefinitely to perpetuate this perceptual abstraction of space had caused the nature of the site to shift drastically beneath the sculpture, a change that set some brutally objective limits on the pertinence of her words.

In the years between the commissioning of *Tilted Arc* and its installation, the political landscape had altered. The arrival of a right-wing Republican administration doubtless emboldened two conservative bureaucrats, who immediately began agitating for its removal. Predictably enough, they claimed to speak on behalf of the ordinary men and women who worked in the office buildings and used the plaza. Wrapping themselves in populist righteousness, they attacked Serra's work as the product of an entrenched, self-interested minority culture brutally indifferent to the needs of the average individual; only by taking it elsewhere could the plaza be restored to its restorative function as a site of shared outdoor relaxation and agreeable pedestrian passage.

Serra's defenders were correct to point out in reply that this picture of the previous life of the site was largely a tendentious fiction: prevailing winds, for example, tended to turn the fountain (when working) into an annoying shower covering a large area of the plaza; it had always been a space in which few were inclined to linger. But the negative case proved to be impervious to empirical challenge. Commentators who should have known better were only too ready to frame the discussion in terms of a caricatured opposition between the elitists and the people.[17]

In this posture of defense of the average man and woman, there was as always a decidedly elitist presupposition about what such people can

and cannot absorb. The same sort of thinking produced the absurdly superfluous statues installed at the entrance to Maya Lin's contemporaneous Vietnam Veterans Memorial in Washington, added in response to the same sort of protests that uncompromising abstraction insulted the interests of ordinary visitors. It has since become obvious that Lin's abjuring of illustrative embellishment in favor of simple shape, the orchestration of movement through the site and the serial accumulation of engraved names (all of which come directly out of the advanced art practice of the 1960s and 1970s) exactly corresponds to the emotional needs of the "average" mourners.

While no comparable affective bond would have been possible with *Tilted Arc*, those ordinary passers-by who might have discovered some worthwhile apperceptions in the sculpture were denied any comparable means of demonstrating the fact. The petitions against it were obviously unrepresentative, orchestrated by the self-appointed defenders of popular virtue, and Serra was rightfully compelled to resist their attacks with every resource at his command. The requirements of that defense, however, exposed a gap in his general conception of the site in site-specific art. He was seeking to protect the possibility of a certain experience and a certain form of rarefied self-examination. Krauss has expressed it in a way that seems entirely congruent with the artist's repeatedly stated ambitions:

> How one enters and where one leaves is variable; but all trajectories live in the indissoluble marriage of the spatial with the temporal, an experience which, if we can live it intensely enough, brings us to the preobjectival condition for meaning. . . . The specificity of the site is not the subject of the work, but – in its articulation of the movement of the viewer's body-in-destination – its medium.[18]

But the very conditions that guaranteed the heightened visibility of *Tilted Arc* instigated changes in its medium that exposed the arbitrary limitations inherent in Serra's conception of it. And despite the artist's best intentions, the full historical complexity of the Federal Plaza did indeed become the subject – not the malleable medium – of the work.

His best hope of saving *Tilted Arc* was to make his argument in the courts on constitutional as well as contractual grounds. Having described his sculpture as endangered by the state, on account of his refusal to affirm the legitimacy of any form of political power, Serra found himself appealing to another part of the state to act as his protector on the grounds of free speech and the moral rights of artists.[19] The trap that he created for himself was that, had his suit been successful, *Tilted Arc* would have

become a permanent monument to the virtues of the American judicial system. Though the final dismantling of the work in 1989 was a victory only for the corruption of democratic procedures, its survival would have entailed an implicit contradiction of his intellectual premises, that is, his resolute intention to affirm nothing beyond the psycho-physical experience of sculpture.

The physical extinction of *Tilted Arc*, however, has allowed it to fulfill the same conditions of meaning established in the work of Asher or Matta-Clark. Serra's sculpture came to organize and clarify its context by refusing – albeit involuntarily – traditional forms of permanence and monumentality. New York's Federal Plaza remains as transformed by his art as he ever dreamed it would be: as long as the shared memory of the trauma of the sculpture's removal remains, the site can be seen in no other way than as deficient, as subracted-from. The only vocabularies in which *Tilted Arc* can now be grasped are ones adequate to account for the historical events and conflicts that surrounded it. Large questions concerning the relations between public symbols and private ambitions, between political freedom, legal obligation and aesthetic choice, have been put vividly and productively into play by the work, engendering debates that might have remained abstract and idle had it not existed – and which might have been complacently put aside had it gone on existing.[20]

9

Profane Illuminations:
The Social History of Jeff Wall

Crossover between the studio and the seminar room has been a conspicuous feature of advanced practice over the last fifteen years. Since the 1970s, informed discussion about art has turned for ideas and language to the vanguards of established academic disciplines like anthropology and literary studies, the ones most receptive to the style of thinking pioneered by Lévi-Strauss, Barthes, Foucault, and Derrida. In part because art training has become more closely tied to universities or to conceptually orientated programs like that of the California Institute of the Arts, a new generation of artists has been ready to absorb the practical implications of the new critical regime with little or no delay.

But what can one say about the other, parallel development in the study of art within the academy: the strong emergence over the same period of (for want of a better term) a social history of art? Here any passage from college classroom to studio has been much less obvious: the kinds of erudition generated by wide-ranging historical inquiry have been resistant to being codified in ways that suggested immediate practical applications and rewards. If there was to be any transition between new forms of historical awareness and new moves in art, it would necessarily be more deliberate and complicated.

Only a few artists can be said to have bridged the two pursuits, and prominent within this small group has been Jeff Wall. Compared to the legion of artists who have taken their bearings from poststructuralism, Wall for years received strikingly little attention in English-language criticism. While this was balanced by substantial coverage in European journals, his comparative neglect may be one further sign of the difficulty that the topic of history poses for certain critical orthodoxies. His accumulated work over a decade and a half testifies to the potential of social-historical

151

inquiry to motivate persuasive work in the studio, and also to some of the limiting conditions of the social history of art as it has actually been practiced in North America and Britain over the same period.

* * *

At the end of the 1970s, after a decade-long hiatus in his activity as an artist, Wall began his series of large, back-lit photographic transparencies, establishing a signature format he has continued to use for all of his work (pl. 53). In their exploitation of the existing conventions of film still and popular photo-roman, they bear a resemblance to the contemporaneous work of Cindy Sherman: in a few the artist himself likewise becomes the subject. But the overbearing scale and brilliant projection of color in Wall's pictures are only the most obvious markers that distinguished his project from hers. While Sherman has lately found her way

53 Jeff Wall, *Picture for Women*, 1979. Cibachrome transparency, fluorescent lights, and display case, 163 × 229 cm. Paris, Musée National d'Art Moderne.

back to overt art-historical reference in her photographs, Wall began with it; while she has taken art history to be a fixed catalogue of masterpieces to be interrogated and turned inside out by the artist, he situated himself within the processes by which art history as a changing field of knowledge becomes available to the artist in the first place.

Wall has forthrightly declared in a recent interview that "none of my work could have been done without the turmoil in art history."[1] He spent a significant part of the 1970s, his period away from art-making, pursuing a postgraduate degree in the discipline at the Courtauld Institute in London. Since then interviews have shown him to be at ease with learned citations from the art of the past, and he has explicitly likened certain of his works to canonical paintings going back as far as the seventeenth century. But this kind of general expertise does not point directly to the deeper involvement of his art with an historical enterprise. Nor does the subject matter of his thesis research, which ranged from Berlin Dada to Duchamp. What seems to have mattered most for his return to practice – and his proposing grounds for a non-trivial return to figuration – was the changed value that social historians were beginning to give to subject matter in the French painting of the immediately preceding period, from Courbet to Post-Impressionism.

It was, in particular, this newer research into French modern-life painting that was exposing a sharp and unsustainable divide in the intellectual assumptions of the discipline – and was thus creating the turmoil in question. As modern art had been admitted to serious attention by academic art historians, largely after World War II, it had arrived already wrapped in modernist packaging. Michael Fried was only sharpening a general assumption when he asserted in 1965 that "the history of painting from Manet through Synthetic Cubism and Matisse may be characterized in terms of the gradual withdrawal of painting from the task of representing reality – or of reality from the power of painting to represent it. . . ."[2]

This was a view implicitly shared by many others in the field who lacked Fried's express commitment to searching out a pedigree for 1960s color-field abstraction. And it meant that there could be no systematic iconography for the art of the modern era. The formal preoccupations of a Wölfflin could be transferred easily enough to the nineteenth and twentieth centuries, but this was not the case with Warburg's or Panofsky's systematic parsing of traditional subject matter. The latter mode of inquiry had been underpinned by centuries-old symbolic systems of religious emblematics or princely allegory. After artists had consciously rejected such governing orders, to what system could the interpreter reasonably

appeal beyond contingent personal histories or the technical parameters of art?

The perceived radicality of social art history was paradoxically traditional in its actual challenge to this complacent bifurcation of history; it simply insisted that there was no reason to stop applying iconographic concerns at any juncture. Had societies at any point ceased to be governed by symbolic codes? Were there grounds for believing that artists were any more free from the power of these codes than the rest of humanity? Obviously not, but the symbolic life of a secularized social order, one continually subject to drastic transformations in its economy, demographics, and communications, was going to be more hidden and transitory – and that much harder to describe.

The territory needed a map, and art historians availed themselves of three basic kinds. The first was as literal as could be: the complex physical and social geography of Paris was exploited as a master code for grasping the seemingly opaque or incongruous iconographic choices of the avant-garde that clustered in the city from the 1850s to the 1880s. So much that seemed wilful and unexpected in that iconography could be matched to the actual dislocation and provisional reconstruction of the city under Baron Haussmann, and "Haussmannization" became a talismanic word for a generation. The second was that same geography but as specifically filtered through the imagination of Charles Baudelaire, identified as the great prophet of modernity, then filtered a second time through the imagination of Walter Benjamin's reading of Baudelaire. The third was derived from one outcome of the attempt, in the uprisings of 1968, to remap the city from below. During the following decade the British journal *Screen* took its lead from French theory in the project of linking a Marxist critique of ideology with a poststructuralist account of the formation of subjectivity: sharing many of the same sources and ambitions, the most sophisticated wing of social art history had by the early to mid-1970s extended its theoretical horizon beyond the Frankfurt School to become adequately conversant with the likes of Lacan, Althusser, Barthes, Foucault, and Irigaray.

The last map was the one that most powerfully underwrote attention to subject matter as primary, doing so by its ability to place the iconography of advanced nineteenth-century art under a negative sign. Canonical examples of liberated technique, such as Delacroix's *Death of Sardanapalus* and Manet's *Bar at the Folies-Bergère*, could be situated beyond the standard accounts of adventurous colorism, abbreviated description, and expressive handling of the brush, beyond even preoccupations with the

154

artist's individual sexual psychology. Instead they were to be seen primarily as symptomatic instances of structured sexual positioning – fantasies of male visual control as indulged in the former, or interrupted in the latter – potentially generalizable to the culture as a whole. And it was with this last map that Wall began at the point of his return to sustained studio work and from there proceeded backwards through the other two, as often as not in advance of their full realization in the writing of academic social historians.

* * *

Among his earliest large transparencies are two that took up the challenge of precisely these monuments by Delacroix and Manet. *Picture for Women* of 1979 (pl. 53) found its point of departure in the latter. The lines of bare bulbs in the studio echo Manet's globular lamps in a perfect diagram of Albertian perspective, the window frames and the two symmetrical lamp standards chart the artist's translation of depth into a functional linear grid (that being the stable order permitting the *Bar*'s multiple violations of unified illusion). Studio space and mental map become one. The flanking standards, which rise out of the frame, also edge male and female to the wings of a central panel dominated by the camera as lens and recording device. The play with edges is a further formal homage to Manet, and, like the painting, it employs the effect of a mirror behind the model, finding a new purpose to that painting's unstable interplay between the spectator's centrality (as "seen" by the woman) and displacement (as "reflected" in the objective optic of the mirror). It revived this disparity in order to make concrete the fresh theoretical speculation then circulating around questions of male spectatorship and the complicity of both Renaissance perspective and the camera's technology in that regime.

Nor is the Renaissance evoked in an idle way. Wall's departures from Manet push the *Bar* into the most ritualized of painting's formats, the devotional triptych. As in the van Eycks' Ghent altarpiece, male and female take the positions of Adam and Eve flanking the all-seeing God, who constitutes them in sexual difference. While the Italian Renaissance theorized perspective in terms of the godhead at the vanishing point (as in Raphael's *Disputà*), the late twentieth century resorts to Lacan's Name of the Father. *Picture for Women* makes the two so entirely coincident that it becomes the task of the viewer to work out the actual distance that separates them. And all of this is saved for art, as opposed to clever illustration, by the thoroughly prosaic and contemporary character of

155

54 Jeff Wall, *Destroyed Room*, 1979. Cibachrome transparency, fluorescent lights, and display case, 159 × 234 cm. Original installation Vancouver, Nova Gallery (now Ottawa, National Gallery of Canada).

every detail, the consistency with which it appears to do no more than expose a working procedure.

The Destroyed Room (pl. 54), completed the year before, records an elaborately constructed tableau, arranged as an allegory of some disaster in a contemporary woman's life, keyed to the color and compositional order of Delacroix's fantasy of wholesale mayhem and murder. Though his prototype was far from Manet's urban naturalism, Wall subjected the result to the least pretentious mode of presentation he had used to date. The illuminated panel was first hung pressed against a street-level display window of a Vancouver gallery, housed in a nondescript commercial building. This entailed, to begin with, a modest acknowledgement of the identity between his lightboxes and the attention-seeking devices of outdoor advertising. Unprepared passers-by were doubtless arrested and perplexed by a vivid, momentary illusion of some enigmatic catastrophe in a place customarily reserved for brightly enticing reassurance. But like all temporary, site-specific pieces, this installation is as significant for the per-

manent idea it implanted as it is for the impression it may or may not have made on its limited original audience. It was the residue of grand historical painting as offered to and transformed by the vision of the random urban pedestrian. Delacroix rather than Manet was Baudelaire's idea of the consummate artist: *The Destroyed Room* is Delacroix under the gaze of the *flâneur* and his lowlife surrogates – the prostitute, street criminal, and derelict ragpicker. For each of them the violent tableau would hold distinctly different meanings.

Wall did not make a habit of this unexpectedly public mode of display, but he proceeded in his suspended narratives to work his own way through the inherited mythology of the *flâneur* as hero of modernity. Benjamin had called particular attention to disjunctive interplay in Baudelaire's poetry between the most aggressively common image and the most elevated allegorical abstraction. A direct counterpart to this attention in social art history was a turn toward those artists who combined a precision of urban typology with a certain pompous academic scale and compositional order. From this altered point of view, the stiffness and estrangement of ritualized leisure in Seurat were revelatory, as was "the unexpected desolation" present in the monumental street scenes by Gustave Caillebotte – the real discovery of that moment in scholarship (pl. 55).[3]

In the making of his intense, mural-sized transparencies, Wall found a plausible contemporary equivalent to the physical impact achieved by these artists, in his words, "a specific opposite to painting."[4] In the painstaking, finely detailed staging of his photographic subjects, he found a way to match their laborious deliberation over composition and technical refinement, all without descending into quotation or museum-bound revivalism. The analogy with film is unavoidable, but rather than making the more obvious identifications with director, cinematographer, or editor, Wall singled out the crucial but unsung role of the art director, the creator of the look of a film and the necessary master of every trick of illusion.

Even with its elaborately refined construction, the illuminated transparency might have remained a remote metaphor for *flâneur*-academicism had not Wall constructed thematic parallels to Benjamin's reading of nineteenth-century modernity that were explicit to the point of literalism. In the latter's aphoristic formula, it was the figure of a woman, the prostitute, who summed up the perpetual displacement of human subjectivity in thrall to the capitalist mirage; she is "the pure commodity . . . who is seller and product in one," and this same condition overtakes the ordinary bourgeois male, who submits his own being to the regime of things and their exchange.[5] Wall's *No* of 1983 (pl. 56) could be placed

55 Gustave Caillebotte, *Le Pont de l'Europe*, 1876. Oil on canvas, 125 ×
180 cm. Geneva, Musée du Petit Palais.

beside that unreadable encounter between the man and woman at the left
side of Caillebotte's *Le Pont de l'Europe* (pl. 55). The setting of the
painting was a marvel of nineteenth-century capitalist expansion, the
iron bridge spanning the rail lines leaving the Gare Saint-Lazare; the
adjoining district was itself entirely new, its wide avenues and straight lines
epitomizing Haussmann's rationalized urbanism. *No* places its non-
encounter between prostitute and passing businessman in an exact late
twentieth-century counterpart to Caillebotte's assertively modern environ-
ment, a faceless financial and corporate center typical of scores of modern
cities, which have repeated the pattern set by Haussmann in ruthlessly
displacing older, more varied social ecologies. The man's buttoned-up
overcoat and the woman's cheap fur evoke a chill outdoors, but the
architecture encloses the scene into an interior with no visual outlet: a
transformation of boulevard into room is precisely what Benjamin described
as the vision and experience of the *flâneur*.

At the same time, the still chilliness of *No* displays a rigid and rarefied
abstraction similar to that which Benjaminian theorizing tended to generate

56 Jeff Wall, *No*, 1983. Cibachrome transparency, fluorescent lights, and display case, 229 × 330 cm. Bordeaux, FRAC Aquitaine.

57 Wall, *Diatribe*, 1985. Cibachrome transparency, fluorescent lights, and display case, 203 × 229 cm. Toronto, Ydessa Hendeles Art Foundation.

in art-historical work. That parallel academic activity, subject itself to the seductive fascinations of Paris, has largely failed to move on from competitive cultivation of expertise in the interpretation of one past cultural episode. Wall, on the other hand, has been able to advance from this parochialism (national, chronological, and theoretical) by returning to the most basic of the three mapping exercises outlined above: the description of a geography that is at once familiar and strange.

In his case the obvious resource was directly under his feet: the city of Vancouver. Some of his earliest panels are panoramic landscapes (more recently realized in a large format) which exploit the self-evident scenic potential of the format. In each one, the city is seen only at its fringes or is

58 Vincent Van Gogh, *Outskirts of Paris*, 1886–8. Oil on canvas, 46.4 × 54.6 cm. Private collection.

registered at a distance by the rough incursions of industry into the surrounding wilderness. Those fringes are typically a clutter of cheap, ill-planned suburban housing, mixed with a patchwork of warehouses, over-passes and littered waste ground, which the camera and scale of the image force incongruously into the dramatic sweep and grandeur of the traditional landscapist's distant prospect.

Epic sweep in those panels prevents the urban fringe from offering the reassurance of a melancholy picturesque. A suggestion of the latter does, however, hang over the close-up studies of similar locations which followed a few years later, *Bad Goods* of 1984 and *Diatribe* of 1985 (pl. 57), for example. For the latter work, Wall has proposed adventurous analogies with Poussin's *Landscape with Diogenes* and, by thematic extension from that prototype, with the peripatetic philosophers of antiquity, in whose stead he places the young welfare mothers impersonated by his models. As Diogenes threw away his last possession in pursuit of truth, it is they, as

"the least favored members of society," who possess "a generic, objective relation to the traditional aims of critical philosophy."[6] His gloss is persuasive as a report on the erudite chain of thought prompted by his *flânerie*-by-automobile in the outskirts of Vancouver and on his discovery of the social invisibility suffered by poor young women coping with small children in that landscape. But one has to wonder if the actual density of information in the panel is sufficient to guarantee a response of this sophistication. At the same time, he has a secure claim to have discovered the importance of the suburban *terrain vague* as a diagnostic feature of modernity at more or less the same moment that it was called to the attention of academic art history in T.J. Clark's *The Painting of Modern Life*. More than with any classical landscape, action and setting in *Diatribe* converge in an uncanny way with Van Gogh's small, uncharacteristic painting *Outskirts of Paris* (pl. 58), which launched Clark's dissection of the topic, and which was then hardly known in the literature.

Clark describes Van Gogh's work as, in all likelihood, a provisional response to Seurat's monumental procession of suburban humanity in *Sunday Afternoon on the Island of the Grande Jatte*.[7] The blank, undecided nature of the *Outskirts of Paris* was an achievement in itself and may be the grounds of its accuracy, but it resists any more ambitious scale than the one Van Gogh gave it. Nor did he pursue the direction that the painting suggests, with his subsequent shift to rural Provence removing any necessity to do so. The size and unnatural clarity of Wall's panels demanded a higher, more Seurat-like degree of articulation. And when he found the necessary organizing principle, it came with an impeccably Benjaminian provenance: *shock* as the defining feature of modern experience, the sensory assault that lends to urban life its perpetual aspect of the uncanny.

This, for Benjamin, was the reason that the truth of modernity assumes allegorical form. William Empson, writing in the same period, had arrived at a similar realization when he observed that "the facts of the life of a nation . . . are very strange indeed, and probably a half-magical idea is the quickest way to the truth."[8] A sympathetic response to Wall's subsequent work will require assent to some such proposition. The liquid explosion set off by the tense streetperson in *Milk* in 1984 (pl. 59) begins to provide a satisfactory focus and intensity of internal incident; it succeeds in dramatizing the condition of homelessness with minimal reliance on pathos (something few artists have managed since Martha Rosler's prescient *Bowery in Two Inadequate Descriptive Systems* of 1974: see "Unwritten Histories of Conceptual Art" below).

59 Jeff Wall, *Milk*, 1984. Cibachrome transparency, fluorescent lights, and display case, 187 × 229 cm. Reims, FRAC Champagne-Ardennes.

Conveying a subjection to shock did not necessarily require such abrupt and incongruous action. *The Guitarist* of 1986 (pl. 60) pursued another vein of illusion altogether, one plausibly (and in fact) provided by the actors themselves. The adolescent squalor of the setting – graffiti and detritus together – carry the imprint of myriad shocks and undigested impressions from the city outside, as well as from a half-understood history of symbolic protest by their elders since the 1960s. The panel documents the complete vernacular assimilation of collage aesthetics cemented by Punk, which is now pre-history for this generation. For this reason it was prescient about the sensibility – Punk and Hardcore thrash mixed with disorganized counter-cultural attitudes going back through the Hippies to the Beats – that in the early 1990s came to fascinate a worldwide audience in the music of bands from neighboring Seattle such as Soundgarden,

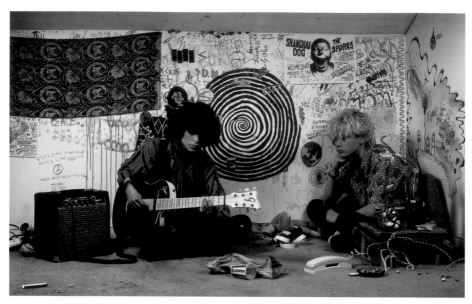

60 Jeff Wall, *The Guitarist*, 1986. Cibachrome transparency, fluorescent lights, and display case, 119 × 190 cm. Private collection.

Mudhoney, Pearl Jam, and (of course) Nirvana. The late Kurt Cobain of the last came up with the descriptive coinage "Kerouwacky": his *Smells like Teen Spirit* could have provided the work with a good alternative title.

Casting a certain parental regard over the tableau, Wall claims all this back for art by maneuvering contemporary disorder and aimlessness into a conceptual grid, again provided by the urbanity of nineteenth-century Paris. The dark-haired eponymous figure, actually a young woman born in Guatemala, lifts itself from the immediate photographic continuum to join Manet's Latin guitarists and dancers, the painter's response to the fascination exerted by the touring Spanish troupes of the 1860s. The pertinence of the connection derives from Manet himself having used these entertainers to collapse the historical distance between his own moment and the tradition of Spanish tonal painting and self-declarative technique extending from Velázquez to Goya. The manufacturer of the electric guitar has sought to disguise the origins of the instrument behind an Iberian aura, taking the name of the latter artist as a brand identity and allowing Wall in all plausibility to emblazon the magic signature at the center of the composition. The beauty and androgyny of the central figure crosses this

line of descent at another angle, connecting Manet's *Mlle. V ... in the Costume of an Espada* with Caravaggio's ephebic lute-players.

No informed (adult) viewer who takes time over the work will be able to fend off these connotations. The dense condensation of vivid historical reference disrupts the unity of the photographic impression from the inside without resort to collage or montage, and this is brought home by the inclusion of their achieved vernacular equivalent. (*The Guitarist* – down to a precise motif like the knitted, stuffed toy – anticipates both the thematics and the characteristic raw material of Mike Kelley's installations of the last few years; it deploys both matter and ideas in a way that is more precise and certainly less physically cumbersome.)

A parallel internal fissure takes place in *Outburst* of 1989 (pl. 61), a panel that returns to the overt theme of urban shock, amassing the terror of factory discipline and the thousand daily assaults of sweat-shop labor

61 Jeff Wall, *Outburst*, 1989. Cibachrome transparency, fluorescent lights, and display case, 229 × 312 cm. Vanvouver Art Gallery.

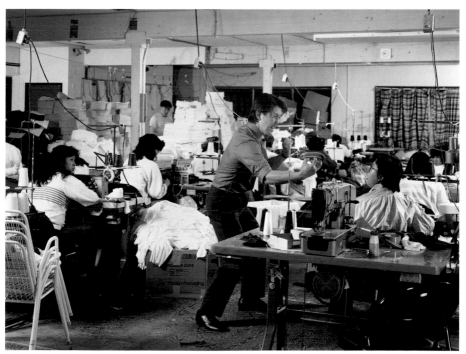

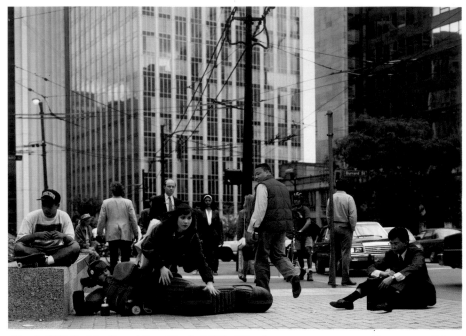

62 Jeff Wall, *The Stumbling Block*, 1991. Cibachrome transparency, fluorescent lights, and display case, 226 × 335 cm. Toronto, Ydessa Hendeles Art Foundation.

into one figure of sudden, startling outrage. But it is not the violent emotion that rends the image from within as much as it is the small adjustments to the supervisor's gesture. Something in the curve of the fingers most of all turns his stance into one akin to an emblematic martial-arts pose. Here, the allegorical key comes from popular culture, the Asian as filtered by film fantasies of occult power. No element of the scene precisely contradicts a prosaic exposé of petty authoritarianism (conceivably, the man might even be a fanatic prone to imitating Bruce Lee in moments of anger), but the reaction of the female worker is invested with alarm on another level altogether, one triggered by unexpectedly seeing her own existence mirrored in a horrific stereotype.

Two of the most recent panels take such suggestions of the occult and make them explicit in comedic science fiction and out-and-out visions of the fantastic. *The Stumbling Block* (pl. 62) imagines that it has become a responsibility of municipal government to administer shocks. Staking out the pavement is a civic employee, equipped in outlandish protective gear –

166

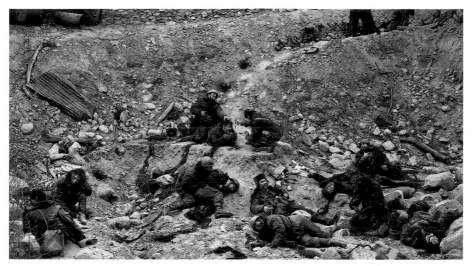

63 Jeff Wall, *Dead Troops Talk (A vision after an ambush of a Red Army patrol, near Mogor, Afghanistan, winter 1986)*, 1991–2. Cibachrome transparency, fluorescent lights, and display case, 229 × 417 cm. Toronto, Ydessa Hendeles Art Foundation.

somewhere between Samurai armor, the pads of an ice-hockey goalie, and a sleeping bag – which renders him incapable of movement. A simulated electronic device, connected by computer cable to the monopod body-casing, bears an official seal reading "Office of the Stumbling Block – Works Dept"; his helmet keeps him in radio contact with headquarters. The personification of urban shock, its translation into static farce, signals a change in the logic that had governed Wall's work for more than a decade: that is, its tense inscription of allegorical meaning into a screen of apparently seamless naturalism. The voluntary pratfalls undergone by Wall's characters connect the panel to the suppressed potential for a genre of silent film in technicolor, with all the promise of heightened fantasy entailed in that counter-factual entity.

The high-technology stumbling block is a comically passive surrogate for the artist's now far more interventionist control of advanced reproductive media, one in which the temporal succession of film is replaced with the spatial suture of disparate images permitted by photographic digitalization. That process also permits a gradual working-up of a composition part by part in a way that approximates the studio procedures of traditional narrative painting (in Wall's prior work that approximation

167

64 Jeff Wall, *Vampires' Picnic*, 1991. Cibachrome transparency, fluorescent lights, and display case, 229 × 335 cm. Ottawa, National Gallery of Canada.

had been restricted for technical reasons to the building of sets and direction of actors). The characters in *The Stumbling Block* were all posed in the studio, but perhaps the first full extension of that change can be seen in *Dead Troops Talk (A vision after an ambush of a Red Army patrol, near Mogor, Afghanistan, winter 1986)* (pl. 63). In that allegory about the end of the Cold War, seen from a place and through an event maximally remote from Western awareness, Wall gives free rein to the occult. Entirely constructed in the studio, integrating the sort of special effects normally encountered in Hollywood horror, its imagery can shift in a matter of inches from the pathetic to the noble to the utterly grotesque, from Baron Gros to Ilya Repin to Hieronymus Bosch to Goya yet again (another way of describing it would be as a modern equivalent to the survivors of *The Raft of the Medusa* with all the gore that Géricault recorded in the morgue but could never put on a monumental canvas). At the same time, negotiating this mobility of reference requires an orderly march through a composition unabashedly based on the rigid pyramidal structures of

Ancien-Régime academic practice. Advanced technology seems to have permitted a move past the surreptitious, ad-hoc academicism of modern-life painting in the later nineteenth century to a frank encounter with the real thing. The compositional pyramid is the leitmotif of virtually all Wall's work of 1991–4, even that still based on live photography; it assumes emblematic form in the reclining male nude at the center of *Vampires' Picnic* of 1991 (pl. 64), in which a Hellenistic warrior and Hogarth's Rake in Bedlam are elided under the auspices of George Romero's genre-bending combinations of comedy and cannibalistic shock on film (shades again of the repressed in Géricault's castaways).

One way of finding an aphoristic verbal gloss for Wall's work would be to give a positive turn to T.W. Adorno's famously negative appraisal of Benjamin's first, 1938 version of his Baudelaire essay: "If one wished to put it very drastically, one could say that the study has settled at the crossroads of magic and positivism. That spot is bewitched." He went on to recommend to Benjamin that "only theory could break the spell – your own resolute, salutarily speculative theory."[9] For this reader at least, that first essay remains superior to the allusive and abstracted revision which he then offered in conformity to the demands of the Frankfurt school. That bedevilled crossroads may yet offer a vantage point from which to see the territory where existing theory cannot take us. As Benjamin himself said in pained defense of his first approach, "speculation can start its necessarily bold flight with some prospect of success only if, instead of putting on the waxen wings of esotericism, it seeks its source in strength of construction alone."[10]

Part 5

Natural History

10

The Simple Life: Pastoralism and the Persistence of Genre in Recent Art

Through the preceding essays, considering recent work from Gerhard Richter to Jeff Wall, questions of genre have continually recurred. How can that archaic-sounding concept be important any more for understanding the condition of art? There is little need to elaborate how powerful the idea of genre was in Baroque and Neo-Classical practice. Though borrowed from literary criticism – from the division of poetry into epic, drama, lyric, elegy and so on – generic distinctions proved in fact to be more cleanly and effectively adaptable to painting, to the extent that the categories could be arranged into a clear hierarchy. The ordering principle was derived from Aristotle, from his observation that the most important task of art was to imitate representative human action. Thus the highest category of art was what the French called "history painting" (an imperfect translation of *la peinture d'histoire*): multi-figured compositions enacting great events from antiquity, the Bible, the history of the Church, and the nation's ruling dynasties. The categories descended from there according to the degree of significant human presence involved and the extent to which the mind was engaged with general truths over and above merely local interests or sensual attractions. Thus generalized human figures from mythology would rank as a subsidiary of history. Next came portraiture, graded according to the social rank of the sitter, followed in descending order by picturesque scenes of anonymous types (which would correspond to comedy in literature), landscape, and still-life. Official status and rewards were apportioned to artists according to the rank of the genre in which they practiced.[1]

This system prevailed for a good two hundred years until, in the mid-nineteenth century, the appearance of an artistic avant-garde brought about a drastic destabilizing of that hierarchy. What were essentially

comedic scenes (in the sense of the Aristotelian distinction between comedy and tragedy), landscape, and intimate portraits replaced history painting as vehicles for superior intellectual and moral ambition.[2] From Courbet forward, the claim is made – and increasingly accepted – that the greater alertness, breadth of comprehension and potential for psychological transformation in the observer will be demanded by subjects once deemed intrinsically inferior to historical narrative in precisely these respects. The analytic Cubism of Braque and Picasso brought this development to something of a culmination by consistently yoking the highest demands on the viewer's concentration and intelligence to the humblest classes of subject matter: still-lifes, interiors, and portraits of anonymous types.

The great disparity between the conceptual and thematic levels of this art in particular has been a powerful encouragement to the belief that subject matter is a pretext to the real business of art or dispensable altogether. In the context of such belief, even the idea of generic criticism has come to seem redundant. Unusual circumstances have been required to revive it in any explicit form, and its expression has tended to be correspondingly vehement. One such moment arrived in the days of the Popular Front in America, at the Artists Congress against War and Fascism held in New York in 1936. There Meyer Schapiro launched a strenuous defense of the continued relevance of history painting against modernist appropriations of its erstwhile prestige.[3] His polemic reveals that beneath the standard distinctions between conformist public art and avant-garde freedom, between accessibility to the masses and esoteric abstraction, was an argument about the hierarchy of genres; he indicted, with great eloquence, the avant-gardists for the crime of reducing adventurous art from the historical genre to the status of still-life:

> . . . it is essential in the anti-naturalist art that just those relationships of visual experience which are most important for *action* are destroyed by the modern artist. As in the fantasy of a passive spectator, colors and shapes are disengaged from objects and can no longer serve as a means in knowing them. The space within pictures becomes intraversible; its planes are shuffled and disarrayed, and the whole is reordered in a fantastically intricate manner. Where the human figure is preserved, it is a piece of picturesque still-life, a richly pigmented lumpy mass, individual, irritable, and sensitive; or an accidental plastic thing among others, subject to sunlight and the drastic distortions of design. If the modern artist values the body, it is no longer in the Renaissance sense of a firm, clearly articulated, *energetic structure*, but as temperamental and vehement flesh.[4]

I have added emphasis to certain words to point up how fundamentally Aristotelian Schapiro's criteria remain. What he wants to discount is the fact that abstraction had increasingly taken over not only the outward prestige of traditional history painting but also its crucial function of representing mind over matter. What he wanted instead was a connection between the rhetorical requirements of history painting and a public space defined in democratic rather than authoritarian terms, as he put it, an art that would "ask the same questions that are asked by the impoverished masses and oppressed minorities."[5]

The question which he did not ask, however, was whether the high genre had ever, or could ever, ask such questions. The historical record is not encouraging on this score. A capacity to read a painting in terms of its value as abstracted, generalized truth had been linked to an élite position of mastery from the moment that the genre had been definitively codified within the French Academy. The link between vision and control remained central in later academic theory. In England, Sir Joshua Reynolds defined citizenship in "the republic of taste" by an individual's ability to abstract from particulars: to comprehend the constant regularities behind visual phenomena was to demonstrate the breadth of vision necessary to comprehend the general interest of the body politic. This requirement was assumed, it need hardly be said, to be the exclusive possession of a genteel minority.[6]

That conjunction was substantially repeated in the most powerful arguments offered in the late twentieth century for the priority of abstraction in painting – one of the clearest signs that the "anti-naturalism" excoriated by Schapiro had inherited the erstwhile prerogatives of history painting. While few, if any, of the advocates of modernist abstraction contended that the ideal viewer demonstrated a fitness to rule in his habits of attention to works of art, the equation persisted between the competence to grasp an abstract work and a subjective position of undivided mastery and control.[7] To cite, as an almost obligatory example, Michael Fried's formulation of the autonomy thesis in the 1960s: a successful abstract work, by means of its all-over activation of the pictorial surface, achieves an instantaneous presentness, separate from the accidents of its actual use or setting; the viewer who can mentally share in this presentness will be elevated to a condition of disinterested self-sufficiency, joined to "an enterprise ... inspired by moral and intellectual passion ... informed by *un*common powers of moral and intellectual discrimination [my emphasis]."[8] To see adequately into such a high-minded painting, to discover a unified order within a challenging field of complex visual

incident, was, for him, to activate a superior form of inner life in a society that offered few comparable occasions for doing so.[9]

* * *

The question that remains, in coming to terms with the hegemony of abstraction, is what happened to the other genres? As Richter's practice suggests, they have largely been dispersed into vernacular forms. Today, if one's primary desire is for a landscape over the mantelpiece or a board-room portrait (as opposed to a landscape or a portrait that happens to be by Matisse), one generally leaves the realm of validated fine art altoge-ther.[10] Where the old hierarchy had apportioned shares of artistic serious-ness to each level, according a rhetorical notion of decorum (there was a right kind of style for a given subject), the devaluation of subject matter has left "merely" functional modes of figurative representation with vir-tually no claim to the status of art at all.

No sacrifice on this scale could take place without there having been a considerable price to be paid. The collapse of the definition of artistic seriousness into the exclusive criteria of history painting has made un-realistic demands for comprehensiveness on the modernist abstraction that had assumed its duties and its prestige. This is not to say, however, that such problems with the highest category of art are entirely new, either in visual art or in the literary modes from which its hierarchy of genres was fashioned. Unrelieved high-mindedness, it had long been recognized, was impoverishing; its narrowness undermined the very claim of high styles, with their protocols of "nobility" in theme and expression, to represent the widest possible compass of knowledge and experience. Several centuries of European art and literature had taught that the cele-bration of heroic values in art could best survive comparison with reality by including the contrary voice and outlook of common life. From the time of Virgil forward, faltering belief in the transcendent virtue of rulers (and such belief always falters from the instant it is solicited) elevated the rustic type, the shepherd or swain, to the place once occupied by Achilles, Alexander, or Augustus. In this form of courtly conceit, the poet or painter transfers the lordly pretence of representing the whole of society (*l'état c'est moi*) to characters who derive their representative status from their ubiquity and from their presumed closeness to nature and the basics of life.

Traditionally, the name given to this incorporation of the commonplace within the exalted – and vice-versa – has been pastoral. Its basic and

original sense derives from a class of poetry that celebrates the pleasures and song of simple herdsmen, but a steady expansion of its significance was already under way in the Augustan eighteenth century. Samuel Johnson, in 1750, generalized its scope to designate a "poem in which any action or passion is represented by its effects upon a country life[,] ... a representation of rural nature ... exhibiting the ideas and sentiments of those, whoever they are, to whom the country affords pleasure or employment."[11] That final qualifier — "whoever they are" — implies the basic character of pastoral contrast: those who fashion or enjoy cultivated forms of art are compelled to compare their own condition, which permits this refinement, with that of the rustic whose existence affords no such luxury but who enjoys in compensation a natural, more "truthful" simplicity of life. One tests the truth of one's sentiments by translating them, within circuit of the poem, from a high idiom into a vernacular one.[12]

The idea of the pastoral owes much of its contemporary currency to the writings in the 1930s of the English critic William Empson. Fully conscious of its archaism in modern literature, he revived the term as a way of designating this play of contrast, whether the traditional thematic markers of the genre were present or not. For him the pastoral emerges from any movement of thought that shifts from "this is fundamentally true" to

> "true about people in all parts of society, even those you wouldn't expect," and this implies the tone of humility normal to pastoral. I now abandon my specialized feelings because I am trying to find better ones, so I must balance myself for a moment by imagining the feelings of the simple person.... I must imagine his way of feeling because the refined thing must be judged by the fundamental thing, because strength must be learnt in weakness...[13]

In Empson's handling, pastoral is seen as a means of ironic reflection on the powers of the artist alongside those of the ruler or courtier; it comes to identify any work in which a distinctive voice is constructed from the implied comparison between an author's suitably large artistic ambitions and his or her inevitably limited horizons and modest strengths. Pastoral offers a set of conventions in which that disparity between exalted ends and finite means can be given figural expression and makes itself a matter for art.

In the history of painting, there are plain analogies to the older forms of literary pastoral. The *Fête champêtre* by Giorgione and Titian proceeds from the same courtly culture that generated the Virgilian pastoral poetry of the Renaissance. Poussin's *Phocion* landscapes articulate the virtues of

the hero — normally the province of majestic narrative — through the testimony of a nature shaped by ordinary human labor. And he directs the viewer to the *Arcadian Shepherds* for knowledge of mortality, the most fundamental truth of existence. But can pastoralism still be said to have any place in twentieth-century art when such clear and well-understood codes of iconography have ceased to operate?

In light of the foregoing discussion of the fate of the genre hierarchy in the twentieth century — repudiated in its explicit form, but still providing the terms in which value in art is communicated and assessed — the answer would be yes. Following Empson, one can distill the essential pastoral contrast from its traditional subject matter and see it as the principal means by which the suppressed lower genres have returned within the narrowed confines of the fine-art practice. Pastoral, in fact, speaks to and protests against that narrowness, not as an external complaint such as the one voiced by Schapiro in 1936, but as an integral component of the most ambitious art-making. And it has been conspicuous at two key moments in the history of high abstraction in the twentieth century: the aforementioned analytic phase of Cubism and the consolidation of American Abstract Expressionism during the 1950s.

In the first instance, Picasso's portraits of 1910–12 can stand as examples of the most developed sophistication and self-consciousness concerning the issues of formal abstraction and representation in general. They include a depiction of the suitably refined features of Kahnweiler, his dealer and intellectual advocate, and in such a painting subject matter and technical means seem entirely at home with one another. But that human presence is over-shadowed by one of another kind, one that is aggressively simple and mockingly uncultivated in character. The so-called *Poet* (pl. 65), painted in the summer of 1911, conveys this other brand of humanity.[14] What attitude is the viewer meant to assume toward this personage, this bohemian idler, whose existence is the nominal reason for the painting? The proliferation of pipes, together with his quizzically inebriated expression, marks him as a character with a penchant for useless self-gratification, and Picasso makes the auto-erotic implications of that activity more than explicit by placing one large pipe at waist level and transforming its bowl into an erect phallus pouring out smoke. This also happens to be one passage in the picture that insistently calls attention to the artifice of the painted sign; the solid, constructive stroke of the "pipe" is here pointedly juxtaposed to the fluid scribbling with thinned-out pigment that produces the "smoke" (the loose smear obscures the underlying structure, yet enhances, by contrast, the fundamental solidity of that

178

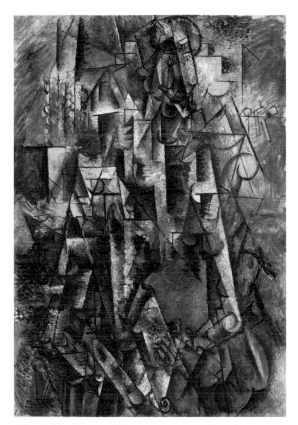

65 Pablo Picasso, *The Poet*, 1911. Oil on linen, 131
× 89.5 cm. Venice, Peggy Guggenheim Collection.

structure). The diagonal created by the phallus is then doubled (this time
encircled by a descending hand) and rhymed several times over, to serve as
the principal device that integrates the lower zone of the picture into the
overall lozenge-shaped architecture of the composition as a whole.

This passage invites us to exercise our virtuosity as sophisticated viewers,
to abstract from particulars, and thus to confirm our membership in the
community of the visually cultivated. We are given all that we need to
reflect deeply on the processes of seeing and representing, but it is difficult
to remain continuously serious about that activity. For it is these processes
that generate this priapic simpleton; even the squinting expression of his
eyes is at the same time a key anchoring point of the abstract pictorial

179

geometry. We cannot have one reading without the other. The pictorial process makes him, and we see it as him; he is its hero. His capacity to appear comic and rude depends completely on the success of the painting as seen through the high discourse. As such, he represents that discourse and the entire high-modernist concern with the universal problems of representation as such, claiming them as also the property (or properties) of the simple man.

What then does the painter gain from this double game? First of all the figure is a playful self-mockery or pretense of humility: I am like this too, the painter suggests, a useless onanist, drunk on my solitary pleasures. His willingness to poke fun at what is, in every other respect, a project of the highest seriousness only reinforces our confidence in that project and the correctness of our shared belief in it. Further, it lends a feeling of scope to the image by asserting that this highly esoteric artistic language can encompass a broad range of human life. Thus, it bolsters the claim of its language to a universality posited in the intellect with another, complementary kind of universality: a certain generosity and capacity for expansive human sympathy. The sophisticated viewer, Picasso implies strongly, may also identify with the comic representative of Cubist procedures and thus find another, agreeable way of imagining the communal bond shared between the avant-garde artist and his audience. The artist, through this imagery, proposes that we can take the measure of our common situation only by looking at it both from above (from our shared understanding of the high-art tradition) and from below (from the position of the eccentrics and third-raters attracted to any avant-garde). Picasso explicitly included his audience within this game in *The Aficionado* (pl. 4) of the following year, where the onlooker (in the guise of a pompous enthusiast for the second-rate French bullring) occupies the place of the poet with his pipes.[15]

Empson has identified this persistent form of modern pastoral, which replaces the chivalrous shepherd of earlier times, as the ironic joining of "the idea of everything being included in the ruling hero" to "the idea of everything being included in the humble thing, with mystical respect for poor men, fools, and children."[16] The painted thematics of *The Poet* or *The Aficionado* run parallel to the rude disruptions of collage from commonplace sources undertaken by Picasso and Braque in these same years. And a similar corrective movement, using some of the same means, was undertaken by the most sophisticated American artists during the 1950s. Its object, however, was not so much their own art as that of their immediate predecessors, the majestically scaled abstraction of the founders of the New York School.

That first generation of the postwar avant-garde in America were among the last believers in heroic adventure as a resource for art. Finding nothing in the culture of sufficient stature to warrant representation at that exalted level, they extinguished explicit figuration the better to retain the formal characteristics of heroicizing art from the past: large scale, expansiveness of effect, the rhetoric of action and risk. In this sense, their art was old-fashioned in its ambition, a throwback to the seventeenth century of Rubens, Lebrun, and Bernini, that is, to the time when art could confidently summon up belief in *Vir Heroicus Sublimis* (to cite the title of one of Barnett Newman's own triumphant works) and in its own capacity to represent the qualities and actions of superior individuals.

Such ambition ignored the parallel tradition of scepticism and doubt about both, which paradoxically was the principal means by which the heroic protagonist in art had been kept alive from the times of royal absolutism into the twentieth century. While many in the next generation of artists stayed on the path established by de Kooning, Pollock, and Rothko,[17] others – Robert Rauschenberg and Jasper Johns being the leading figures – made common cause with the ironic and mock-heroisms flourishing in other media in New York. Baudelaire's derelict ragpicker as majestic protagonist of the modern city reappeared in the guise of the fringe hustlers of the jazz scene celebrated in Norman Mailer's "The White Negro." At the opposite end of the pastoral spectrum from such aggressive types was the figure of the holy fool embodied in the work and person of John Cage, who offered a cultivated simplicity akin to the supposed innocence of the child, open to play and an uncensored apprehension of the world.

One can find traces here and there of Mailer's stance in the fine-art world, in a Rauschenberg combine painting like *Hymnal* of 1955 with its thematics of urban anonymity broken only by crime and police surveillance, or in the rhetoric of Allan Kaprow's influential essays.[18] But it was the latter position that seemed most to suit the artists emerging in that decade. The mute simplicity of Johns's numbers, flags, maps, and diagrams, along with his compositional principle of mantra-like repetition, bridge the blankness of meditation with the drills of the child's lesson book, the absorption of the puzzle box and rituals of the playing field. And this retreat to the experience of childhood was passed on intact to the cohort that came to be identified as Pop.[19]

Benjamin H.D. Buchloh, though he is more severe on the subject, has perceptively discerned that the "participatory aesthetics" encouraged in works by Johns and Rauschenberg were deliberately kept "at so infantile a

level as to invite participants to wind up a music box, to clap their hands, or to hide an object."[20] But there was strength in this. These artists, and those who came after, were reconnected to that long, complex line of European pastoralism from which the first generation of the New York School had been separated in its pursuit of unalloyed grandeur of utterance. This rediscovery included Duchamp, in whose ready-mades and chance pieces the cult of the child has always been a large and underestimated component. In his work and then in that of his American epigones, it allowed a distinctive voice to be constructed from the pastoral contrast between large artistic ambitions and a simultaneous awareness – figured through the surrogate of the child and consciously childish activities – of everyone's limited horizons and modest powers. Through this ironic reduction of the heroic point of view (the child is powerless but gives the power once again to observe the world), they managed to recover figuration without lapsing into anti-modernist provinciality. The results were inevitably less glorious but arguably more sophisticated – because more realistic and better informed by history – than aspirations toward an abstract sublime.

<p style="text-align:center">*　*　*</p>

The artist Annette Lemieux recently said, ". . . when I use a flag . . . viewers are reminded of Jasper Johns. And when people say that, I think, God, no one remembers Betsy Ross."[21] That remark illuminates Johns's work as well as it does her own. His various *Flags* recoded the grandly periodizing notion of "American-Type Painting" in terms of everyday vernacular patriotism, using a design that began life as an improvised piece of handicraft by an ordinary seamstress.[22] Lemieux is expressing worry that her choices of imagery are too easily assimilated into a form of criticism that values theories of appropriation over the matter being appropriated. Johns's work has likewise been too easily mined to produce simple conundra – is it a painting or is it a flag? – and made a point of origin for highly abstract meditations on the status of artworks as context-dependent signs. This mode of interpretation has largely replaced the modernist one exemplified by Fried; it, and the art that it privileges, have since come to constitute the high genre, and more recent practice in a pastoral mode has had to play within and against an even more severe and cerebral form of abstraction.

A sternly impressive statement of this transformation came from Annette Michelson in her lengthy essay on the sculpture of Robert Morris, published

in 1969.[23] This was, as far as I know, the first piece of art criticism to cite Jacques Derrida on the metaphysics of presence, years in advance of his translation into English and assimilation into the larger academic culture in America.[24] She saw the high modernism championed and articulated by Fried, with its denial of contingency and temporality in the viewer's experience, as bound by such a metaphysics. Morris's sculptures, by contrast, were

> to be seen not as embodying or essentializing sculptural ideas or categories, but as proposing a patient investigation, profoundly innovative in its sharpness and intensity of focus, of the conditions for a reconsideration of sculptural processes, a redefinition of its parameters. . . . Demanding an attention in time for its apprehension, it impelled, as well, a shift in emphasis in notions of value, as of gratification. It is the consistency and clarity of its logic, the validity and amplitude of its development, the intellectual trajectory described by that development which gives pleasure.[25]

This is an austere notion of pleasure, consistent with the tenor of Michelson's prose as well as with her announcement, at the start of her essay, that Morris's enterprise "commands recognition of the singular resolution with which a sculptor has assumed the philosophical task which, in a culture not committed on the whole to speculative thought, devolves with particular stringency upon its artists."[26]

This last statement is among the most accurate justifications for the exacting requirements which the best work in Minimalist and Conceptual art imposes upon its audience. One could expand upon it to say that, in a culture where philosophy has been largely withdrawn into technical exchanges between academic professionals, artistic practice in the Duchampian tradition has come to provide the most important venue in which demanding philosophical issues can be aired before a substantial lay public. It has provided another kind of academy, an almost antique variety analogous with those associations for learned amateurs which sprang up across Europe during the Enlightenment. And one of the surest signs of the strength in that tradition is that the attendant dangers of narrowing vision were recognized in practice almost at the moment that Minimalism ushered in the new dispensation.

In 1966 Dan Graham contributed an article to *Arts Magazine* entitled "Homes for America" (pls. 66, 67), a gesture which has lately, and with justice, begun to be recognized as one of the key artworks of the 1960s.[27] But its success was achieved with a text that ostensibly takes its reader

a world away from Michelson's elevated concerns. It begins with an alphabetical list of twenty-four names given by property developers to clusters of private, single-family houses ("Belleplain, Brooklawn, Colonia, Colonia Manor, etc."), followed by prose of emphatic plainness and declarative simplicity:

> Large-scale "tract" housing "developments" constitute the new city. They are located everywhere. They are not particularly bound to existing communities; they fail to develop either regional characteristics or separate identity. These "projects" date from the end of World War II when in southern California speculators or "operative" builders adapted mass-production techniques to quickly build many houses for the defense workers over-concentrated there.[28]

The article continues to describe, in the same vein, the economies of scale inherent in those techniques as determining every formal feature of these manufactured communities. Toward the end of piece, Graham deduces that they

> ...exist apart from prior standards of "good" architecture. They were not built to satisfy individual needs or tastes. The owner is completely tangential to the product's completion. His home isn't really possessable in the old sense; it wasn't designed to "last for generations"; and outside of its immediate "here and now" context it is useless, designed to be thrown away. Both architecture and craftsmanship as values are subverted by the dependence on simplified and easily duplicated techniques of fabrication and standardized modular plans.[29]

There is nothing in the typography or layout of Graham's modest article to distinguish it from the directly adjacent pieces of straightforward art journalism; it is all the more embedded in its context in that it begins in the same column of type where the previous article leaves off and ends where the next starts.[30] Only the unstylish, pedantic exposition of his facts, along with the marginal appropriateness of the subject to a fine-art periodical, transforms this last passage suddenly into something else entirely: without ever breaking character and ceasing to be an account of its ostensible subject, it becomes an analysis of Minimal art, absolutely on a par with of the high-minded and self-consciously stringent mode of criticism which Michelson would come to consolidate by 1969. By its faultless indirection, it remains commensurately abstract, yet by finding an appropriately plain language of description in a mode of life common to a vastly larger number of people than are affected by advanced art, it has a

claim to be more powerful and comprehensive. By inscribing, furthermore, the genuine anonymity of assembly-line builders onto the studied and stylish anonymity pursued by the Minimalists, he deftly exposes the latter group's unrenounced addiction to avant-gardist heroics.[31]

Graham's photographs have misled some into seeing the point of the piece as identifying correspondences between Minimalist forms and the blandly anonymous character of the suburban built environment.[32] The piece is not about such patent likenesses of appearance, which perpetuate a late-modernist fixation on self-sufficiency of visual aspect; it is about larger conditions in the common life of society which have undercut characteristically modernist affirmations of possession and individuality, rendering them archaic and unrealistic. Minimalism, one sees, gains its pertinence by concentrating and enacting the logic of those conditions, ones equally on view in a systematic analysis of the postwar housing industry. That – rather than the phenomenal artifacts, the housing tracts and industrial parks, that result from it – constitutes its object of imitation. The promise of realism contained in the plain diction of the piece is confirmed at the level of abstract critical allegory.[33]

<p style="text-align:center">* * *</p>

The tendency of critics to assert their prerogatives by cultivating a forbiddingly difficult language has, of course, only increased since the time of Graham's quiet intervention. Its tenor has been mirrored in a correspondingly austere and demanding installation aesthetic developed within Conceptual art. Here Europe took the early lead. Landmarks of that quasi-puritan denial of the senses can be found in works such as the Art & Language *Index* at the 1972 Documenta exhibition or Hanne Darboven's *Century*, from about the same period. A quite recent, less-heralded example, which attests to the persistence of this mode, was a 1991 installation by the pioneer conceptualist Stanley Brouwn in the Durand Dessert Gallery in Paris, where an absolutely plain, whitepainted series of connecting rooms had been altered only to the extent of the openings between them having been slightly changed in dimension. It seemed the point of the piece that this alteration, described in a discreet and laconic text, be on the very edge of perceptibility in the viewer's field of movement and vision.

Michael Asher has likewise sought and achieved this kind of sensory weightlessness in a cumulative project of museum installation works. He is able to match the austerity of a Brouwn but at the same time attach his

Homes for America

Early 20th-Century Possessable House to the Quasi-Discrete Cell of '66

D. GRAHAM

Belleplain	Garden City
Brooklawn	Garden City Park
Colonia	Greenlawn
Colonia Manor	Island Park
Fair Haven	Levitown
Fair Lawn	Middleville
Greenfields Village	New City Park
Green Village	Pine Lawn
Plainsboro	Plainview
Pleasant Grove	Plandome Manor
Pleasant Plains	Pleasantside
Sunset Hill Garden	Pleasantville

Large-scale 'tract' housing 'developments' constitute the new city. They are located everywhere. They are not particularly bound to existing communities; they fail to develop either regional characteristics or separate identity. These 'projects' date from the end of World War II when in southern California speculators or 'operative' builders adapted mass production techniques to quickly build many houses for the defense workers over-concentrated there. This 'California Method' consisted simply of determining in advance the exact amount and lengths of pieces of lumber and multiplying them by the number of standardized houses to be built. A cutting yard was set up near the site of the project to saw rough lumber into those sizes. By mass buying, greater use of machines and factory produced parts, assembly line standardization, multiple units were easily fabricated.

Each house in a development is a lightly constructed 'shell' although this fact is often concealed by fake (half-stone) brick walls. Shells can be added or subtracted easily. The standard unit is a box or a series of boxes, sometimes contemptuously called 'pillboxes.' When the box has a sharply oblique roof it is called a Cape Cod. When it is longer than wide it is a 'ranch.' A two-story house is usually called 'colonial.' If it consists of contiguous boxes with one slightly higher elevation it is a 'split level.' Such stylistic differentiation is advantageous to the basic structure (with the possible exception of the split level whose plan simplifies construction on discontinuous ground levels).

There is a recent trend 'two home homes' which are two boxes split by adjoining walls and having separate entrances. The left and right hand units are mirror reproductions of each other. Often sold as private units are strings of apartment-like, quasi-discrete cells formed by subdividing laterally an extended rectangular parallelopiped into as many as ten or twelve separate dwellings.

Developers usually build large groups of individual houses sharing similar floor plans and whose overall grouping possesses a discrete flow plan. Regional shopping centers and industrial parks are sometimes integrated as well into the general scheme. Each development is sectioned into blocked-out areas containing a series of identical or sequentially related types of houses all of which have uniform or staggered set-backs and land plots.

'two home homes'

The logic relating each sectioned part to the entire plan follows a systematic plan. A development contains a limited, set number of house models. For instance, Cape Coral, a Florida project, advertises eight different models:

A The Sonata
B The Concerto
C The Overture
D The Ballet
E The Prelude
F The Serenade
G The Noctune
H The Rhapsody

As the color series usually varies independently of the model series, a block of eight houses utilizing four models and four colors might have forty-eight times forty-eight or 2,304 possible arrangements.

split level and ground level 'two home homes'

In addition, there is a choice of eight exterior colors:

1 White
2 Moonstone Grey
3 Nickle
4 Seafoam Green
5 Lawn Green
6 Bamboo
7 Coral Pink
8 Colonial Red

Each block of houses is a self-contained sequence — there is no development — selected from the possible acceptable arrangements. As an example, if a section was to contain eight houses of which four model types were to be used, any of these permutational possibilities could be used:

AABBCCDD	ABCDABCD
AABBDDCC	ABDCABDC
AACCBBDD	ACBDACBD
AACCDDBB	ACDBACDB
AADDCCBB	ADBCADBC
AADDBBCC	ADCBADCB

BBAACCDD	BADCBADC
BBAADDCC	BACDBACD
BBCCAADD	BCADBCAD
BBCCDDAA	BCDABCDA
BBDDAACC	BDACBDAC
BBDDCCAA	BDCABDCA
CCAABBDD	CABDCABD
CCAADDBB	CADBCADB
CCBBDDAA	CBADCBAD
CCBBAADD	CBDACBDA
CCDDAABB	CDABCDAB
CCDDBBAA	CDBACDBA
DDAABBCC	DACBDACB
DDAACCBB	DABCDABC
DDBBAACC	DBACDBAC
DDBBCCAA	DBCADBCA
DDCCAABB	DCABDCAB
DDCCBBAA	DCBADCBA

The 8 color variables were equally distributed among the house exteriors. The first buyers were more likely to have obtained their first choice in color. Family units had to make a choice based on the available colors which also took account of both husband and wife's likes and dislikes. Adult male and female color likes and dislikes were compared in a survey of the homeowners:

'Like'

Male	Female
Skyway	Skyway Blue
Colonial Red	Lawn Green
Patio White	Nickle
Yellow Chiffon	Colonial Red
Lawn Green	Yellow Chiffon
Nickle	Patio White
Fawn	Moonstone Grey
Moonstone Grey	Fawn

'Dislike'

Male	Female
Lawn Green	Patio White
Colonial Red	Fawn
Patio White	Colonial Red
Moonstone Grey	Moonstone Grey
Fawn	Yellow Chiffon
Yellow Chiffon	Lawn Green
Nickle	Skyway blue
Skyway Blue	Nickle

A given development might use, perhaps, four of these possibilities as an arbitrary scheme for different sectors; then select four from another scheme which utilizes the remaining four unused models and colors; then select four from another scheme which utilizes all eight models and eight colors; then four from another scheme which utilizes a single model and all eight colors (or four or two colors); and finally utilize that single scheme for one model and one color. This serial logic might follow consistently until, at the edges, it is abruptly terminated by pre-existent highways, bowling alleys, shopping plazas, car hops, discount houses, lumber yards or factories.

66 Dan Graham, *Homes for America*, artist's paste-up, 1966. Type, manuscript, and black and white photographs on paper. 102 × 154 cm. Brussels, Daled Collection.

Although there is perhaps some aesthetic precedence in the row houses which are indigenous to many older cities along the east coast, and built with uniform façades and set-backs early this century, housing developments as an architectural phenomenon seem peculiarly gratuitous. They exist apart from prior standards of 'good' architecture. They were not built to satisfy individual needs or tastes. The owner is completely tangential to the product's completion. His home isn't really possessable in the old sense; it wasn't designed to 'last for generations'; and outside of its immediate 'here and now' context it is useless, designed to be thrown away. Both architecture and craftsmanship as values are subverted by the dependence on simplified and easily duplicated techniques of fabrication and standardized modular plans. Contingencies such as mass production technology and land use economics make the final decisions, denying the architect his former 'unique' role. Developments stand in an altered relationship to their environment. Designed to fill in 'dead' land areas, the houses needn't adapt to or attempt to withstand Nature. There is no organic unity connecting the land site and the home. Both are without roots — separate parts in a larger, predetermined, synthetic order.

Top left: set-back rows (rear view); Bayonne, N.J.

Top right: set-back rows (front view); Bayonne, N.J.

Bottom right: two rows of set-backs; Jersey City, N.J.

feel today. He had just completed his Fourth Piano Concerto, and was appreciated as a composer-conductor-pianist everywhere except in his own native Russia, where he was a musical exile. Igor Stravinsky, another musical exile, had arrived in America in 1925 when he conducted his own works with the New York Philharmonic and appeared with other orchestras as a pianist. During 1926 he completed his second *Suite for Small Orchestra*. His popularity here remains undiminished. The summer of 1966 was the occasion for a unique festival at Lincoln Center, under the direction of Lukas Foss. Featuring works of Stravinsky it included Foss and Elliot Carter who were influenced by Stravinsky. At the final concert Stravinsky conducted his own music in what I consider to be the most moving musical event I have witnessed. He is currently conducting, composing, and as audacious in response to his critics as ever.

Arnold Schonberg, the other great influence of our times (along with Webern and Berg), was composing his Third String Quartet in 1926. He was almost unknown in this country and not widely appreciated in Europe, except for works he had written before he devoted his life to his use of the twelve tone technique. Just recently, his Chamber Symphony and highly dramatic *Survivor from Warsaw* were performed brilliantly by Leonard Bernstein and the New York Philharmonic with great success, and his music is studied and performed all over the world. His place in music is still not fully recognized.

The more popular composers of forty years ago were also able performers. Paul Hindemith played the viola with the Amor-Hindemith quartet, and somehow still found time in 1926 to finish *Cardillac*, a three-act opera, and *Three Studies for Piano*. In addition he began *Music for Mechanical Instruments, Opus 40*, which included a Toccata for player piano. While our native Roger Sessions was not to receive the Guggenheim Fellowship until a year later, Maurice Ravel was commissioned in America to write his *Chansons Medicasses* by Elizabeth Sprague Coolige and during the same year his opera *Les Sortileges* was first performed in Paris. It had a libretto by Collette, but both of these works could not have kept him out of the poor house if it were not for his concert tour of England. (This was two years before he wrote *Bolero*.) Boulez, who was one-year-old then, finds himself in the same position today, and his brilliant conducting enables him to support himself while he continues composing.

Leos Janacek wrote one of his last works, *Sinfonietta for Orchestra*, and forty years later, his music is being 'discovered' again in America. Darius Milhaud, still composing today as furiously as ever, completed his one-act opera *Le Pauvre Matelot* in 1926 and we are fortunate enough to have him as the guiding spirit of many composers of today, including such unique talents as William

Bolcum, a composer in his early twenties, and Dave Brubeck the Jazz pianist.

To conclude this whirlwind tour of composers' activities, 1926 was the year that Roy Harris completed *Andante*, his first major work for orchestra. This was also the year that Ibert composed his *Concerto for Winds*, and Villa-Lobos completed *Choros Number 14*. Bela Bartok, considered by many to be the greatest composer of this century, completed his First Piano Concerto. This remarkably beautiful composition, like all of Bartok's music, has the expressive force and soul that is unique in all of modern music.

In Jazz Duke Ellington and Bix Beiderbecke are as influential today as they were forty years ago, and like hundreds of other Jazz artists of the 'twenties as well as those of today, are appreciated more in every country in the world than in America.

Today, we have so many gifted composers, conductors, soloists, Jazz and folk artists that it is only possible to mention a few. Composers are more plentiful than ever, and in spite of the generosity of many individuals and foundations, it is still almost impossible for anyone to make even a substandard living from their music. There is a healthy trend now however—the return of the composer who has also excelled as a practical musician. Even a few years ago any composer seen carrying an instrument was a rarity. In 1966 this kind of snobbery is obsolete. Harold Farberman and Michael Colgrass are both virtuoso percussionists who are equally well respected as composers. Morton Subotnick is a first-rate clarinetist, and Ezra Laderman is an excellent flutist, though both are established as young composers of importance. Gunther Schuller, recently appointed as head of the New England Conservatory and the composer of perhaps the most exciting new opera since *Wozzeck* was a great French Hornist. And Edwin London and myself both played the French Horn in symphony orchestras as well as leading our own Jazz groups.

There is also an increase in composers who came at least in part from the Jazz experience. Hall Overton, currently writing an opera for next season, and Salvatore Martirano whose *Contrasto* was just performed by the New York Philharmonic are both masterful Jazz pianists.

Two composers became successful authors in 1966. Ned Rorem and Virgil Thomson both had highly interesting and entertaining books published. 1966 was the year that Leonard Bernstein announced his intention of leaving his full-time job as Musical Director of the New York Philharmonic to devote more time to his composing.

In Jazz there is a new revolution every week and there are more expert players than ever before. In addition to Monk, Coltrane and Ornette Coleman, 1966 has hundreds if not thousands of amazing players all over the country. Among the foremost of these yet to be discovered by the public is Jeremy Steig, by far the best flutist I have ever heard

in Jazz, as well as the most versatile and lyrical player of avant-garde improvised music. Cecil Taylor, Sun-Ra and Roswell Rudd are finally being recognized.

Two of modern Jazz's greatest exponents died this year: pianist Bud Powell and singer Dave Lambert. Fortunately their music remains.

Jazz is no longer 'fashionable' but some of the masters such as Max Roach, Miles Davis, Zoot Sims, Al Cohn, Stan Getz, Ray Bryant, Gerry Mulligan, Dizzy Gillespie, Bill Evans and a few others can make a living playing in America. Many others have left for Europe. But Jazz remains as alive as ever and will be in 2006, just as it was in 1926.

In concluding I would like to say that music is more important today than it has ever been, and the great legacy that we have will remain long after the tons of trash in all the arts have been buried by the sweep of time and history. Beethoven's Ninth Symphony is still a very contemporary work today, and that is why it has survived so many years. All of us who are fortunate enough to live forty years from now will look back at music in 1966 with amazement and pride at how much was really there.

Homes for America

Early 20th-Century Possessable House to the Quasi-Discrete Cell of '66

D. GRAHAM

Belleplain	Garden City
Brooklawn	Garden City Park
Colonia	Greenlawn
Colonia Manor	Island Park
Fair Haven	Levittown
Fair Lawn	Middleville
Greenfields Village	New City Park
Green Village	Pine Lawn
Plainsboro	Plainview
Pleasant Grove	Plandome Manor
Pleasant Plains	Pleasantside
Sunset Hill Garden	Pleasantville

Large-scale 'tract' housing 'developments' constitute the new city. They are located everywhere. They are not particularly bound to existing communities; they fail to develop either regional characteristics or separate identity. These 'projects' date form the end of World War II when in southern California speculators or 'operative' builders adapted mass production techniques to quickly build many houses for the defense workers over-concentrated there. This 'Cali-

21

67 Dan Graham, "Homes for America," *Arts* magazine, January 1966–7. The magazine's editors were responsible for the altered layout and substitution of photographs by Walker Evans.

fornia Method' consisted simply of determining in advance the exact amount and lengths of pieces of lumber and multiplying them by the number of standardized houses to be built. A cutting yard was set up near the site of the project to saw rough lumber into those sizes. By mass buying, greater use of machines and factory produced parts, assembly line standardization, multiple units were easily fabricated.

Each house in a development is a lightly constructed 'shell' although this fact is often

"Contingencies such as mass production technology and land use economics make the final decisions, denying the architect his former 'unique' role." Above: Wooden Houses, Boston, 1930, from *American Photographs* by Walker Evans, published by The Museum of Modern Art. Below: house plan courtesy Cape Coral Homes.

The
SERENADE

Three Bedrooms,
Two Baths,
Enclosed Garage,
Screened Porch

concealed by fake (half-stone) brick walls. Shells can be added or subtracted easily. The standard unit is a box or a series of boxes, sometimes contemptuously called 'pillboxes.' When the box has a sharply oblique roof it is called a Cape Cod. When it is longer than wide it is a 'ranch.' A two-story house is usually called 'colonial.' If it consists of contiguous boxes with one slightly higher elevation it is a 'split level.' Such stylistic differentiation is advantageous to the basic structure (with the possible exception of the split level whose plan simplifies construction on discontinuous ground levels). There is a recent trend toward 'two home homes' which are two boxes split by adjoining walls and having separate entrances. The left and right hand units are mirror reproductions of each other. Often sold as private units are strings of apartment-like, quasi-discrete cells formed by subdividing laterally an extended rectangular parallelopiped into as many as ten or twelve separate dwellings.

Developers usually build large groups of individual homes sharing similar floor plans and whose overall grouping possesses a discrete flow plan. Regional shopping centers and industrial parks are sometimes integrated as well into the general scheme. Each development is sectioned into blocked-out areas containing a series of identical or sequentially linked types of houses all of which have uniform or staggered set-backs and land plots.

The logic relating each sectioned part to the entire plan follows a systematic plan. A development contains a limited, set number of house models. For instance, Cape Coral, a Florida project, advertises eight different models:

A The Sonata
B The Concerto
C The Overture
D The Ballet
E The Prelude
F The Serenade
G The Noctune
H The Rhapsody

In addition, there is a choice of eight exterior colors:

1 White
2 Moonstone Grey
3 Nickle
4 Seafoam Green
5 Lawn Green
6 Bamboo
7 Coral Pink
8 Colonial Red

Each block of houses is a self-contained sequence—there is no development—selected from the possible acceptable arrangements. As an example, if a section was to contain eight houses of which four model types were to be used, any of these permutational possibilities could be used:

AABBCCDD	ABCDABCD
AABBDDCC	ABDCABDC
AACCBBDD	ACBDACBD
AACCDDBB	ACDBACDB
AADDCCBB	ADBCADBC

AADDBBCC	ADCBADCB
BBAACCDD	BADCBADC
BBAADDCC	BACDBACD
BBCCAADD	BCADBCAD
BBCCDDAA	BCDABCDA
BBDDAACC	BDACBDAC
BBDDCCAA	BDCABDCA
CCAABBDD	CABDCABD
CCAADDBB	CADBCADB
CCBBDDAA	CBADCBAD
CCBBAADD	CBDACBDA
CCDDAABB	CDABCDAB
CCDDBBAA	CDBACDBA
DDAABBCC	DACBDACB
DDAACCBB	DABCDABC
DDBBAACC	DBACDBAC
DDBBCCAA	DBCADBCA
DDCCAABB	DCABDCAB
DDCCBBAA	DCBADCBA

As the color series usually varies independently of the model series, a block of eight houses utilizing four models and four colors might have forty-eight times forty-eight or 2,304 possible arrangements.

A given development might use, perhaps, *four* of these possibilities as an arbitrary scheme for different sectors; then select four from another scheme which utilizes the remaining four unused models and colors; then select four from another scheme which utilizes all eight models and eight colors; then four from another scheme which utilizes a single model and all eight colors (or four or two colors); and finally utilize that single scheme for one model and one color. This serial logic might follow consistently until, at the edges, it is abruptly terminated by pre-existent highways, bowling alleys, shopping plazas, car hops, discount houses, lumber yards or factories.

Although there is perhaps some aesthetic precedence in the row houses which are indigenous to many older cities along the east coast, and built with uniform façades and set-backs early this century, housing developments as an architectural phenomenon seem peculiarly gratuitous. They exist apart from prior standards of 'good' architecture. They were not built to satisfy individual needs or tastes. The owner is completely tangential to the product's completion. His home isn't really possessable in the old sense; it wasn't designed to 'last for generations'; and outside of its immediate 'here and now' context it is useless, designed to be thrown away. Both architecture and craftsmanship as values are subverted by the dependence on simplified and easily duplicated techniques of fabrication and standardized modular plans. Contingencies such as mass production technology and land use economics make the final decisions, denying the architect his former 'unique' role. Developments stand in an altered relationship to their environment. Designed to fill in 'dead' land areas, the houses needn't adapt to or attempt to withstand Nature. There is no organic unity connecting the land site and the home. Both are without roots—separate parts in a larger, pre-determined, synthetic order.

equally minimal interventions in the space of exhibition to a strongly figured narrative about the conditions of spectatorship in a field far wider in space and time than that provided by the gallery or museum.[34] One of the strongest of these works finds a pastoral means to this end, in this case the iconography of the mythological American as pioneer and predator.

The occasion was his contribution to the exhibition *The Museum as Site*, staged at the Los Angeles County Museum of Art in 1981.[35] The piece consisted of three parts. In one, a wooden sign carrying the inscription "Dogs Must Be Kept on Leash Ord. 10309" was replaced in the park surrounding the museum at precisely the same spot from which a previous sign had been lifted by "vandals" (pl. 68). The marker was produced by the parks workshop to match the rustic, handcrafted look of the missing one and the other notices posted in the park. It signals urban prohibitions on animal freedom, and also calls to mind the ancient danger to unwary beasts posed by the tar pits which dot the park, pits which have produced a famous bounty of fossils of prehistoric mammals, and which are in themselves a magnet for visitors. (Asher's catalogue photograph of this element of the piece shows the sign directly juxtaposed to the protective fence around a pit, the sheen of the water collected on its surface, and a large concrete statue of a Mastodon supplied as an illustration to visitors.) These dull-looking, placid ponds are, in addition, the most palpable sign that Los Angeles floats on a lake of oil.

Secondly, a poster in color and a black and white still photograph, both showing an identical scene from the Hollywood film *The Kentuckian*, were mounted inside a glass vitrine in the main entrance court of the museum (pl. 68). In the scene, two gunmen confront Burt Lancaster, playing the title role, as he steps into a forest clearing accompanied by a woman, a boy, and a dog on a leash. Here Asher placed the only public acknowledgement that the piece existed, a laconic description of its elements, along with marks on a map of the park and museum to indicate their location (here the replaced sign is described as being "on the path between the B.G. Cantor Sculpture Garden and the lake pit"). Thirdly, as the viewer was informed at this spot, the museum's permanent collection houses a painting by Thomas Hart Benton entitled *The Kentuckian* (pl. 70).

It is left to the visitor to discover that the painting, dated 1954, had been commissioned to coincide with the release of the film, and that it had belonged to Lancaster himself until he donated it to the museum in 1977. It depicts the actor as a pioneer explorer, striding over a mountain ridge with bedroll and musket, followed by his dog and a boy carrying a hefty

190

68 Michael Asher, untitled installation, 1981. *The Museum as Site: Sixteen Projects*, Los Angeles County Museum of Art. Detail showing sign in Hancock Park.

powderhorn. Characteristic of Benton and like the film, it is an idealized celebration of America's westward expansionism in the nineteenth century. The museum, of course, is geographically located at the end of one path of that expansion and endowed with wealth from both the exploitation of the West's resources (pre-eminently oil) and the mythmaking of the film industry. Inside it, the visitor could find Benton's painting in its usual place in the permanent collection, without any additional information referring to Asher's temporary enlistment of it in the completion of his piece. His catalogue photograph documenting this element is a wide shot which includes the painting on one side and on the other a sign on a waist-high pedestal reading "MEMBERS ONLY". Beyond this point the ordinary visitor is barred from further penetration; "the Kentuckian" himself appears headed in that direction.

Though Asher works on the museum, he withholds the pleasures of obvious aggression against the institution.[36] The museum or gallery has

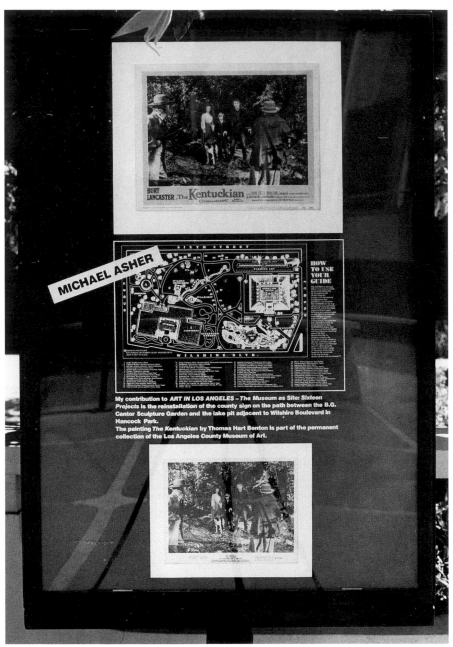

69 Michael Asher, untitled installation, 1981. *The Museum as Site*: *Sixteen Projects*, Los Angeles County Museum of Art. Detail showing information panel at museum entrance, still, and poster for the film *The Kentuckian*, indication on site map of replaced sign in Hancock Park.

70 Michael Asher, untitled installation, 1981. *The Museum as Site: Sixteen Projects*, Los Angeles County Museum of Art. Detail showing installation of Thomas Hart Benton, *The Kentuckian*, 1954. Donated to museum by Burt Lancaster.

become only too happy to be commented upon, defaced or dismantled, and thereby enhanced in its importance and prestige as a provider of stimulating moments of perception.[37] In Asher's piece, with the same kind of deft economy Graham achieved in *Homes for America*, the institution is shown to be vulnerable to a nearly effortless redescription as something other than the enlightened and disinterested cultural provider it wants to be seen to be.

On the individual level, he denies to the practiced viewer of Conceptual work the normal ritual associated with the encounter: the echoing footsteps in the bare, under-populated gallery, the table, placard or bound pages placed just so, waiting for his or her concentrated attention. Instead, the viewer is enticed into a series of pastoral identifications – the credulous viewer, the stranger to the museum, the family of tourists, the pensioner walking a dog in the park, the child for whom the tar pits are the great

object of fascination, the vain actor and museum patron pleased to identify himself with an heroic fictional role. Attending to a map of signposts, thresholds and barriers, Asher only marks an itinerary around Hancock Park traced by many before him, but it is one that manages to articulate an extensive network of relations between contemporary practice and the social, the economic, and even the natural history of this specific site. His discreet intervention performs the essential pastoral trick, that is, by adopting what the great world would regard as limited points of view, it achieves the largest possible comprehension and scale.

<p style="text-align:center">* * *</p>

Annette Lemieux's tart observation on Jasper Johns and the American flag found an apposite place in the foregoing account of the high genre's resiliency within recent art theory. She belongs to the recent generation of artists who have themselves grown conversant with ambitious theorizing. But unlike many who have simply used theory as a license for artful manipulation of received images, she has in her art implicitly invited sceptical attention to a particular movement in current critical thinking: one that threatens to disarm a key pastoral contrast in the artistic record of the 1960s by denying any fundamental opposition between high modernism and Pop art.

Speaking of Kenneth Noland's targets and chevrons, Rosalind Krauss has recently written, "It is the world of commercial emblems and corporate logos generated from within a serial expansion, which speaks mainly about repetition and mass production. . . ." This short sentence typifies the normal movement of high-art discourse from something relatively concrete – the graphic economy characteristic of trademarks – to a picture of modern production as a sign system, that is, to a description pitched at the highest level of abstraction. This passage then goes on to equate the epiphanies of Fried's ideal viewer with the passion of the everyday consumer of pop images:

> . . . this very abstract presence, this disembodied viewer as pure desiring subject, as subject whose disembodiment is, moreover, guaranteed by its sense of total mirroring dependency on what is not itself – that is, precisely the subject constructed by the field of pop and the world into which it wants to engage, the world of the media and the solicitation of advertising.[38]

The confidence of this statement highlights, by contrast, the more modest and observant strategies to be found in the work of Lemieux.

The geometric motifs of 1960s abstraction, which provide a stabilizing historical foundation for a good deal of her work, may lead one's thoughts initially to the crisp insignia of modern corporate multinationals. But it is an unnecessarily restricting premise to assume that these motifs are thus trapped forever in one closed circuit of self-replicating signs. We can concede that subjectivity is constructed in and through sign systems without restricting our analysis to those of maximum abstraction. Visual signs, as Lemieux is concerned to establish, have long histories in a society and in individual life spans. So her displacements of characteristically 1960s shapes and arrangements – by shifts to subjectively evocative colors and juxtaposition with other kinds of object – follow more varied paths of association (pl. 71).

One abiding use of hieratic and centralized signs is in the military. The globalization of "low-intensity" conventional conflicts and the resulting centrality of the armaments trade in the world economy is as pervasive and potentially important for art as the global culture of consumerism. Works of art seem more to resemble or to be more in dialogue with the manufactured products that pervade our everyday lives in the West, but in too many places in the world Kalashnikov assault rifles are also status symbols.

In the West, however, war affects people far more unequally than does advertising and marketing, as Lemieux, from her own family experience, is in a good position to know. She is, moreover, young enough to have a father who served in Vietnam rather than World War II, and can find in childhood recollection tokens for the experience of a morally ambiguous and distanced warfare. The problem for art that would address that aspect of the great world is to find ways to project it, on the one hand, into the limited scope of one's artistic means and, on the other, into some commensurately small, mappable human world.

The geometric insignia extrapolated from earlier abstraction manage to serve both ends and provide the basis for her characteristic economy of statement. The women in a military household are those who feel acutely their exclusion from direct knowledge of war, a condition that the rest of society takes for granted and counts on to numb perception. Months can go by with even the whereabouts of a soldier unknown to his family. The absence of the father/brother/son along with his perilous destination are registered by the insignia left behind, objects that carry particular fascination for children and other thoughts for adults.

The decline in public consciousness of war can be measured by the loss of the public significance once carried by these symbols of absence. In

71 Annette Lemieux, *Vacancy*, 1986. Oil on canvas, oval frame with glass, canvas
233.6 × 182.9 cm. Private collection.

World War II the star stood for an absent or dead son; the smaller world of several of Lemieux's pieces is the women's sphere during that war, which is recalled less as a better, more moral conflict than as a time when symbols meant something. Her stripes and stars are located within this field of meaning by the juxtaposition, in the same visual field, of small found objects, recognizable relics of that smaller world, which provide discreet clues to a reading. Precise execution is everything in this kind of work, and it has to steer just this side of sentimentality to work at all. That it keeps to this side most of the time is the clearest sign of its clarity as a project.

<p style="text-align:center">* * *</p>

Optimistic 1960s art and the symbols of war call to mind the most public architect of the American cult of counter-insurgency, John F. Kennedy. His fantasies of risk and daring have fed the romantic cult that surrounded him in life and has shown little sign of diminishing since. Warhol demonstrated, in the immediate aftermath of the assassination, that Kennedy as a subject could be saved for art, but only through rigorous distancing procedures and the indirection of the pastoral.[39] Christopher Williams, a contemporary of Lemieux, has revived that strategy to telling effect. As his art developed during the 1980s, his central subject matter – following that of much high-profile Foucauldian theory – has been the archive, that much-discussed intersection between photographic trace, knowledge, and power. And one early piece took him to an archive where the indexing and display of power are unmistakable: the Kennedy Presidential Library in Massachusetts.

His characteristic technique has been to impose from the outset a simple and rigid criterion of selection from the larger repository of images: in this case, the piece consisted of all the photographs of Kennedy taken on one chosen day in 1963, in which he appears with his back to the camera.[40] The group of four prints (three black and white and one color) generated by this procedure were then uniformly subjected to an identical regimen of rephotography, enlargement and cropping (pls. 72, 73). The selection criterion – he calls it a "filter" – transforms the ordinarily radiant center of such portraiture into a momentary void or occlusion. The effect is to signal to the cultivated viewer that the "best" theory of the sign is in use (presence being acknowledged as an illusion predicated on absence), while it documents the ordinary efficiency of the publicity of power (in that it is seen so seldom to fail in the ostensible enterprise of documentary photography).

72 and 73 (facing page) Christopher Williams, SOURCE: *The Photographic Archive,*
John F. Kennedy Library, Columbia Point on Dorchester Bay, Boston, Massachusetts,
02125, U.S.A.; CONDITIONS FOR SELECTION: *There are two conditions: the photograph*
or photographs must be dated May 10, 1963, and the subject, John F. Kennedy, must
have his back turned toward the camera. All photographs on file fulfilling these
requirements are used. TECHNICAL TREATMENT: *The photographs are subjected to the*
following operations: rephotography (4 × 5" copy negative), enlargement (from 8 ×
10" to 11 × 14" by use of the copy negative), and cropping (¹/₁₆" is removed from
all sides of the rephotographed, enlarged image). The final component of the title,
PRESENTATION, is a variable, as it cites the name, title, and date of the exhibition, and
the name and address of the venue, followed by the name of the artist. Details.

But that highly cerebral awareness of abstract systems of information is
unavailable without a simultaneous recognition of meaning on the level of
historical folk memory: the visible body at the point of portraiture's failure
is the body revealed as unaware and vulnerable in the year of its death.
The outlaw assassin is the dark follower and product of the publicity of
power; the Kennedy regime intensified and relied upon that publicity more
than any of its predecessors, only to become its most notable victim.
Inscribing the premonition of death into his distanced and impersonal

procedures, Williams gives to his historical portraiture all the real coldness that is common to both his theoretical armature and his raw material.

The topic of political murder returned in subsequent works, but with a marked difference in level and scale. One of them, entitled *Angola to Vietnam** of 1989 (pls. 74–6), introduces the topic most commonly associated with the pastoral, the bounty of wild nature.[41] Once again, he based his work in an archive with a Harvard connection, in this case, the collection of glass replicas of botanical specimens housed in a university museum of natural history. The "glass flowers," as they are commonly

known, are the work of the Blaschkas, a family firm of Dresden craftsmen, who produced the 847 replica specimens between 1887 and 1936.[42] The flowers were produced by a father and son until the death of the former in 1895; the son then carried on alone for another forty years. Their complex skills have, for practical purposes, been lost, so that the archive is no longer being added to or duplicated. And since the collection's earliest years, extravagant stories have grown up around the Blaschkas' supposedly secret techniques. This alchemical mystique contributes to the magnetism surrounding the collection, which attracts large numbers of fascinated tourists to its outwardly prosaic and pedagogical display.

Williams subjected the collection to an initial, mental rearrangement that did no disturbance to its empirical purposes; he has reclassified the models from a botanical taxonomy to classification by country. His filter then comes from another map of the world, that provided by a 1985 Amnesty International report on countries in which political disappearances had been documented. The overlap yielded twenty-seven specimens, each of which he had photographed to his own precise instructions. In the installation of the work, the prints are hung with descriptive labels listing country of origin, botanical data, collection indices of the botanical specimen, and the technical specifications of the photograph itself. The close-up framing of the specimens follows closely the conventions used by Harvard's own photographer.[43] However, where the official images, in sparkling color, make the flowers appear vibrantly alive, Williams's choice of black and white minimizes spurious illusions.

The somberness of the black and white print provides the visual decorum appropriate to the subject. That subdued understatement proceeds from a general detachment and balance which prevails in the piece and which is generally appropriate to a work in the high genre. Its most abstract characteristic, the principle of selection which determines number and interval, is just as appropriately drawn from the realm of international politics, in that the archive of plant specimens stands for the drive of an imperious institution to exercise a global dominion of scientific expertise. Yet the piece leavens that rather chilling abstraction by calling on a common yearning for a seasonless natural world that is a place of healing, beauty, and abundance; the glass flowers exert their power by standing as tokens for this redemptive wish – as art itself has often done. What is imagined as a lost art approaching alchemy has conjured life from an inanimate substance. By virtue of that substratum of feeling, the abstraction that defines the piece at the same time concretely figures a *tristes tropiques*, where the murderous denial of such longings, and all more

modest desires for everyday human fulfillment which accompany them, is a reality our rulers permit and frequently encourage in our name. Williams's photographs sometimes reveal breaks and repairs in the models, pointing up an aspect of popular fascination with the flowers that runs in the opposite direction to the illusion of permanence. The literature for visitors concentrates on the fragility of the models: their susceptibility to accident, abuse, catastrophe, and permanent extinction.[44] The circumstances that led to each lost flower, each permanent subtraction from the community, are carefully explained. Clearly responding to the preoccupations and inquiries of the lay audience, this literature makes the glass replicas seem more alive than their natural referents – more alive in that they, like human individuals, cannot be replaced. Their reception is already marked by the imagination of human suffering and death, an anthropomorphizing empathy to which high theory is normally hostile.

In gauging the success of the piece, an old and resonant remark by Clement Greenberg comes to mind: "The best visual art of our time," he wrote in 1947, ". . . is that which comes closest to non-fiction, has least to do with illusions, and at the same time maintains and asserts itself exclusively as art."[45] That Williams has fulfilled the terms of that demanding dictum (in ways that Greenberg himself would never have imagined) comes in no small part from his detour through the pastoral. The same could be said of the Graham and the Asher pieces. The logic and order of each, that which gives it its identity as art, is drawn from the same enlarged view, the same administered world that engendered Levittown, or the Kennedy and Harvard archives; and such has always been the fate of the highest genre. Each piece accepts that system on its own terms; each manifests an almost Apollonian economy of gesture and abhorrence of vulgar excess.

Yet that reticence of authorial presence, while retaining its unimpeachable elevation, finds crucial common ground with the everyday anonymity of those for whom being or not being "an Author" will never be an option. Each work, by virtue of its restrained detachment, frames the unpredictable vernacular uses of its material, the imaginative transformations already effected out in the world, over historical time, through thousands of unremarked individual transactions. Asher and Williams, both setting out to displace spectatorship beyond contemplative aestheticism, rediscover the spectator in one or another manifestation of pastoral heroism: in the pilgrim, the assassin, the seeker in the garden. The corresponding genres of representation into which their pieces fall – landscape, statesman's portrait, still-life – are again able to function, but only because the park users and

1

Angola, 1989
Blaschka Model 439, 1894
Genus no. 5091
Family, Sterculiaceae
Cola acuminata (Beauv.) Schott and Endl.
Cola Nut, Goora Nut

74 Christopher Williams, *Angola to Vietnam**. Detail.

16
Mexico, 1989
Blaschka Model 160, 1890
Genus no. 9228
Family, Compositae
Dahlia pinnata Cav.
Dahlia variabilis (Willd.) Desf.
Dahlia

75 Christopher Williams, *Angola to Vietnam**. Detail.

2
Argentina, 1989
Blaschka Model 289, 1892
Genus no. 7438
Family, Solanaceae
Nierembergia gracilis Hook.
Nierembergia calycina Hook.

3
Bolivia, 1989
Blaschka Model 268, 1892
Genus no. 5397
Family, Begoniaceae
Begonia boliviensis A.DC.

4
Brazil, 1989
Blaschka Model 104, 1889
Genus no. 3870
Family, Leguminosae
Erythrina Crista-galli Linn.
Coral-tree, Coral-plant, Cockscomb

5
Central African Republic, 1989
Blaschka Model 783, 1923
Genus no. 5112
Family, Ochnaceae
Ochna multiflora DC.

76 Christopher Williams, *Angola to Vietnam**, 1989. 27 gelatin silver prints with captions, each photograph 35.5 × 28 cm. or the reverse.

6
Chile, 1989
Blaschka Model 180, 1890
Genus no. 7474
Family, Scrophulariaceae
Calceolaria scabiosaefolia Roem and Schult.

7
Colombia, 1989
Blaschka Model 158, 1890
Genus no. 8642
Family, Cucurbitaceae
Cyclanthera pedata Schrad.
Pepino de Comer

8
Dominican Republic, 1989
Blaschka Model 601, 1896
Genus no. 4493
Family, Euphorbiaceae
Hura crepitans Linn.
Sandbox tree

9
El Salvador, 1989
Blaschka Model 639, 1898
Genus no. 7158
Family, Verbenaceae
Petrea volubilis Jacq.
Purple Wreath

10
Ethiopia, 1989
Blaschka Model 478, 1894
Genus no. 8381
Family, Rubiaceae
Coffea arabica Linn.
Coffee, "Coffa"

11
Guatemala, 1989
Blaschka Model 227, 1891
Genus no. 1660
Family, Orchidaceae
Lycaste Skinneri (Batem.) Lindl.

12
Haiti, 1989
Blaschka Model 601, 1896
Genus no. 4493
Family, Euphorbiaceae
Hura crepitans Linn.
Sandbox Tree

13
Honduras, 1989
Blaschka Model 469, 1894
Genus no. 4155
Family, Meliaceae
Cedrela odorata Linn.
West Indian Cedar, Jamaica Cedar, Spanish Cedar

14
Indonesia, 1989
Blaschka Model 693, 1903
Genus no. 1318
Family, Musaceae
Musa paradisiaca Linn.
subsp. sapientum (Linn.) Ktze.
Banana

15
Lebanon, 1989
Blaschka Model 770, 1906
Genus no. 1961
Family, Moraceae
Ficus Carica Linn.
The Fig

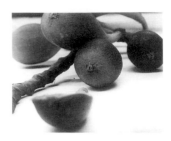

17
Namibia, 1989
Blaschka Model 95, 1889
Genus no. 3164
Family, Crassulaceae
Cotyledon orbiculata Linn.

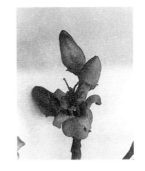

18
Nicaragua, 1989
Blaschka Model 424, 1894
Genus no. 4546
Family, Anacardiaceae
Anacardium occidentale Linn.
Cashew Acajou

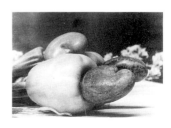

19
Paraguay, 1989
Blaschka Model 494, 1894
Genus no. 663d
Family, Palmae
Arecastrum Romanzoffianum (Cham.) Becc.
var. australe (Mart.) Becc.
cocos australis Mart.
Pindo Palm

20
Peru, 1989
Blaschka Model 180, 1890
Genus no. 7474
Family, Scrophulariaceae
Calceolaria scabiosaefolia Roem and Schult.

21
Philippines, 1989
Blaschka Model 387, 1893
Genus no. 5020
Family, Malvaceae
Gossypium herbaceum Linn.
Gossypium Nanking Meyen
Nanking Cotton

22
South Africa, 1989
Blaschka Model 95, 1889
Genus no. 3164
Family, Crassulaceae
Cotyledon orbiculata Linn.

23
Sri Lanka, 1989
Blaschka Model 694, 1903
Genus no. 1318
Family, Musaceae
Musa rosacea Jacq.

24
Togo, 1989
Blaschka Model 439, 1894
Genus no. 5091
Family, Sterculiaceae
Cola acuminata (Beauv.) Schott and Endl.
Cola Nut, Goora Nut

25
Uganda, 1989
Blaschka Model 482, 1894
Genus no. 3892
Family, Leguminosae
Cajanus Cajan (Linn.) Druce
Cajanus indicus Spreng.
Pigeon Pea

26
Uruguay, 1989
Blaschka Model 175, 1890
Genus no. 7447
Family, Solanaceae
Browallia viscosa HBK

27
Vietnam, 1989
Blaschka Model 272, 1892
Genus no. 8594
Family, Cucurbitaceae
Luffa cylindrica (Linn.) Roem.

museum visitors themselves continually arrange the material into patterns of cognitive and emotional response that the artist exploits but cannot himself any longer create or impose. Advanced art cannot live for long without the abandoned lower genres, and must now depend on the people into whose modest keeping those genres have fallen.

The practice of fine art is, like any formalized discipline, a prisoner of its history. It cannot cease to be a highly specialized activity requiring considerable learning and patient application from its practitioners and primary audience, that is, not without ceasing to exist at all. The emergence and persistence of the genre hierarchy imposed a line between the discipline of art and the wider realm of visual communication in all its manifold forms. To attempt to extinguish this boundary is the product either of an idle denial of the historical record or of a wish for an entropic loss of articulateness and difference in cultural life – which is proceeding quickly enough anyway. That the fine arts have acceded to some of the former territory of academic philosophy, but for a far larger audience, is a direct product of this discipline and a mark of its democratizing potential.

It is difficult nowadays to talk about the capacities of advanced art without being caught up in a polarized debate about elitism, canons, and claims to commensurate prestige lodged on behalf of more accessible kinds of cultural production. As in so many things that seem to be discoveries of the present, this has long been an issue in serious art practice, even if commentators and historians have been slow to recognize it. Every artist who finds a pressing need for the already handled, already transformed expressions of vernacular culture admits to his or her creative project a multitude of anonymous collaborators. Those discussed above, from Picasso to Lemieux and Williams, have built into the core of their practice a recognition that assured sovereignty over their means and materials could be as much a problem as a source of power. Pastoral forms of irony within advanced art function as correctives to the congealing of professional codes of competence, to facility that too easily makes formula look like invention, to the constraints imposed by relentless high-mindedness on the breadth of human sympathy. They transform the limitations imposed by hierarchy and artificial division, the costs of exclusivity and specialized protocols, into matter for art. And the pastoral entails a final recognition that the fine arts' inability to transform themselves further, to become a genuine culture for all, remains their great and defining inadequacy.

211

11

Unwritten Histories of Conceptual Art: Against Visual Culture

> Historical objectification ought to be sped up while
> there is still a collective experience and memory which
> can assist in the clarity of an analysis while, simul-
> taneously, opening up a space to ask fundamental
> questions regarding history-making. (Michael Asher,
> 1989)[1]

Almost every work of serious contemporary art recapitulates, on some
explicit or implicit level, the historical sequence of objects to which it
belongs. Consciousness of precedent has become very nearly the condition
and definition of major artistic ambition. For that reason artists have
become avid, if unpredictable, consumers of art history. Yet the organized
discipline of the history of art remains largely blind to the products of this
interest and entirely sheltered from the lessons that might accrue from
them.

That art historians of a traditional cast should display little interest in
new art, however historically informed, is of course a familiar story:
within living memory, all art produced since 1600 was merged into the
single category of "post-Renaissance." Recent changes in art history have
not greatly altered the situation, despite the growing prominence in the
discipline of theorists pursuing a postmodern vision of culture. Their
particular postmodernism has not grown from within visual art itself, but
derives instead from certain contentions within literary theory, most of all
the drive to relax the distinctions between a canon of great authors and
the universe of other texts once excluded from the teaching and learning
of literature. Influential voices, impressed by that example, have lately
recommended that the idea of a history of art be set aside, to be replaced
by a forward-looking "history of images," which will attend to the entire

range of visual culture. One benefit of such a change, the argument goes, will be that "the cultural work of history of art will more closely resemble that of other fields than has been the case in the past," and that transformation temptingly "offers the prospect of an interdisciplinary dialogue . . . more concerned with the relevance of contemporary values for academic study than with the myth of the pursuit of knowledge for its own sake."[2]

This is a fair definition of what postmodernism has come to mean in academic life. But as a blueprint for the emancipation of art history, it contains a large and unexamined paradox: it accepts without question the view that art is to be defined by its essentially visual nature, by its working exclusively through the optical faculties. As it happens, this was the most cherished assumption of high modernism in the 1950s and 1960s, which constructed its canon around the notion of opticality: as art progressively refined itself, the value of a work lay more and more in the coherence of the fiction offered to the eye alone. The term visual culture, of course, represents a vast vertical integration of study, extending from the esoteric products of fine-art traditions to handbills and horror videos, but it perpetuates the horizontal narrowness entailed in modernism's fetish of visuality. Its corollary in an expanded history of images (rather than art) likewise perpetuates the modernist obsession with the abstract state of illusion, with virtual effects at the expense of literal facts.[3]

What is plainly missing in this project is some greater acknowledgment of the challenges to modernist assumptions that changed the landscape of artistic practice from the later 1950s onwards. The postmodern art historian of the 1990s cites for support "consequences of the theoretical and methodological developments that have affected other disciplines in the humanities."[4] But the revival of Duchampian tactics in the hands of artists like Jasper Johns, Robert Morris, and Donald Judd long ago erased any effective elite/vernacular distinctions in the materials of art, while at the same time opening contexts and hidden instrumental uses of art to critical scrutiny. The great theoretical advantage of this activity, as opposed to doctrines imported from other disciplines, was its being made from existing art and as such requiring no awkward and imprecise translation in order to bear upon the concerns of art history. Nor could these practical artistic ventures be contained within the category of the image, a fact which a succeeding generation of overtly Conceptual artists then took as fundamental. The "withdrawal of visuality" or "suppression of the beholder", which were the operative strategies of Conceptualism, decisively set aside the assumed primacy of visual illusion as central to the making and understanding of a work of art.[5]

During the early 1970s the transitory, hazardous and at times illegal performances staged by Chris Burden remained, apart from a select group of collaborators, unavailable to spectatorship.[6] The photographic documentation by which such events were subsequently publicized serves to mark the inadequacy of recorded image to actual phenomenon. Conceptual work of a materially substantial and permanent character was no more amenable to the category of visual culture. Works like the *Index* of the Art & Language group dared the spectator to overcome a positively forbidding lack of outward enticement in order to discover a discursive and philosophical content recorded in the most prosaic form possible.

Even in discrete objects in traditional formats, there is something of a tradition – stretching from Elaine Sturtevant to Sherrie Levine – whereby the visual appeal of painting or photography is acknowledged but expelled by tactics of replication.[7] Perhaps as revealing as any theoretical exegesis is a bantering remark made in a recorded conversation between two collectors, both perceptive enough to have supported Sturtevant:

> I am sure that you have often noticed that visitors to your apartment – like the visitors to our loft – shrug off the Warhol or the Stella before you tell them that it is Sturtevant. Watch how their eyes roll! their hair stands on end! their palms collect sweat! Over and over they fall to fighting, arguing, debating. If this isn't the shock of the new, then the term is meaningless. Art is involved with so much more than visual appearance, as television has very little to do with the eye, or radio with the ear.[8]

His interlocutor replies, with equal accuracy and equal heat, that Sturtevant suffered abuse and ostracism during the 1960s and 1970s for having so acutely defined the limitations of any history of art wedded to the image. Those now defining themselves as historians of images rather than art have so far shown little capacity to grasp the practice of artists on this level, certainly none that adds anything to that already achieved by the practitioners themselves. Instead, they reproduce the exclusions traditional to their discipline, validating the past centrality of painting and its derivatives, which are most easily likened to the image world of the modern media and to unschooled forms of picturing.

But Conceptualism, which long anticipated recent theory on the level of practice, can be encompassed only within an unapologetic history of art. Its arrival in the later twentieth century recovered key tenets of the early academies, which, for better or worse, established fine art as a learned, self-conscious activity in Western culture. One of those tenets was a

mistrust of optical experience as providing an adequate basis for art: the more a painting relied on purely visual sensation, the lower its cognitive value was assumed to be. The meaning of a work of art was mapped along a number of cognitive axes, its affinities and differences with other images being just one of these – and not necessarily the strongest. Art was a public, philosophical school; manipulative imagery serving superstitious belief and private gratification could be had from a thousand other sources.

It was only in the later nineteenth century that the avant-garde successfully challenged a decayed academicism by turning that hierarchy on its head: the sensual immediacy of color and textured surfaces, freed from subordination to an imposed intellectual program, was henceforth to elicit the greater acuity of attention and complexity of experience in the viewer. The development of Conceptual art a century later was intended to mark the limited historical life of that strategy, but postmodern theory has had the effect of strengthening conventional attachments to painting and sculpture. The art market, quite obviously, functions more comfortably with discrete, luxury objects to sell; and the second-hand, quotation-ridden character of much of the neo-traditionalist art of the 1980s has been well served by theorists (Jean Baudrillard being a leading example) who have advanced the idea of an undifferentiated continuum of visual culture.

The aspirations of Conceptualism have been further diminished by a certain loss of heart on the part of its best advocates, who are united in thinking (amid their many differences) that the episode is essentially concluded. Benjamin H.D. Buchloh voiced this general conclusion when writing that Marcel Broodthaers

> anticipated that the enlightenment-triumph of Conceptual Art, its transformation of audiences and distribution, its abolition of object status and commodity form, at best would only be short-lived and would soon give way to the return of the ghost-like re-apparitions of (prematurely?) displaced painterly and sculptural paradigms of the past.[9]

Charles Harrison, editor of the journal *Art-Language*, laid down the requirement for any Conceptual art aspiring to critical interest that it conceive a changed sense of the public alongside its transformation of practice. But on precisely these grounds, he finds the group's own achievement to be limited: "Realistically, Art & Language could identify no *actual* alternative public which was not composed of the participants in its own projects and deliberations."[10]

In Jeff Wall's view, that isolated imprisonment was the cause of the pervasive melancholy of early Conceptualism: both "the deadness of

215

language characterizing the work of Lawrence Weiner or On Kawara" and the "mausoleum look" embodied in the grey texts, anonymous binders, card files and steel cabinets of Joseph Kosuth and Art & Language. "Social subjects," he observes, "are presented as enigmatic hieroglyphs and given the authority of the crypt," pervasive opacity being an outward confession of art's rueful, powerless mortification in the face of the overwhelming political and economic machinery that separates information from truth.[11] The ultimate weakness of this entire phase of art, in his view, lies in its failure to generate subject matter free from irony. For both Harrison and Wall, their pessimistic verdicts on the achievements of Conceptual art have led them to embrace monumental pictorialism as the most productive way forward, a move that sustains the idea of an encompassing visual culture as the ultimate ground of discussion.

These three names represent the most formidable historians of Conceptual art, and their strictures must be treated with all possible seriousness. If the history of Conceptual art is to maintain a critical value in relation to the apparent triumph of visuality, it must meet the conditions implied in their judgments on its fate: 1) it must be living and available rather than concluded; 2) it must presuppose, at least in its imaginative reach, renewed contact with lay audiences; and 3) it must document a capacity for significant reference to the world beyond the most proximate institutions of artistic display and consumption.

* * *

Christopher Williams is by no means the only artist whose body of work offers significant individual pieces that answer these conditions. The previous essay concluded with a look at the local meanings, set in the context of the pastoral, carried by two of his pieces. Of equal importance is his simultaneous attention to the precise, contingent history of Conceptual art practices, which puts his enterprise on an equal footing with the written histories of the phenomenon. SOURCE: The Photographic Archive, John F. Kennedy Library...marked an overt return to the mimicry of bureaucratic information and classification that characterized Conceptualism in its early years, the reflex that Buchloh has termed "the aesthetic of administration."[12] With that 1981 piece, in advance of Wall calling explicit attention to Conceptualism's "authority of the crypt," Williams undertook his own remapping of material stored in an institution that is both a funerary monument and an index of official secrecy and power (pls. 72, 73).

216

That analysis of the imaginary regime of power takes place through mechanical sorting, a simple identification of flaws or noise in a system. Its instant evocation of the similar devices deployed by first-generation Conceptualists amounts to a claim to satisfy the first condition, the continuity of Conceptual art in the present. An inescapable point of comparison exists in Andy Warhol's immediate response to the first Kennedy assassination, his manipulation of a limited, rudimentary repertoire of images (see "Saturday Disasters," pp. 56–8). The simple diagnostic device that Williams applied to the system of the presidential archive yielded a series that is likewise comprehensible within popular narrative and for that reason potentially available to a much wider audience.

His *Angola to Vietnam** of 1989 (pls. 74–6) incorporates the lay spectator even more firmly within an analysis of information and power, while simultaneously addressing itself to the enormous inherent difficulty of figuring political reality in serious art. On the surface this seems a surprising result, in that the method of the piece adheres so closely to the procedures of early Conceptualism. Like the Kennedy archive intervention, however, it disputes Wall's assertion that Conceptual art could undertake no subject matter in good faith. This is to say, Williams demonstrates that even if Conceptual art rarely found its subject matter, it possessed the keys to new modes of figuration, to a truth-telling warrant pressed in opposition to the incorrigible abstraction that had overtaken painting and sculpture in traditional materials.

The strict symmetry in *Angola to Vietnam** between photograph and written caption had its precedent in one signal instance of such strong descriptive meaning from the 1970s, Martha Rosler's *The Bowery in Two Inadequate Descriptive Systems* (pls. 77, 78).[13] Though not primarily identified as a Conceptualist, Rosler added a milestone to the practice with this single piece. *The Bowery* juxtaposed a series of strictly depopulated photographs of derelict storefronts with a running list of American slang expressions for drunks and drunkenness, from familiar to arcane, from whimsical to despairingly bleak. The anti-expressive intensity in the combination of text and photograph defies both ordinary pathos and critical paraphrase. And that rigorous formal regulation and documentary exactness is in turn undergirded by the fundamental precedent of Hans Haacke's *Shapolsky et al. Manhattan Real Estate Holdings, a Real-Time Social System, as of May 1, 1971* (pls. 79, 80), which framed the economic system underlying urban decay and homelessness.[14] There the artist operated entirely within the established systemic and serial logic that governed the advanced art of the moment. But by introducing only one

77 Martha Rosler, *The Bowery in Two Inadequate Descriptive Systems*, 1974.
45 black and white photographs mounted on 24 black panels, each print 20.3 ×
25.4 cm.

allowable shift in the matter disposed in the system – in this case the
interlocking, clandestine ownership network of a fabulously lucrative
network of slum properties – he generated an economic X-ray of both
the geography and class system of New York city. *Shapolsky et al*
generated a mode of description likewise beyond paraphrase, which then
turned around on the art world with notoriously explosive consequences,
when the director and board of the Guggenheim Museum banned its
exhibition.[15]

In addition to the strongly referential mapping established in these
examples, Williams also shares Haacke's recognition of audience com-
position, as manifested in the polls and visitor profiles that the latter
elicited in various installations from 1969 to 1973.[16] *Angola to Vietnam**
takes that preoccupation one step further in its choices of primary material,

218

thereby forcing the gallery-bound viewer imaginatively to enter a directly analogous, but distinctly different space of confrontation between exhibits and spectators. Williams enlisted *in absentia* the alternative public attracted by the Harvard glass flowers in order to undo the mordant assumption of failed communication common in orthodox Conceptualism. In that space the artist is in no position to make judgments about competence, as he or she shares the incompetence of many of the visitors – and is likely to be inferior to the expertise of the truly impressive amateurs of horticulture (just as audiences in public museums and galleries are more various and more alert to difficult work than many art professionals assume). Despite the pessimistic conclusions of Art & Language, among others, the pretensions of ostentatious art lovers need never have been confused with the potential state of any and all audiences.

Lingering aura may have become an embarrassment when attached to fine-art objects but it exists in any form of relic, which is necessarily a

78 (following pages) Martha Rosler, *The Bowery in Two Inadequate Descriptive Systems*, 1974. Details.

blossom nose rum bud

 grog blossom

soaker, soak sponge

souse

 rummy boozer juicer

falling down drunk

 gassed whipped

stiff blotto

ossified

 paralyzed

 overcome

79 Hans Haacke, *Shaplosky et al. Manhattan Real Estate Holdings, A real Time System as of may 1, 1971.* Two maps (photo-enlargements), one of the Lower East Side and one of Harlem, each 8 × 10 in (61 × 50.8 cm.). 142 typewritten data sheets, attached to the photos and giving the property's address, block and lot number, lot size, building code, the corporation's address and its officers, the date of acquisition, prior owner, mortgage, and assessed tax value, each 10 × 8 in (25.4 × 20.3 cm.), 6 charts on business transactions, each 24 × 20 in (61 × 50.8 cm.). Explanatory panel 24 × 20 in (61 × 50.8 cm.). Installation view of first showing, Milan, Galleria Françoise Lambert, January 1972.

repository of memory, and a relic may be turned to critical use without violating its other functions. Early Conceptual art had taken the work of art, conventionally understood as a synthesis of warmly subjective visual expression, and mapped it onto coldly utilitarian categories of information. Williams proceeded in a symmetrically opposite direction: he began with actual, abstract taxonomies (one scientific, one ethical and political) and presented them through their existing visual tokens, strictly adhering to the requirements of administrative rationality. But through these very means he arrived at the subjective depth, the inseparability of feeling and form, once plausibly promised by traditional artistic means, while investing the work with a moral intelligence that is thoroughly contemporary.

* * *

At the end of the twenty-seven captioned photographs of *Angola to Vietnam**, Williams placed a single image entitled *Brasil* (pl. 81), which was no more than a tearsheet cover from the French edition of the fashion

214 E 3 St.
Block 385 Lot 11
5 story walk-up old law tenement

Owned by Harpmel Realty Inc., 608 E 11 St., NYC
Contracts signed by Harry J. Shapolsky, President('63)
 Martin Shapolsky, President('64)
Principal Harry J. Shapolsky(according to Real Estate
Directory of Manhattan)

Acquired 8-21-1963 from John the Baptist Foundation,
c/o The Bank of New York, 48 Wall St., NYC,
for $237 600.- (also 7 other bldgs.)

$150 000.- mortgage at 6% interest, 8-19-1963, due
8-19-1968, held by The Ministers and Missionaries
Benefit Board of the American Baptist Convention,
475 Riverside Drive, NYC (also on 7 other bldgs.)

Assessed land value $25 000.- , total $75 000.- (includ-
ing 212 and 216 E 3 St.) (1971)

216 E 3 St.
Block 385 Lot 11
5 story walk-up old law tenement

Owned by Harpmel Realty Inc., 608 E 11 St., NYC
Contracts signed by Harry J. Shapolsky, President('63)
 Martin Shapolsky, President('64)
Principal Harry J. Shapolsky(according to Real Estate
Directory of Manhattan)

Acquired 8-21-1963 from John the Baptist Foundation,
c/o The Bank of New York, 48 Wall St., NYC
for $237 600.-(also 7 other bldgs.)

$150 000.- mortgage at 6% interest, 8-19-1963, due
8-19-1968, held by The Ministers and Missionaries
Benefit Board of the American Baptist Convention,
475 Riverside Drive, NYC (also on 7 other bldgs.)

Assessed land value $25 000.-, total $75 000.- (includ-
ing 212-14 E 3 St.) (1971)

80 Hans Haacke, *Shaplosky et al.*, 1971. Detail.

81 Christopher Williams, *Angola to Vietnam**, 1989. Detail. (*Brasil*. Front cover of French *Elle*, 15 August 1988. Six-color web offset printing on machine coated paper, 29.7 × 22.7 cm.)

magazine *Elle* (hence the spelling) featuring the smiling faces of a multi-ethnic group of models, each wearing a hat labelled with a different country of origin. This was a further palimpsest, a ghastly map of the world drawn by multinational image production. Without any declamatory moralizing, he put his finger on the connection between global consumption and global repression, a recognition that gains much of its force by the disparity startlingly opened up between fine print and pure ready-made.

At the level of comparative practices in art, *Brasil* deftly called the bluff of certain image appropriators, the so-called Simulationists, who had enjoyed their brief success in the later 1980s by illustrating academic enthusiasm for the idea of an image-saturated, postmodern culture. The

bluff is called because the political incisiveness of Williams's appropriation depends on the complete non-identity, the severing of continuity, between *Brasil* and the universe of images to which it materially belongs down to the last molecule: the framed sheet is not advertising-image-plus-ironic-frame; it is a marker for the utter bankruptcy of administered imagery, an uncompromising cancellation of the visual rendered in paradoxically visible form.[17]

This device also proved to be the key to a further, more recondite return to the history of Conceptual art. The *Brazil/Brasil* repetition singled out the only country found in both the Amnesty International list and the *Elle* cover. In *Bouquet* (1991), Williams redoubled his displaced cross-references, pushing the list of countries ready-made in the magazine photograph back through a botanical map of the world to generate the names of eight varieties of flower available as live specimens. Los Angeles floral designer Robert C. Smith was then enlisted to arrange the cut blossoms across a damask-covered tabletop. At the center of the work is a photograph in color of the Smith arrangement (pl. 83).

The published version of the piece also features a plain, monochrome frontispiece showing the art-historical archives maintained by the Getty Center for the History of Art and the Humanities in a warehouse in the Marina del Rey district of Los Angeles (pl. 82).[18] For Wall, Conceptual art figures the crypt that art becomes when rendered into information; Williams records a ready-made stand-in for that characteristically deadened and hermetic mode of presentation. As in his earlier pieces, however, he instantly shifts the resonance of institutional morbidity to one of actual human loss, dedicating the installation to two Conceptual artists who took their own lives: Bas Jan Ader and Christopher D'Arcangelo.

The deliberately solipsistic means used by Williams to generate the botanical varieties of *Bouquet* reproduce the hermeticism so often adopted by Conceptual art as simultaneous provocation of and protection from inappropriate forms of attention. At the same time, the declared referents and the vernacular subject of the photograph force the committed viewer to confront a large gap in the collective memory. Existing accounts of Conceptual art are notably selective; their emphasis on the lessons of a closed episode limits analysis to a high level of abstraction; individual works enter these histories only if they exemplify a general characteristic, speak to general conditions, and look forward to that end with particular vividness or strength. The task of recovering the living potential of Conceptualism, however, requires awareness of the fullest possible range of precedents. Ader and D'Arcangelo both closed their careers pursuing dif-

82 Christopher Williams, *The Archives of the History of Art, The Getty Center for the History of Art and Humanities*, 1991. Gelatin silver print.

ferent but equally extreme forms of self-effacement, and to that extent they stand for a lost continent of forgotten activity. *Bouquet* is an example of a work of art that demands further work not only from the professional historian of art but also from the historian inside every serious viewer.

Had Ader not been lost at sea in 1975, during an attempt to complete his three-part performance *In Search of the Miraculous*, his subsequent recognition might have been substantial. The second element of this work, completed in 1973, embodies much of that promise. Subtitled *One Night in Los Angeles* (pls. 84, 85), it documents a dusk-to-dawn journey, undertaken by the artist on foot, from an inland valley in southern California to the sea. The evocations of the place and its mythology are manifold: the freeways (along which walking is forbidden), the nocturnal crime scenes of Hollywood *film noir*: the Pacific as the stopping point of westward

83 Christopher Williams,
*Bouquet, for Bas Jan Ader
and Christopher
D'Arcangelo*, 1991. Detail
(framed photograph 73.7 ×
82.9 cm.)

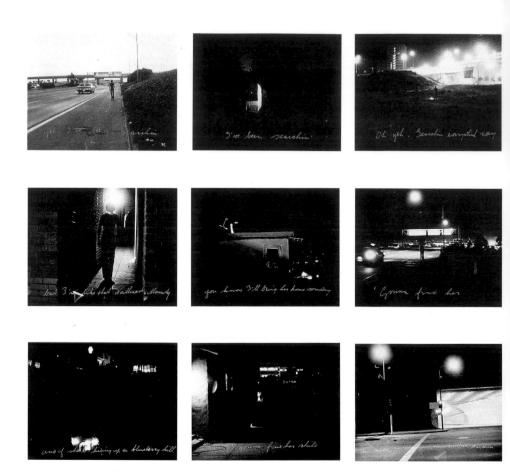

84 Bas Jan Ader, *In Search of the Miraculous (One Night in Los Angeles)*, 1973. 18 photographs with white ink, each 20.3 × 25.4 cm. Inscribed with lyrics of *Searchin'* by Jerry Lieber and Mike Stoller, as recorded by the Coasters. Private collection, London.

migration. Ader's slight, indistinct presence is doubled in another register by a contrastingly emphatic and rhythmically sharp voice, rendered in white script in a line linking the rows of images. Each photograph is secured in the sequence by a phrase from the Coasters' hit of 1957, *Searchin'* (written by Jerry Lieber and Mike Stoller, its narrator elsewhere invokes the pulp detectives Sam Spade and Bulldog Drummond in his pursuit of a lover). Even viewers who have never heard the song will pick up its rollicking beat; the script gives the piece movement and flair, mocks

incipient self-importance, and through its good humor manages to elicit a poignancy from the hackneyed theme of the quest.

Knowledge of what came after can make that poignancy almost unbearable. The third element of *In Search of the Miraculous* represented a literal going on from the last photograph in *One Night in Los Angeles*, though he transferred his point of departure from the West Coast to the East, looking back toward his European origins. In 1974, he conceived the idea of completing the work with a solo voyage in a small sailboat from Cape Cod to Cornwall in Britain (a wildly ambitious leap beyond Chris Burden's *B.C. Mexico* of 1973). During the spring of the following year, his notion became a firm project, undertaken with every apparent expec-

Gonna find her

85 Bas Jan Ader, *In Search of the Miraculous (One Night in Los Angeles)*, 1973.
Detail. Private collection, London.

tation of success: he had arranged for a show documenting the project to take place in Amsterdam (pl. 86), and plans were in place to exploit success in the sixty-day crossing with further exhibitions of material generated by his feat.[19]

But all these signs of calculated sensationalism in the service of career are belied by the fragility of his thirteen-foot craft and by the fact that, despite having some experience on boats, his seamanship seems to have been entirely untested at the requisite level. The voyage calls to mind less Burden's Robinson-Crusoe foray in the Sea of Cortez and more the suicidal venture across the Gulf of Mexico by the unstable Dada provocateur Arthur Craven. Deliberately or not, Ader's adventure amounted to reckless self-endangerment and was the nearest thing to suicide.

Though Dutch-born, Ader had received most of his art training in southern California and joined the first wave of West-Coast Conceptualism

86 Bas Jan Ader, *In Search of the Miraculous*, July 1975. Bulletin, Art and Project Gallery, Amsterdam. Collection Estate of Bas Jan Ader.

at the end of the 1960s (Williams's catalogue illustrates the postcard piece *I'm Too Sad Too Tell You* from 1970 [pl. 87]).[20] Almost entirely over-shadowed since by the sustained careers of Burden and Bruce Nauman, his work was at that stage operating in similar territory, including the translation of elementary verbal constructions into performance – notably a photograph and film series on falling, as from the roof of his California bungalow or into an Amsterdam canal from a bicycle. With similar simplicity, Williams's horizontal bundle of flowers mirrors both the falling performances and the terrible, unseen moment when Ader must have been pitched from his boat (which was found half-submerged six months later off the coast of Ireland). The position and framing of the bouquet further echo Williams's memorials to political martyrdom in *Angola to Vietnam**.

At the same time, *Bouquet* leavens that funereal cast by evoking the humor of Ader's work, notably evident in an untitled photo-montage (pl. 89) and the video *Primary Time* of 1974, where he awkwardly arranged and disarranged a bunch of flowers in a vase. Removing and replacing individual stems, using a reserve supply strewn on a tabletop out of

233

87 Bas Jan Ader, *I'm Too Sad to Tell You*, 13 September 1970. Postcard, 8.8 × 13.8 cm.

camera range, his actions gradually shift the arrangement toward one of its three primary colors. When a single color is achieved, the slow, apparently aimless procedure begins again, passing slowly through heterogeneity towards another monochrome. Making their belated appearance in *Bouquet* are stand-ins for the flowers that once lay on the invisible table as Ader carried out his wry homage to, and mockery of, Mondrian, Rietveld, and the floral clichés about his native country.

The eclipse of Ader's disorganized but burgeoning career overtook him in a fit of romantic, even mystical self-dramatization; D'Arcangelo's obscurity as an individual creator was willed by him from the start. In one important group exhibition at Artists Space in 1978 – which helped to launch his co-participants toward wide acclaim – his contribution consisted in the removal of his name from the installation, catalogue, and publicity. No intervention could have caused greater difficulties for the critic and historian, in that any precise citation of D'Arcangelo's piece would destroy the grounds of its existence; indeed, it is probably impossible to cite the contributions of the other three artists in light of his participation without doing the same (silence will be maintained here).

The bulk of D'Arcangelo's work, ended by his unexpected suicide in 1979, comprised nominating utilitarian carpentry (generally alterations to New York loft spaces) as works of art, which he defined by his input of labor and materials rather than by any phenomenal aspect they might possess. In the installation of *Bouquet*, Williams hung the framed floral photograph on a temporary section of wall, standing out in the space of the gallery (pl. 90). This stud and sheetrock construction faithfully adheres to the materials specified in *Thirty Days Work*, an exhibition space that D'Arcangelo had executed with Peter Nadin and Nick Lawson at 84 West Broadway, New York, in preparation for a 1979 show which included Nadin, Dan Graham, Louise Lawler, and Lawrence Weiner (pl. 88). Williams, in his positive extrusion of what was once deliberately anonymous background matter, puts certain obvious metaphors to work: the burial of D'Arcangelo's work as part of its premise makes Williams's wall into a tomb of the unknown artist; it recalls the romance of the "art-worker" period of the 1970s; it extracts from lost history an *artistic* deflation of Minimalism's pretentious phenomenology which can stand with Graham's seminal *Homes for America* of 1966.[21] As *Homes* assumed a disguise that made it difficult to detect against its art-magazine background (discussed in "The Simple Life" [pp. 186–7]), D'Arcangelo's collaborative work often owed the most substantial part of its existence to the postcard announcing the exhibition, which was otherwise more or less inaccessible to actual viewing.

The public manifestation of *Bouquet* coexists with another mode of

88 Christopher D'Arcangelo, *Thirty Days Work*, 1978. Announcement, 13.5 × 34.8 cm.

> **The Work shown in this space is a response to the existing conditions and/or work previously shown within the space.**
>
> **Nov. 9—**
> **30 days work:**
> **1,450 sq. ft.**
> **Function by Peter Nadin**
> **Design by function**
> **Execution by Peter Nadin , Christopher D'Arcangelo and Nick Lawson**
> **Materials: Compound, Drywall, Wood, Nails, Paint.**
>
> * **We have joined together to execute functional constructions and to alter or refurbish existing structures as a means of surviving in a capitalist economy.**

89 Bas Jan Ader, *Untitled (flowerwork)*, 1974. 21 color
photographs, each 27.8 × 36 cm.

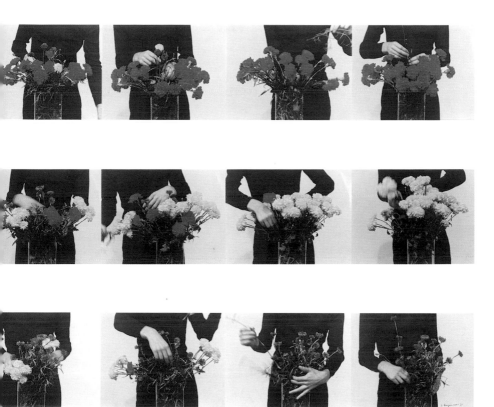

presentation: private owners of the work (which exists as a multiple edition) may or may not have the same wall built, but in its absence the framed photograph must be leaned against rather than hung on an existing wall (pl. 90). That offering-like position at floor level in turn recalls a second aspect of D'Arcangelo's practice, this one in the realm of performance, when he would enter museums, surreptitiously lower paintings to the floor and leave them leaning against a wall (pl. 91). A ritualistic motif of falling, sacrifice, and commemoration continually recurs in the life of *Bouquet*, encoded in this instance in a plain instruction concerning its position in a room.

The complex investigations invited by the piece (no more than sketched here) transform Conceptual art from something cold and impersonal into a drama of lives driven onto treacherous emotional shoals. This move carries some risk in a postmodern intellectual culture imbued with suspicion of all reference, especially to themes of self-sacrifice in biographies of artists. But

90 (above and facing page) Christopher Williams, *Bouquet*. Two views of gallery installation.

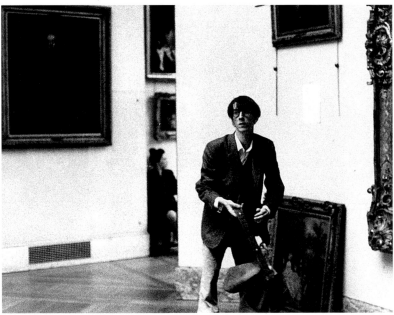

91 (above and facing page) Christopher D'Arcangelo, performance, c.1976. Action sequence, Paris, Musée du Louvre.

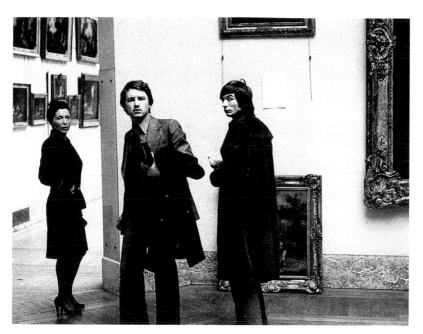

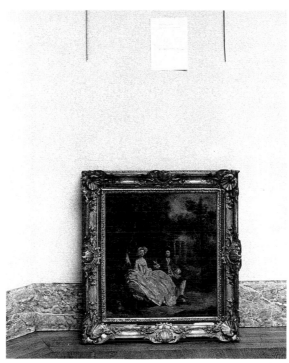

an attitude of complacent superiority to the real pain and loss that artistic commitment can entail, Williams makes plain, is part and parcel of a regime of art-historical ignorance. And in these two cases, the impact of *Bouquet*, its power to compel curiosity, has in fact begun to dispel some of that indifference.[22]

But Williams risks, it must be said, a potentially high aesthetic and ethical cost for that accomplishment. This is less the case with the photograph as a tribute to Ader, buttressed as it is by its participation in the system of *Angola to Vietnam**, and congruent as it is with its subject's public flamboyance in life (though the very success of the piece runs the danger of encouraging others to make Ader into a retrospectively romanticized cult figure, leaving the same deeper amnesia to be dislodged all over again). Calling attention to D'Arcangelo's private despair is more of an intrusion, most of all because the enterprise of historical narrative can only violate the fierce reticence of the artist's work. The wall, when installed in a 1990s gallery, may well appear as an alien architecture belonging to another time and another set of ethical priorities. But in quoting *Thirty Days Work* as a demarcated object – the phenomenal antithesis of what it once stood for – *Bouquet* takes upon itself the fallen condition of the merely visual. In an important way, the piece has to make this sacrifice of an imaginary state of integrity; that gesture in itself constitutes a tribute to the severity of its predecessor, and its risk of compromise has proven to be the condition of anything at all being said about its subject. The solidity of the wall marks a temporal boundary, dividing the time during which D'Arcangelo's intentions were respected by silence from a future that cannot afford that respect, lest it lose all memory of why those intentions mattered.

Notes

Chapter 1

1 "The Impressionists and Edouard Manet," *Art Monthly Review*, 30 September 1876, pp. 117–22; made conveniently available since the first publication of the present essay in Charles S. Moffett (ed.), *The New Painting: Impressionism 1874–1876*, Fine Arts Museum of San Francisco, 1986, pp. 28–34.

2 Mallarmé, "Impressionists," in Moffett, *New Painting*, p. 30.

3 Ibid.

4 Ibid., p. 34.

5 [Paul Signac], "Impressionistes et révolutionnaires," *La Révolte*, IV, 13–19 June 1891, p. 4; quoted in Robert and Eugenia Herbert, "Artists and Anarchism: Unpublished Letters of Pissarro, Signac and Others," *Burlington Magazine*, CII, November 1960, p. 692.

6 For a contemporary description of the spectator in *Le Chahut*, see Gustave Kahn, "Seurat," *L'Art moderne*, 5 April 1891, pp. 109–110. On Corvi and the connection to Seurat, see Robert Herbert, "'La Parade du cirque' de Seurat et l'esthétique scientifique de Charles Henry," *Revue de l'Art*, 50, 1980, pp. 9–23. A monumental and maudlin depiction of the same dispirited location by Fernand Pelez was exhibited at the Salon in 1888: see Robert Rosenblum, "Fernand Pelez, or the Other Side of the Post-Impressionist Coin," in M. Barasch and L. Sandler (eds.), *Art the Ape of Nature*, New York: Abrams, 1981, pp. 710–12.

7 Signac, "Impressionistes," p. 4.

8 The lecture was given 17 March 1891 under the title "Harmonie des formes et des couleurs"; in April 1889, Signac wrote to Van Gogh expressing his desire to equip workers with Neo-Impressionist color theory; see *Complete Letters of Vincent Van Gogh*, III, Greenwich, CT, 1948, no. 548a. On these texts, see R. and E. Herbert, "Artists and Anarchism," p. 481n.

9 Signac, "Impressionistes," p. 4.

10 John Rewald (ed.), "Extraits du journal inédit de Paul Signac," in *Gazette des Beaux-Arts*, 6th per., XXXVI, July–September 1949, p. 126; entry dated 1 September 1891.

11 Mallarmé, "Impressionists," in Moffett, *New Painting*, p. 33.

12 Clement Greenberg, "Collage," in *Art and Culture*, Boston, 1961, pp. 70–83; revision of "The Pasted Paper Revolution," 1958, reprinted in Greenberg, *The Collected Essays and Criticism*, ed. J. O'Brian, Chicago: University of Chicago Press, 1992, pp. 61–6.

13 Ibid., p. 70.

14 For the most persuasive statement of this position from the time, see Craig Owens, "The Allegorical Impulse: Toward a Theory of Postmodernism," *October*, 13, Fall 1980, p. 79. I am happy to say that the dialogue continued when Owens took up the present argument in his assessment of the then-flourishing gallery scene on the lower east side of Manhattan, "The Problem with Puerilism," *Art in America*, LXXII, Summer 1984, pp. 162–3.

15 Greenberg, "Avant-Garde and Kitsch," in *Collected Essays*, I, p. 6.

16 Greenberg, "Towards a Newer Laocoon," in ibid., p. 32.

17 Greenberg, "Avant-Garde and Kitsch," pp. 10–11.

18 The historical account sketched in this paragraph is partly based on the author's research on David's pre-Revolutionary painting, the audience of the Salon exhibitions, and the politicization of culture in Paris during the final crisis of the Ancien Régime, published in "*The Oath of the Horatii* in 1785: Painting and Pre-Revolutionary Radicalism in France," *Art History*, I, December 1978, pp. 424–71, subsequently incorporated into *Painters and Public Life in Eighteenth-Century Paris*, New Haven and London: Yale University Press, 1985. The author's more recent *Emulation: Making Artists for Revolutionary France*, New Haven and London: Yale University Press, 1995, concerns the pathos entailed in this belief for the first generation of artists to be formed within David's studio. For Courbet at the Salon of 1851, see T.J. Clark, *The Image of the People*, London: Thames and Hudson, 1972, pp. 130–54 and *passim*.

19 Meyer Schapiro, "The Social Bases of Art," proceedings of the First Artists Congress against War and Fascism, New York, 1936, pp. 31–7; "The Nature of Abstract Art," *The Marxist Quarterly*, I, January 1937, pp. 77–89, reprinted in Schapiro, *Modern Art: The Nineteenth and Twentieth Centuries*, New York: George Braziller, 1977, pp. 185–211.

20 Schapiro, "Abstract Art," in *Modern Art*, pp. 192–3.

21 Schapiro, "Social Bases," p. 33; the passage continues:

> Thus elements drawn from the professional surroundings and activity of the artist; situations in which we are consumers and spectators; objects which we confront intimately, but passively or accidentally – these are the typical subjects of modern painting. . . . The preponderance of objects drawn from a personal and artistic world does not mean that pictures are more pure than in the past, more completely works of art. It means simply that the personal and aesthetic contexts of secular life now condition the formal character of art . . .

22 Ibid., p. 37.

23 As Greenberg stated forthrightly at the conclusion of "Avant-Garde and Kitsch," p. 22.

24 Ibid., p. 12.

25 See, for example, Eugen Weber, "Gymnastics and Sports in Fin-de-Siècle

France," *American Historical Review*, LXXVI, February 1971, pp. 70–98; Richard Holt, *Sport and Society in Modern France*, London: Macmillan, 1981, *passim*.

26 See Michael Miller, *The Bon Marché: Bourgeois Culture and the Department Store 1869–1920*, Princeton: Princeton University Press, 1981, *passim*.

27 On the political convictions and involvement of both in Marxist circles of the period, see Allan Wald, *The New York Intellectuals: The Rise and Decline of the Anti-Stalinist Left from the 1930s to the 1980s*, Chapel Hill: University of North Carolina Press, 1987, pp. 207–8, 213–17.

28 Karl Marx, *The Eighteenth Brumaire of Louis Bonaparte*, New York, 1963, p. 104. Recent research has documented the virulence of the official campaign against republican institutions and values during Bonaparte's brief presidency: see Thomas Forstenzer, *French Provincial Police and the Fall of the Second Republic*, Princeton: Princeton University Press, 1981.

29 Walter Benjamin, "The Paris of the Second Empire in Baudelaire," in *Charles Baudelaire: A Lyric Poet in the Age of High Capitalism*, trans. H. Zohn, London: New Left Books, 1973, p. 59.

30 Ibid., p. 106.

31 For a detailed summary of the documents, see Bruno Chenique, "Géricault: Une Vie," in Régis Michel and Sylvain Laveissière (eds.), *Géricault*, I, Paris: Réunion des Musées Nationaux, 1991, pp. 280–7.

32 See Jules Michelet, *L'Etudiant, cours de 1847–1848*, Paris, 1877. On the use of Delacroix's *Liberty* in 1848, see T.J. Clark, *The Absolute Bourgeois*, London: Thames and Hudson, 1972, pp. 16–20.

33 Schapiro, "Abstract Art," p. 192.

34 There were immediate political and biographical reasons for his shift, which the research of Serge Guilbaut has amply demonstrated: see his "The New Adventures of the Avant-Garde in America: Greenberg, Pollock, or from Trotskyism to the New Liberalism of the 'Vital Center,'" *October*, 15, Winter 1980, pp. 63–4; subsequently incorporated into his *How New York Stole the Idea of Modern Art*, Chicago: University of Chicago Press, 1982, pp. 21–6.

35 Guilbaut, *How New York Stole*, p. 25, first noted this quality of openness.

36 The term comes, of course, from the work in the sociology of leisure-based subcultures in postwar Britain fostered during the 1970s by the Centre for Contemporary Cultural Studies at the University of Birmingham. The specific line of approach was laid out by Phil Cohen (see below) in his "Sub-Cultural Conflict and Working-Class Community," *Working Papers in Cultural Studies*, Spring 1972, pp. 5–51. For a summary of work in this vein, see Stuart Hall and Tony Jefferson, *Resistance through Rituals*, London: Hutchinson, 1976. A brief aside in that volume (p. 13) made the first connection between the subcultural response and the phenomenon of an artistic avant-garde: "The bohemian sub-culture of the *avant-garde* which has arisen from time to time in the modern city, is both distinct from its 'parent' culture (the urban culture of the middle-class intelligentsia) and yet also part of it (sharing with it a modernising outlook, standards of education, a privileged position vis-à-vis productive labour, and so on)."

37 Hall and Jefferson, *Resistance*, p. 47.

38 Phil Cohen, "Subcultural Conflict and Working-Class Community," pp. 22–33 and *passim*.

39 See Patricia Mainardi, "Courbet's Second Scandal, *Les Demoiselles du village*," *Arts*, LIII, January 1979, pp. 96–103.

40 Antonin Proust, *Edouard Manet, Souvenirs*, Paris, 1913, p. 15: "Quelque effort qu'il fit en exagérant ce déhanchement et en affectant le parler trainant du gamin de Paris, il ne pouvait parvenir à être vulgaire."

41 The critical commentary in 1865 of Jean Ravenel (a pseudonym of Alfred Sensier) stressed this clash, as has been elucidated by T.J. Clark in "Preliminaries to a Possible Treatment of *Olympia* in 1865," *Screen*, XXI, Spring 1980, pp. 17–22; subsequently incorporated into his *Painting of Modern Life: Paris in the Art of Manet and his Followers*, New York: Knopf, 1984, pp. 139–44.

42 See Michel Butor, "Monet, or the World Turned Upside-Down," in Thomas Hess and John Ashbery (eds.), *Art News Annual*, XXXIV, 1968, p. 25.

43 For a summary of evidence concerning the deliberate pairing of the pictures, see John House, "Meaning in Seurat's Figure Painting," *Art History*, III, September 1980, pp. 346–9.

44 Emile Verhaeren, "Georges Seurat," *La société nouvelle*, April 1891, trans. Norma Broude, in *Seurat in Perspective*, Englewood Cliffs: Prentice-Hall, 1978, p. 28.

45 See Robert Herbert, "Seurat and Jules Chéret," *Art Bulletin*, XL, March 1958, pp. 156–8.

46 Verhaeren, "Seurat," p. 28.

47 See Holt, *Sport and Society*, pp. 115–20.

48 T.W. Adorno, "On Commitment," in A. Arato and E. Gebhardt (eds.), *The Essential Frankfurt School Reader*, Oxford: Blackwell, 1978, p. 318.

49 Mallarmé, "Impressionists," p. 33.

50 Letter of 9 January 1887, in Camille Pissarro, *Letters to His Son Lucien*, J. Rewald (ed.), London: Kegan Paul, 1943.

51 See J.P. Crespelle, *The Fauves*, New York, 1962, p. 112.

52 See Ellen Oppler, *Fauvism Reexamined*, New York: Garland, 1976, pp. 13–38.

53 André Derain, *Lettres à Vlaminck*, Paris: Flammarion, 1955, pp. 146–7.

54 See Raoul Hausmann, *Courrier Dada*, Paris: Le Terrain Vague, 1948, p. 40.

55 Maurice Raynal, "Quelques intentions du cubisme," *Bulletin de l'effort moderne*, 4, p. 4; quoted in Benjamin H.D. Buchloh, "Figures of Authority, Ciphers of Regression," *October*, 16, Spring 1981, p. 44.

56 See William Weber, *Music and the Middle Class*, London: Croom Helm, 1975, pp. 105–6. Weber describes how artisan-class, radical choral groups emerged during the Revolution of 1830 and by 1832 were sufficiently organized to give a massed concert involving twenty singing clubs and six hundred singers. Several of the clubs subsequently began to perform at commercial theaters and promenade concerts. This improvised form of communal musical life was suppressed by the state in the general crackdown of 1833–5, but the form was resurrected by an entrepreneur named William Wilhem, who began receiving state subsidies for singing classes in 1836. Called the Orphéon Societies, their membership was drawn primarily from the working

and artisan classes, but the audience at their well-attended and fairly expensive concerts was middle class and aristocratic. The climax of the development came in 1859 when the Orphéon Societies were summoned to perform in the new Palace of Industry for Napoleon III.

57 The work of Toulouse-Lautrec as a designer and illustrator can be taken as emblematic of this shift. His cultivated irony, perversity, and compositional extremism continued previously established kinds of avant-garde attention to lowlife spectacle. In his commercial work, however, certain patented modernist devices became the preferred vocabulary of an emerging sector of the entertainment industry. The collapse of art into its subject was displayed as concretely as possible in 1895, when the Folies-Bergère entertainer La Goulue went out on her own at the Foire du Trône, setting up her act in a structure that appeared from the outside to be literally constructed out of two large painted panels by Lautrec. See P. Huisman and M.G. Dortu, *Lautrec by Lautrec*, New York, 1964, p. 84.

Chapter 2

1 *How New York Stole the Idea of Modern Art: Abstract Expressionism, Freedom, and the Cold War*, Chicago: University of Chicago Press, 1983.

2 See, among others, Max Kozloff, "American Painting during the Cold War," *Artforum*, XI, May 1973, pp. 42–54; Eva Cockcroft, "Abstract Expressionism: Weapon of the Cold War," *Artforum*, XII, June 1974, pp. 39–41.

3 For more detailed discussion of this moment, see Guilbaut, "The Frightening Freedom of the Brush: The Boston Institute of Contemporary Art and Modern Art," in *Dissent: The Issue of Modern Art in Boston*, Boston: Institute of Contemporary Art, 1985, pp. 52–93.

4 Represented most graphically and notoriously by the article "Jackson Pollock: Is he the greatest living painter in the United States?" *Life*, 8 August 1949, which contained the statement (p. 42): ". . . Jackson Pollock, at the age of 37, has burst forth as a shining new phenomenon of American art." For a somewhat tendentious but usefully clarifying examination of *Life*'s affirmative role in the reception of the New York School, see Bradford R. Collins, "*Life* Magazine and the Abstract Expressionists, 1948–1951: A Historiographic Study of a Late Bohemian Enterprise," *The Art Bulletin*, LXXIII, June 1991, pp. 283–308. T.J. Clark elaborates at length on some verbal remarks by Guilbaut concerning the *Vogue* photographs in "Jackson Pollock's Abstraction," in Guilbaut (ed.), *Reconstructing Modernism: Art in New York, Paris, and Montreal 1945–1964*, Cambridge, MA: MIT Press, 1990, pp. 172–243.

5 Francis V. O'Connor and Eugene V. Thaw, *Jackson Pollock: Catalogue Raisonné of Paintings, Drawings, and Other Works*, New Haven and London: Yale University Press, 1978, IV, p. 228.

6 See Jacqueline Bograd Weld, *Peggy: The Wayward Guggenheim*, London: Bodley Head, 1986, pp. 308ff.

7 See Peggy Guggenheim, *Out of this Century*, London: André Deutsch, 1980, p. 295.

8 On Putzel's and Sweeney's backgrounds and relations with Guggenheim, see Weld, *Peggy*, pp. 194, 300, 330–2. On the former, see the important article

of Melvin P. Lader, "Howard Putzel: Proponent of Surrealism and Early Abstract Expressionism in America," *Arts*, LVI, March 1982, pp. 85–96. Sweeney at this point was technically a member of the Museum of Modern Art's Junior Advisory Committee. He directed a number of exhibitions before assuming the formal staff position of Director of the Department of Painting and Sculpture in 1945; see *The Museum of Modern Art: The History and the Collection*, London: Thames and Hudson, 1984, p. 22.

9 See Angelica Zander Rudenstine, *The Peggy Guggenheim Collection, Venice*, New York: Abrams, 1985, p. 775. On Sweeney's role, see Stephen Naifeh and Gregory White Smith, *Jackson Pollock: An American Saga*, London: Barrie and Jenkins, 1989, p. 442; on Putzel, see below.

10 Quoted in Weld, *Peggy*, p. 306.

11 Ibid., quoting Greenberg: "The contracts (with Guggenheim and later with Betty Parsons) were utterly unique for that generation of artists...." For the terms of the contract, see Rudenstine, *Guggenheim Collection*, p. 641.

12 "Introduction," *Jackson Pollock*, New York: Art of this Century, 1943, n.p. Reproduced in facsimile in O'Connor and Thaw, IV, p. 230.

13 "Five American Painters," *Harper's Bazaar*, April 1944, quoted in B.H. Friedman, *Jackson Pollock: Energy Made Visible*, New York: McGraw Hill, 1972, p. 63.

14 On Pollock's annoyance in 1943 see Naifeh and Smith, *Pollock*, p. 463; for a facsimile of the polite reply he was persuaded to write to Sweeney, see O'Connor and Thaw, *Pollock*, IV, p. 230.

15 See Weld, *Peggy*, p. 306.

16 See Guggenheim, *Out of This Century*, p. 295.

17 In Pollock's application for a Guggenheim Fellowship, in O'Connor and Thaw, *Pollock*, IV, p. 238.

18 See Pollock's letter to his brother Charles (July 1943) in O'Connor and Thaw, *Pollock*, IV, p. 228. The various accounts of witnesses to the making of the painting are usefully summed up in Naifeh and Smith, *Pollock*, p. 866. Karina Daskalov (unpublished paper, University of California, Berkeley) is justifiably sceptical as to whether the work could have been completed quite that quickly. Guests at the opening of Pollock's 1945 one-man show at Art of this Century were invited to inspect *Mural in situ* ("March 19, 1945, 3–6, 155 E. 61st Street, first floor," read the invitation: see reproduction in O'Connor and Thaw, IV, pp. 234–5).

19 The horizontal rectangle suspended in the middle of *Guardians of the Secret*, which he showed in 1943, served in retrospect as a staging in miniature of the abstract order he then applied to *Mural*.

20 Clement Greenberg, *The Collected Essays and Criticism*, ed. John O'Brian, Chicago: University of Chicago Press, 1986, I, p. 65.

21 Ibid., II, p. 125.

22 Ibid., I, pp. 225–6.

23 On the identity of the Hare sculpture, see the 1971 statement by Marius Bewley in Virginia Dortch, *Peggy Guggenheim and Her Friends*, Milan: Berenice, 1994, p. 115.

24 "American Fashion: The New Soft Look," American *Vogue*, 1 March 1951, pp. 156–9.

25 Beaton's negatives and contact sheets from the sessions, along with some unused color transparencies, are preserved in his archives at Sotheby's, London. I want to thank Philippe Garner and Lydia Cresswell-James of Sotheby's and David Mellor for their assistance.

26 See Guggenheim, *Out of This Century*, p. 296; David Hare told Weld (*Peggy*, p. 326) that he assisted Duchamp at the installation.

Chapter 3

1 There are as yet only fragmentary accounts of this phenomenon. For some preliminary comment, see Iain Chambers, *Urban Rhythms: Pop Music and Popular Culture*, London, 1985, pp. 130ff.

2 For an example of the first, see Rainer Crone, *Andy Warhol*, trans. J.W. Gabriel, London: Thames and Hudson, 1970, *passim*. For the second, see Carter Ratcliff, *Andy Warhol*, New York: Abbeville, 1983, *passim*. Andreas Huyssen, "The Cultural Politics of Pop," *New German Critique*, IV, Winter 1975, pp. 77–98, gives an illuminating view of the effects of this view in Germany. For the third, see Robert Hughes, "The Rise of Andy Warhol," in B. Wallis, (ed.), *Art after Modernism*, New York: Godine, 1984, pp. 45–57.

3 In an interview with G.R. Swenson, "What Is Pop Art?" *Art News*, LXII, November 1963, p. 26. See also the comments about this statement by his closest assistant at that time, Gerard Malanga, in Patrick Smith (ed.), *Warhol: Conversations about the Artist*, Ann Arbor: UMI, 1988, p. 163:

> ... if you remember by reading that really good interview with Andy by Gene Swenson in '63, in *Art News*, where Andy talks about capitalism and communism as being the same thing and someday everybody will think alike – well, *that*'s a very political statement to make even though he sounds very apolitical. So, I think, there was always a political undercurrent of Andy's unconscious concerns for politics, or of society for that matter.

4 De Kooning titled one of his *Woman* series after her in 1954. Norman Mailer's fascination with the actress is rehearsed at length in his *Marilyn, A Biography*, London: Hodder, 1973.

5 The essential discussion of that grid, along with other key conceptual issues, is Benjamin H.D. Buchloh, "Andy Warhol's One-Dimensional Art," in Kynaston McShine (ed.), *Andy Warhol: A Retrospective*, New York: Museum of Modern Art, 1989, pp. 39–57. An instructive comparison can be made between Warhol's neutralization of that mannered form of self-presentation and Rosenquist's Monroe painting of 1962: for all the fragmentation and interference that the latter artist imposes on the star portrait, its false seductiveness is precisely what he lingers over and preserves.

6 Crone, *Warhol*, p. 24, dates the beginning of the Monroe portraits in a discussion of silkscreen technique, without mentioning the death. Ratcliff, *Warhol*, p. 117, dates the first portraits to August in a brief chronology appended to his text, also without mentioning her death in the same month.

7 See Crone, *Warhol*, p. 24, who dates Warhol's commitment to the technique to August 1962. The first screened portraits, he states, were of Troy Donahue. Maco Livingstone, "Do It Yourself: Notes on Warhol's Technique," in

McShine, *Warhol*, pp. 69–70, discusses in further detail Warhol's turn to silkscreen techniques during 1962.

8 See, for example, John Coplans, *Andy Warhol*, New York, n.d., p. 52.

9 See Malanga interview in Smith, *Warhol*, p. 163.

10 This control, of course, could take the form of understanding and anticipating the characteristic imperfections and distortions of the process, that is, of knowing just how little one had to intervene once the basic arrangement, screen pattern, and color choices had been decided. See the illuminating, if somewhat self-contradictory interview with Malanga, in Smith, *Andy Warhol's Art and Films*, Ann Arbor: UMI, 1986, pp. 391–2, 398–400. See also Livingstone's remarks ("Do It Yourself," p. 72) on the ways in which the rephotographed full-size acetate would be altered by the artist ("for example, to increase the tonal contrast by removing areas of half-tone, thereby flattening the image") before its transfer to silkscreen, as well as on the subsequent use of the same acetate to plot and mark the intended placement of the screen impressions before the process of printing began. Warhol's remarks in a conversation with Malanga (*Print Collector's Newsletter*, January–February 1971, p. 126) indicate a habit of careful premeditation; he explains how the location of an impression was established if color was to be applied under it: "Silhouette shapes of the actual image were painted in by isolating the rest of an area on the canvas by means of masking tape. Afterwards, when the paint dried, the masking tape would be removed and the silk screen would be placed on top of the painted silhouette shape, sometimes slightly off register."

11 For a summary of press accounts of the affair, see Roger E. Schwed, *Abolition and Capital Punishment*, New York, 1983, pp. 68–104.

Chapter 4

1 Cheryl Bernstein (i.e., Carol Duncan and Andrew Duncan), "The Fake as More," in Gregory Battcock (ed.), *Idea Art*, New York, 1973, pp. 41–5. It has lately been acknowledged and republished by Carol Duncan in a collection of her writings, *The Aesthetics of Power*, Cambridge: Cambridge University Press, 1993, pp. 216–18; see also her discussion of the origins of the parody and its fictitious author, ibid., pp. 211–15.

2 Gerald Marzorati, "Art in the (Re)Making," *Art News*, June 1986, p. 91.

3 Bernstein, "Fake," pp. 42, 44–5.

4 Peter Halley, "The Crisis in Geometry," *Arts*, Summer 1984, p. 115.

5 Bernstein, "Fake," p. 42.

6 The literature on Sturtevant (b. 1926) is scandalously sparse. For a selection of early work with commentary, see Eugene M. Schwartz and Douglas Davis, "A Double-Take on Elaine Sturtevant," *File*, December 1986, n.p.; interview with Leo Castelli and Dan Cameron, *Flash Art*, November/December 1988, pp. 76–7.

7 See C. Carr, "The Shock of the Old," *Village Voice*, 30 October 1984, p. 103.

8 See Clement Greenberg, "Avant-Garde and Kitsch," and "Towards a New Laocoon," in *Collected Essays and Criticism*, ed. John O'Brian, University of Chicago Press, 1986, i, pp. 5–37.

9 See Marzorati, "Art in the (Re)Making," p. 96.

10 Halley, "Crisis," p. 115.
11 See "Mythologies: Art and the Market. Jeffrey Deitch Interviewed by Matthew Collings," *Artscribe International*, April/May 1986, pp. 22–6; Douglas C. McGill, "The Lower East Side's New Artists," *New York Times*, 3 June 1986, p. C13.
12 Charles Harrison, "Sculpture, Design, and Three-Dimensional Work," *Artscribe International*, June/July 1986, p. 62.
13 See the retrospective remarks of its editors in their introduction to Annette Michelson (ed.) et al, *October: The First Decade*, Cambridge, MA: MIT Press, 1987, p. x.
14 See Harrison, *Essays on Art and Language*, Oxford: Blackwell, 1991, pp. 45–6, for development of this point.
15 Rosalind Krauss, to her credit, has lately begun to address the actual abstraction of the art economy: see "The Cultural Logic of the Late Capitalist Museum," *October*, 54, Fall 1990, pp. 3–17; "Overcoming the Limits of Matter: On revising Minimalism," *Studies in Modern Art*, 1, 1991, pp. 123–41.
16 See, for example, Krauss's remarks on the theoretical writing of Peter Halley, "Theories of Art after Minimalism and Pop: Discussion," in Hal Foster (ed.), *Discussions in Contemporary Culture*, Seattle: Bay Press, 1987, pp. 76, 82.
17 Ibid.
18 See Douglas Crimp, "The Photographic Activity of Postmodernism," *October*, no. 15 (Winter 1980), pp. 98–9.
19 For an overview of the time, see Foster, "Signs Taken for Wonders," *Art in America*, May 1986, pp. 83–91.
20 Conversation with the artist, May 1986.

Chapter 5

1 The Editor (sic), "About *October*," *October*, 1, Spring 1976, p. 3.
2 *Artforum*, October 1967, p. 4: he concludes, "The upper surface is supposed to be three inches above another surface, flush with the rest of the box."
3 "About October," p. 5.
4 Anders Stephanson, "Interview with Craig Owens," *Social Text*, 27, 1991, p. 68.
5 Documenta IX in Kassel and the Pittsburgh Carnegie International are prominent examples, along with *Doubletake*, mounted at the London Hayward Gallery, discussed below (all held in 1992).
6 Benjamin H.D. Buchloh, "Beuys: The Twilight of the Idol: Preliminary Notes for a Critique," *Artforum*, January 1980, pp. 35–43.

Chapter 6

1 The quotation is from Andrew Ross, "On Intellectuals in Politics (reply to Richard Rorty)," *Dissent*, Spring 1992, p. 263. Rorty's observation in reply (p. 266) of "the scene in *Conan the Barbarian* in which Schwarzenegger snaps the homosexual's spine, or Ice Cube's rap about burning down Korean-owned

shops," while pertinent, shows how hardened these opposing positions have become.

2 See discussion and citations above in "Modernism and Mass Culture in the Visual Arts."

3 One published product of the Birmingham school, Dick Hebdige's *Subculture: the Meaning of Style*. London: Methuen, 1980, itself became an instrument in this recuperation.

4 Subsequently, of course, Koons came directly to employ artisans from the industry of vernacular sculpture and dictate imagery to them drawn from mass-media sources (Michael Jackson, Pink Panther). The result has been a precipitate, seemingly irreversible, decline in the interest of his work.

It is also worth noting a likely source, in the writing of another artist, for this entire direction in Koons's work. In 1979, Mike Glier published a report of his research into the imagery of mass-produced figurines in America ("The 1979 Dime Store Figurine," *Artforum*, XVIII, March 1980, pp. 40–5): ". . . that low-brow form of object fetishism, familiar to every Midwestern mother's son." Glier's categories and illustrations, including a Rococo couple in a coach, strikingly anticipate Koons's subsequent selections. His own description of his project draws the connection even tighter:

> . . . I began to think of the vast numbers of these things decorating countless homes. As an artist whose intention it is to communicate, I am jealous of the figurines' success. Contemporary art, by comparison, seems unable, either from disinterest or fear, to address a diverse audience; I think it is suffering from its separatism.
> . . . the dime store figurine is already a successful public sign system. The nature of supply and demand economics has allowed the public to determine the imagery of these collectibles. My investigation is an attempt to discover the popular themes expressed by these objects, in the hope that this information will aid in some small way the necessary re-imaging of future art.

5 Yasmin Ramirez, "Jim Shaw: 'Thrift Store Paintings,'" *Art in America*, LXXIX, December 1991, p. 120.

6 Brian d'Amato, "Spotlight: 'Thrift Store Paintings.'" *Flash Art*, XXIV, December 1991, p. 126.

7 In 1975, Gregory Battcock added a volume on the subject to his impressive list of anthologies of criticism: *Super Realism: A Critical Anthology*, New York: Dutton.

8 Chen shows at the gallery of Louis K. Miesel, who is also the author of the large and richly illustrated compendium, *Photo-Realism* (he claims to have coined the term), which was first published by Abrams in 1980 and re-issued in 1989 in an identical budget edition under the Abradale imprint. He has also produced an equally large sequel.

9 *A Simple Arrangement of Realistic Pictures*, The Gallery at John Jones Frames Ltd., 19 November–22 December 1991.

10 One feature of Holmes's salvation of illusion has been modelling with reflections rather than tone, and this of course entails their precise description.

11 In Clement Greenberg, "After Abstract Expressionism," reprinted in H.

Geldzahler (ed.), *New York Painting and Sculpture*, New York: Dutton, 1969, p. 363.

12 See below, "The Simple Life," for an extended discussion of the question of genres in recent art.

13 Paul Wood, "Internal Exile: Art and Language's Hostage Paintings," *Arts*, LXVI, January 1992, p. 37.

Chapter 7

1 For further commentary on this point, see Charles Harrison's apt comments in "Disorder and Insensitivity: the Concept of Experience in Abstract Expressionist Painting," in D. Thistlewood (ed.) *American Abstract Expressionism*, Critical Forum Series, Tate Gallery, Liverpool, 1993, p. 125.

2 Brooks Adams, review of Ross Bleckner at Mary Boone/Michael Werner, *Art in America*, LXXII, March 1984, p. 159.

3 Ibid., p. 160.

4 See Michael Baxandall, *Painting and Experience in Fifteenth-Century Italy*, Oxford: Oxford University Press, 1972, pp. 11–23.

5 H. Gérard (ed.), *Lettres adressées au baron François Gérard*, Paris, 1886, I, p. 178 (13 July 1791):

> ...comme mon mérite et mon gloire ne m'ont empêché de sentir mon peu de facilité pour peindre, j'ai imaginé de mêler dans mes couleurs suffisament d'huile d'olive pour que ma grande figure, qui est peinte depuis six semaines, et la petite [Eros] depuis quinze jours, soient aussi fraîches que si je venais de les achever; de sorte qu'elles sont, depuis le toupet jusqu'aux talons, entières à recommencer. De plus, il n'y a absolument rien de fait dans mon fond, que je change tous les jours. . . . Je suis bien incertain si je continuerai jusqu'à la fin.

For further discussion, see the author's, *Emulation: Making Artists for Revolutionary France*, New Haven and London: Yale University Press, 1995, pp. 171–9, 171–88.

6 See his letter to Trioson dated 28 July 1791 in Girodet, *Œuvres posthumes*, ed. P.-A. Coupin, Paris, 1829, II, p. 395, where he states that two weeks later he had still made no progress:

> Quant à moi, en particulier, j'ai repris mon travail par la nécessité plutôt que par le goût, et aujourd'hui je viens de commencer à repeindre ma figure pour laquelle j'avais l'imprudence de me servir d'huile d'olive ce qui l'empêcheait absolument de secher. Cela me faire double dépense, sans compter double fatigue, et justement je suis déjà fort las et je n'ai point de sou.

7 Ross Bleckner, interviewed by Aimee Rankin, *Bomb*, April 1987, p. 24.

8 Exhibition catalogue, Guild Hall Museum, East Hampton, 1993.

9 Quoted in Brad Gooch, "Ross Bleckner Revealed," *Harper's Bazaar*, May 1994, p. 181.

10 Rankin interview, p. 22. The remark concerns his Op-art stripe paintings, but

can as easily apply to most of his output, which mitigates the polarity often assumed to exist between the stripes and the nocturnes.

11 His one obvious and declared borrowing, that of Op-art patterns, gains the least in terms of latent associations. The standard critical line that he and Philip Taaffe were recovering a debased and forgettable fad of the 1960s will not survive direct encounter with Bridget Riley's subtle paintings of the period, which are full of knowingness about the history and limits of abstraction.

12 The phrase is from Barbara Rose, *American Painting: the Eighties*, Buffalo, 1979, cited with disapproval in Douglas Crimp, *On the Museum's Ruins*, Cambridge, MA, 1993, pp. 91, 97.

13 See Crimp, *Ruins*, p. 98.

Chapter 8

1 See Mary Jane Jacob, *Gordon Matta-Clark: A Retrospective*, Chicago: Museum of Contemporary Art, 1985, p. 96.

2 See statement by Andrew McNair in ibid.

3 A founding – and undeniably impressive – example of this tendency is Annette Michelson, *Robert Morris*, Washington: Corcoran Gallery of Art, 1969.

4 Quoted in Jacob, *Matta-Clark*, p. 43.

5 See Michael Asher, *Writings 1973–1983 on Works 1969–1979*, ed. B.H.D. Buchloh, Halifax: Press of the Nova Scotia College of Art and Design, 1983, pp. 31–42.

6 For documentation, see ibid., pp. 207–21; also Anne Rorimer, "Michael Asher: Recent Work," *Artforum*, XVIII, April 1980, pp. 46–50.

7 The critic and curator Douglas Crimp stated in his testimony to the 1985 hearing on the future of the sculpture (in Clara Weyergraf-Serra and Martha Buskirk [eds.], *The Destruction of* Tilted Arc, Cambridge, MA: MIT Press, 1991, p. 73):

> . . . confronted with the Federal Office Building, I am somewhat consoled by the fact that one-half of one per cent of the price of its ugliness paid for what I experience as the most interesting and beautiful public sculpture in my neighborhood.

8 See Mike Davis, *City of Quartz: Excavating the Future in Los Angeles*, London: Vintage, 1992, pp. 385–435.

9 Interview, 1980, with Douglas Crimp, in *Richard Serra: Interviews, Etc, 1970–1980*, Yonkers, NY, Hudson River Museum, 1980, p. 168.

10 Ibid., p. 169.

11 For a compendium of these, see *Richard Serra: Weight and Measure 1992*, Düsseldorf: Tate Gallery and Richter Verlag, 1992.

12 *Richard Serra: Interviews, Etc.*, p. 168.

13 Ibid.

14 Richard Serra, "Introduction," *The Destruction of* Tilted Arc, pp. 12–13.

15 *Richard Serra: Interviews, Etc.*, p. 168.

16 Rosalind Krauss, in *The Destruction of* Tilted Arc, p. 82.

17 See Harriet Senie, "Richard Serra's 'Tilted Arc': Art and Non-Art Issues,"

Art Journal, XLVIII, Winter 1989, pp. 297–302.

18 Krauss, "Richard Serra Sculpture," in *Richard Serra*, New York: Museum of Modern Art, 1987, p. 36.

19 A chronology of events and selection from the documentation can be found in *The Destruction of* Tilted Arc.

20 This essay, not previously published, is adapted from a talk given at the 1992 annual meeting in Leeds of the Association of Art Historians. I am grateful to the session organizer Louis Johnson for the invitation.

Chapter 9

1 T.J. Clark, Serge Guilbaut, and Anne Wagner, "Representations, Suspicions and Critical Transparency: an interview with Jeff Wall," *Parachute*, 59, July–September 1990, p. 10.

2 Michael Fried, "Modernist Painting and Formal Criticism," in *The American Scholar*, Autumn 1964, reprinted in Charles Harrison and Paul Wood, *Art in Theory*, Oxford: Basil Blackwell, 1992, p. 770.

3 T.J. Clark, *The Painting of Modern Life*, New York: Knopf, 1984, p. 15.

4 Jeff Wall, *Transparencies*, Munich: Schirmer/Mosel, 1987, p. 100.

5 The best discussion of this subject is in Hollis Clayson, *Painted Love: Prostitution in French Art of the Impressionist Era*, New Haven and London: Yale University Press, 1990, pp. 7–9 and *passim*.

6 Wall, *Transparencies*, p. 98: "Proletarian maternity is just as much a bourgeois scandal as proletarian prostitution is, but it's just the other side of the same coin."

7 See Clark, *Painting of Modern Life*, p. 25.

8 William Empson, *Some Versions of Pastoral*, New York: New Directions, 1974, p. 16.

9 In Ronald Taylor (ed.), *Aesthetics and Politics*, London: Verso, 1977, pp. 129–30.

10 Ibid., p. 136.

Chapter 10

1 The founding formulation of the hierarchy is the preface by André Félibien, *Conférences de l'Académie royale de peinture et de sculpture*, Paris, 1668, though he does not account for the sort of human picturesque referred to since as "genre" painting.

2 For a perceptive discussion of this shift, see Leila W. Kinney, "Genre: A Social Contract?" *Art Journal*, XLVI, Winter 1987, pp. 267–71, especially p. 271.

3 Meyer Schapiro, "The Social Bases of Art," in proceedings of the First Artists' Congress against War and Fascism, New York, 1936, pp. 31–7.

4 Ibid., p. 36.

5 Ibid., p. 37.

6 The lower orders, with their minds necessarily fixed on the mundane details of earning a living, were by definition excluded. For an account of this aspect of academic theory, see John Barrell, *The Political Theory of Painting from*

Reynolds to Hazlitt: The Body of the Public, New Haven and London: Yale
University Press, 1986.

7 See Tim Scott, "Reflections on Sculpture, A commentary by Tim Scott on
 notes by William Tucker," in *Tim Scott: sculpture 1961–1967*, London:
 Whitechapel Gallery, 1967; on this, see Charles Harrison, who has identified
 the importance of these statements in his essay, "Sculpture's Recent Past," in
 T. Neff (ed.), *A Quiet Revolution: British Sculpture since 1965*, London:
 Thames and Hudson, 1987, p. 14. I am much indebted here to Harrison's
 general thinking on modernism; see also his *Essays on Art & Language*,
 Oxford: Basil Blackwell, 1991, pp. 1–62.

8 Michael Fried, *Morris Louis*, New York: Abrams, 1971, p. 10.

9 The most concentrated statement of this position would be Fried, "Art and
 Objecthood," in G. Battcock (ed.), *Minimal Art*, New York: Dutton, 1968,
 pp. 116–47.

10 The demand for these kinds of objects, it seems to me, persists independently
 of the market for museum-oriented art and extends into various kinds of craft
 and amateur manufacture; for some further discussion of the question, see
 "Hand-made Photographs and Homeless Representation" (pp. 97–101).

11 "The True Principles of Pastoral Poetry," *The Rambler*, no. 37, in F. Brady
 and W.K. Wimsat (eds.), *Samuel Johnson: Selected Poetry and Prose*, Berkeley
 and Los Angeles: University of California Press, 1977, p. 171.

12 A useful, systematic definition of the term has been offered by the literary
 historian David Halperin in his *Before Pastoral: Theocritus and the Ancient
 Tradition of Bucolic Poetry*, New Haven and London: Yale University Press,
 1983, pp. 70–77:

 Pastoral achieves significance by oppositions, by the set of contrasts,
 expressed or implied, which the values embodied in its world create with
 other ways of life. The most traditional is between the little world of natural
 simplicity and the great world of civilization, power, statecraft, ordered
 society, established codes of behavior, and artifice in general.

 This passage is just one part of an extremely subtle discussion of the multiple
 criteria involved in identifying the workings of the genre. For further work of
 definition, see Paul Alpers, "What Is Pastoral?" *Critical Inquiry*, VIII, Winter
 1981–2, pp. 437–60.

13 William Empson, *Some Versions of Pastoral*, revised edition, New York: New
 Directions, 1974, p. 19.

14 For a discussion of the painting's history and provenance, see Angelica Zander
 Rudenstine, *The Peggy Guggenheim Collection, Venice*, New York: Abrams,
 1985, pp. 611–13.

15 For a parallel discussion of this painting, see "Modernism and Mass Culture
 in the Visual Arts" (pp. 27–8) and also the author's "Une vie plus simple," in
 T. Prat and T. Raspail (eds.), *L'Amour de l'Art: une exposition de l'art
 contemporain en France*, Lyon Biennale, 1991, pp. 72, 388.

16 William Empson, *Some Versions of Pastoral*, p. 21.

17 Fried's election of Louis to stand as the paragon of high, unalloyed seriousness
 is pertinent here; see note 7 above.

18 See, for example, Allan Kaprow, "The Legacy of Jackson Pollock," *Art News*,

October 1958. The forthcoming research on Kaprow by Robert Haywood will provide a detailed account of this aspect of his practice.

19 The link in the iconography of Pop art to the 1930s and 1940s, the childhood years of the artists involved, is far stronger than any engagement with the up-to-date products and media of the 1960s, even though the latter is emphasized in most accounts. This connection between child-cult and Pop is further treated in the author's "The Children's Hour," *Artforum*, December 1991, pp. 84–8.

20 "Andy Warhol's One-Dimensional Art, 1956–1966", *Andy Warhol: A Retrospective*, New York: Museum of Modern Art, 1989, p. 45.

21 From an interview with Jeanne Siegel, "Annette Lemieux: It's a Wonderful Life, or Is It?," *Arts Magazine*, LXI, January 1987, p. 80.

22 Canonized shortly thereafter in Clement Greenberg's well-known article of that title, "American-Type Painting," reprinted in Greenberg, *Art and Culture*, Boston: Beacon, 1961. The Betsy Ross story contains a banal pastoral irony in itself in that those humble origins stand in implicit contrast to the symbolization of global power by then carried in the same object. This Johns redeems by using the design to turn the normal priorities in abstract painting inside out. The abstract overall unity of the painting, agonizingly won by the likes of Pollock and de Kooning through the accumulation and self-cancellation of small figurative incidents, is achieved at a stroke through one great figurative incident of unimpeachable flatness and coherence. Greenberg was the first nervously to observe this (in "After Abstract Expressionism," in H. Geldzahler (ed.), *New York Painting and Sculpture: 1940–1970*, New York: Dutton, 1969, pp. 364–5). Within it, fully visible, is a bed of dense, randomly torn, newspaper collage. The buried Cubist grid floats to the surface, in the archaic medium of translucent encaustic, leaving behind the frenetic activity of expressive improvisation as a form of waste or detritus.

23 In *Robert Morris*, exh. cat., Washington: Corcoran Gallery of Art, 1969.

24 Ibid., p. 9.

25 Ibid., pp. 35–6.

26 Ibid., p. 7.

27 D. Graham, "Homes for America," *Arts Magazine*, December/January 1966–67. Its subtitle is "Early 20th-Century Possessable House to the Quasi-Discrete Cell of '66." The first publication of the present essay in *October* elicited a personal communication from Graham in which he relates,

> I did read William Empson's "Some Versions of Pastoral" just before the "Homes for America" piece (which I wrote in 2–3 hours in the Public Library), but Godard's "Weekend" and his magazine-like contemporaneous films, the Kinks' "Waterloo Sunset" and "Village Green Preservation Society" LPs were larger influences.

Recognition of the importance of the piece came earliest and most importantly from Benjamin H.D. Buchloh, as is the case with Michael Asher's work discussed below, and this essay is much indebted to those recognitions. For one of his recent discussions, see "From the Aesthetic of Administration to Institutional Critique (Some aspects of Conceptual Art 1962–1969)," in C. Gintz (ed.), *L'Art Conceptuel, une perspective*, Paris: Musée de l'Art

Moderne, 1989, p. 46, reprinted *October*, Winter 1990, pp. 105–43. Its growing currency can be seen in Brian Hatton, "Dan Graham: Present Continuous," *Artscribe*, November–December 1991, pp. 66–7. Perhaps the most illuminating discussion of the work has come from another artist, Jeff Wall, in the two essays published as *Dan Graham's Kammerspiel*, Toronto: Art Metropole, 1991, in which he advances a measured argument with Buchloh: these are overlooked but essential contributions to the literature on Conceptual art in general.

28 Graham, "Homes."

29 Ibid.

30 The layout in *Arts* did not conform to Graham's original conception (see Gintz, p. 156). On this and other aspects of "Homes for America," see Charles Reeve, "T.V. Eye: Dan Graham's *Homes for America*," *Parachute*, 53, December–February 1988–89, pp. 19–24; also Alex Alberro, "Reductivism in Reverse," in *Tracing Cultures: Art History, Criticism, Critical Fictions*, New York: Whitney Museum of American Art, 1994, pp. 7–28. No reasonable editorial intervention, however, could be said to have impaired the logical clarity of the piece; in fact, such intervention might be said to have completed it (*pace* Hatton, "Graham," p. 71).

31 Richard Meyer, "Pin-Ups: Robert Morris, Linda Benglis, and the Sexualization of Artistic Identity," unpublished paper, University of California, Berkeley, describes the extraordinary lionization of Morris in the art world in the 1960s, and quotes a pertinent passage from a recent autobiographical article ("Three Folds in the Fabric and Four Autobiographical Asides as Allegories [or Interruptions]," *Art in America*, November 1989, p. 144), where Morris describes himself in 1961 as a kind of Nietzschean carpenter slaying modernist metaphysics with a circular saw:

> At 30, I had my alienation, my Skilsaw and my plywood. I was to rip out the metaphors, especially those that had to do with "up," as well as every other whiff of transcendence. When I sliced into the plywood with my Skilsaw, I could hear, beneath the ear-damaging whine, a stark and refreshing "no" reverberate off the four walls: no to transcendence and spiritual values, heroic scale, anguished decisions, historicizing narrative, valuable artifact, intelligent structure, interesting visual experience.

This kind of thing makes "Homes for America" seem more incisive than ever.

32 Gregory Battcock, in his *Minimal Art* anthology reproduces some of photographs without the text, observing (p. 175) that they illustrate "Minimal-type surfaces and structures as they are found by the artist in nature – particularly in the suburban landscape. They suggest that Minimal forms are not totally divorced from nature, and that they are subjective and social."

33 It is frequently and rightly observed about Minimalism and site-specific work of the 1960s that, in the face of the inadequacy of existing criticism to give an account of the work, practitioners like Morris, Judd, Bochner, and Smithson had themselves to generate interpretation as they worked. As Michelson writes (*Morris*, p. 13):

Criticism's response...was a crisis. The symptoms were roughly the following:

1. A general and immediate proliferation of new epithets.
2. Attempts to find historical, formal precedents which might facilitate analysis.
3. A growing literature about the problematic nature of available critical vocabulary, procedure, standards.

Artists responded with:

1. A growing personal concern and active involvement with critical practice.
2. Serious attempts to re-define the limits of criticism.
3. A correlative attempt to reform critical language and descriptive terms.

This largely went on in polemical or explanatory contributions to art magazines. What Graham accomplished, in his expansion of the concept of site to include the journalistic component of the support system, was to make the normally separated moments of practice and criticism entirely coincide. As one comes to the end of reading the piece, its second inscription comes into focus all at once as an account of the Minimal art on which Graham's project both depends and which, at the same time, it supersedes.

34 See discussion of Asher in "Site-Specific Art: The Strong and the Weak," pp. 136–43.

35 Los Angeles County Museum of Art, *Art in Los Angeles: The Museum as Site: Sixteen Projects*, 1981, pp. 35–6. For illustrations and an extended description of the piece, see also Buchloh, "Allegorical Procedures: Appropriation and Montage in Contemporary Art," *Artforum*, XXI, September 1982, pp. 50–52.

36 Credit should be given to Stephanie Barron, the curator of the exhibition, for recognizing this: "His piece does not deal with the architecture, or even the institution's 'museumness,' but very specifically with the Los Angeles County Museum of Art, its own site in Los Angeles, and its relation to Hollywood," Los Angeles County Museum of Art, *Museum as Site*, p. 36.

37 See the acute remarks of Harrison, *Essays on Art & Language*, pp. 45–6, on the institution-affirming tendencies of installation work.

38 Krauss, "Theories of Art after Minimalism and Pop: Discussion," in Hal Foster (ed.), *Discussions in Contemporary Culture*, Seattle: Bay Press, pp. 60–62.

39 For further discussion, see above, "Saturday Disasters," pp. 56–8.

40 The full title of the piece consisted of the following:

SOURCE: The Photographic Archive, John F. Kennedy Library, Columbia Point on Dorchester Bay, Boston, Massachusetts, 02125, U.S.A.; CONDITIONS FOR SELECTION: There are two conditions: the photograph or photographs must be dated May 10, 1963, and the subject, John F. Kennedy, must have his back turned toward the camera. All photographs on file fulfilling these requirements are used. TECHNICAL TREATMENT: The photographs are subjected to the following operations: rephotography (4 × 5″

copy negative), enlargement (from 8 × 10″ to 11 × 14″ by use of the copy negative), and cropping (¹⁄₁₆″ is removed from all sides of the rephotographed, enlarged image).

The final component of the title, PRESENTATION, is a variable, as it cites the name, title, and date of the exhibition, and the name and address of the venue, followed by the name of the artist.

41 See the book version of the piece, published as Christopher Williams, *Angola to Vietnam*, Ghent: Imschoot, Uitgevers Voor IC, 1989. The asterisk in the title of the installed work refers to a text on the verso of the book's title-page explaining how the flowers were selected and named. The conception of both versions was anticipated in a 1987 collaborative piece by Williams and Stephen Prina, entitled *The Construction and Maintenance of Our Enemies*, composed of thirteen photographs of plant specimens at the Huntington Botanical Gardens in San Marino, California. These were exhibited at the Kuhlenschmidt-Simon Gallery, Los Angeles, and published (*New Observations*, no. 44, 1987) with captions listing place of origin, taxonomy, and location within the aesthetic order of the garden design.

42 See R.E. Schultes, W.A. Davis, and H. Burger, *The Glass Flowers at Harvard*, New York: Dutton, 1982, pp. 1–12.

43 See the photographs of Hillel Burger in ibid., pp. 20–113.

44 See ibid., pp. 12–16.

45 Greenberg, "The Present Prospects of American Painting and Sculpture," in John O'Brian (ed.), *Clement Greenberg: The Collected Essays and Criticism*, II, Chicago: University of Chicago Press, 1986, pp. 169–70.

Chapter 11

1 From text by Michael Asher in Claude Gintz (ed.), *L'Art conceptuel, une perspective*, Musée d'Art Moderne de la Ville de Paris, 1989, p. 112.

2 Editors' introduction, in Norman Bryson, Michael Ann Holly, and Keith Moxey (eds.), *Visual Culture: Images and Interpretations*, Hanover, NH: University Press of New England, 1994, p. xvii.

3 The classic polemic advancing this position is Michael Fried, "Art and Objecthood," in Gregory Battcock (ed.), *Minimal Art*, New York: Dutton, 1968, pp. 116–47.

4 Bryson et al, *Visual Culture*, p. xvii.

5 These two formulae are the coinages of Benjamin H.D. Buchloh and Charles Harrison respectively.

6 The most notorious instance is *Shoot* (1971), to which could be added *TV Hijack* (1972), *747*, *Icarus* and *Trans-Fixed* (1973); see Anne Ayres and Paul Schimmel (eds.), *Chris Burden: a twenty-year survey*, Newport Beach, Calif.: Newport Harbor Art Museum, 1988, pp. 53–4, 59–60, 66.

7 See discussion above in "The Return of Hank Herron."

8 Douglas Davis in Eugene W. Schwartz and Davis, "A Double-Take on Elaine Sturtevant," *File*, December 1986, n.p. Davis also relates the remarkable story of Duchamp's reaction, in the year before his death, to Sturtevant's restaging of his 1924 performance *Relache*.

9 Buchloh, "From the Aesthetic of Administration to Institutional Critique," in Gintz, *L'Art conceptuel*, p. 53.

10 Charles Harrison, "Art Object and Artwork," in Gintz, *L'Art conceptuel*, p. 63.

11 See Jeff Wall, *Dan Graham's Kammerspiel*, Toronto: Art Metropole, 1991, p. 19. William Wood offered helpful comments on this and other points in this essay.

12 Buchloh, "From the Aesthetic of Administration to Institutional Critique."

13 Published in Martha Rosler, *Three Works*, Halifax: Press of the Nova Scotia College of Art and Design, 1981.

14 *Hans Haacke: Unfinished Business*, exh. cat. New York: New Museum of Contemporary Art, 1986, pp. 92–7; he also produced a parallel piece, *Sol Goldman and Alex DiLorenzo Manhattan Real Estate Holdings, a Real-Time Social System, as of May 1, 1971*, illustrated on pp. 88–91.

15 For a recent account of the incident, see Rosalyn Deutsche, "Property Values: Hans Haacke, Real Estate, and the Museum," in ibid., pp. 20–37.

16 See ibid., pp. 76–9, 82–7, 98–106.

17 For an apposite, illuminating (if inelegantly titled) reflection on the link between multiculturalist sentiment and the demands of international marketing, see David Rieff, "Multiculturalism's Silent Partner: It's the newly globalized consumer economy, stupid," *Harper's Magazine*, CCLXXXVII, August 1993, pp. 62–72; *Brasil* makes more or less the same points instantaneously.

18 See Christopher Williams, *Bouquet, for Bas Jan Ader and Christopher d'Arcangelo*, Cologne: Galerie Max Hetzler, 1991. Louise Lawler, Allen Ruppersberg, and Catherine Gudis offered advice and information that greatly aided my research for this section of the essay.

19 See Paul Andriesse, *Bas Jan Ader*, Amsterdam: Openbaar Kunstbezit, 1988, pp. 82–3, 89–90 (I am grateful to Patrick Painter for providing me with this document):

> On July 9, 1975 he sails from Cape Cod with Falmouth, England as his destination. He estimates that the trip will last sixty days. In order to record the voyage, he takes along a camera and tape recorder. Ader's gallery Art & Project publishes a bulletin, designed by him, in July 1975 which gives publicity to this voyage *In Search of the Miraculous*. The bulletin consists of a large photograph of Ader in his boat at sea and the sheet music for the song "Life on the Ocean Wave." Ocean Wave is also the name of the boat. Agreements have been made with the Groninger Museum to make an exhibition which would constitute the third part of the triptych. (p. 82)

On Burden's piece, see his own description in Ayres and Schimmel, *Chris Burden*, p. 62:

> Newspace, Newport Beach, California, May 25–June 10, 1973. I was dropped off in San Felipe, Mexico, on the Sea of Cortez. In a small canvas kayak I paddled southward to a remote beach, carrying some water with me. I survived there for 11 days; the average daily temperature was 120 degrees. On June 7, I paddled back to San Felipe and was driven to Los Angeles. The piece had been announced by Newspace, and during my stay

in Mexico a notice in the gallery informed visitors of my absence. On June 10 at Newspace, I showed a short movie of my departure and read a diary I had kept.

20 Andriesse, *Ader*, pp. 86–7.
21 Wall, as it happens, admits this last work as the unique piece of Conceptual art to have managed non-ironic subject matter (*Kammerspiel*, p. 28), this being the hidden coincidence between Minimalist principles and the production logic of post-war housing under conditions of military-spending inflation. On both logical and historical grounds, however, there cannot possibly be just a single exception.
22 See James Roberts, "Bas Jan Ader: the artist who fell from grace with the sea," *Frieze*, Summer 1994, pp. 32–5, and a thoughtful, well-informed piece by Collier Schorr, "This Side of Paradise," *Frieze*, Summer 1994, pp. 35–7.

Acknowledgements

This book requires more than the usual acknowledgements of gratitude, in that it consists of writing commissioned or otherwise encouraged by others. The first essay, "Modernism and Mass Culture in the Visual Arts," began life in 1980 as an expression of dismay at the historical misunderstandings entailed in the triumphant announcement, heard then in many quarters, that a postmodernist era had arrived. Being immersed at that time in research on eighteenth-century France, I had no immediate outlet for these thoughts until an invitation came from Serge Guilbaut, David Solkin, and Benjamin H.D. Buchloh to participate in their landmark "Modernism and Modernity" conference at the University of British Columbia in 1981. My paper aimed to document the richness of the modernist tradition in precisely those attributes so confidently arrogated by a born-yesterday postmodernism. The proof was to be found, since the 1960s, in the dependency of vital styles of vernacular expression on precedents in cultivated fine art – a development that echoed the reverse dependency of fine art on the vernacular that had prevailed since the inception of modernism in the mid-nineteenth century. For the published conference papers, those organizers generously allowed me to publish a much longer essay, for it seemed the moment to sort through the various strands of cultural theory then being enlisted simultaneously in the postulating of postmodernity and in the troubled renewal of a social history of art. I am also grateful to Chantal Pontbriand, Yves Michaud, Stefan Germer, and Isabelle Graw for disseminating the piece in French and German translations (in *Parachute*, *Les Cahiers du Musée national d'art moderne*, and *Texte zur Kunst*). Over its prolonged afterlife, I have tried to tighten the argument and relax the prose, yielding the final effort included here.

My published efforts in a contemporary direction might have stopped there if Elisabeth Sussman and David Joselit had not seen some potential

in "Modernism and Mass Culture" that might be applied to the catalogue for their 1987 exhibition, *Endgame: Reference and Simulation in Recent Painting and Sculpture.* The resulting essay, "The Return of Hank Herron," appears here in revised form. Its original conclusion, a discussion of topical reference in the early paintings of Andy Warhol, afterwards gave rise to an independent article, "Saturday Disasters: Trace and Reference in Early Warhol," which was first commissioned in 1987 by Nancy Marmer for *Art in America* on the occasion of the artist's death. It subsequently appeared, with some necessary revisions, as part of another collection edited by Serge Guilbaut: *Reconstructing Modernism* (Cambridge, Mass.: M.I.T. Press, 1990) and in French translation commissioned by Daniel Soutif for the *Cahiers du Musée national d'art moderne* (in that process, perceptive copy-editing by Debi Edelstein was invaluable). The present conclusion to "Hank Herron" is drawn from a subsequent essay that extended some of its latent themes. Edmond Charrière and Catherine Quéloz of the Musée des Beaux-Arts in La Chaux-de-Fonds commissioned essays in 1990 from a number of writers on the legacy of the 1960s, particularly the dissent from the demands of the art marketplace voiced by artists in that period. My contribution appeared under the title "Art contemporain et marché de théorie" in the catalogue for the exhibition *Extra Muros: Art suisse contemporain.*

In 1987, Elizabeth Sussman and David Joselit had again prodded me into direct engagement with the current art they were selecting for the Binational Show, a reciprocal exchange of exhibitions between the Boston ICA and the Städtische Kunsthalle in Düsseldorf. The studio visits that I undertook as part of that responsibility helped push my thinking closer to the practical and intellectual demands faced by artists making concrete decisions in composing their work (here I have to thank Robert Gober, Annette Lemieux, Lorna Simpson, and James Welling in particular). The resulting essay, published as "Versions of Pastoral in Recent American Art," entailed a revisit to the territory of "Modernism and Mass Culture," but one mapped on a finer grid with some different equipment. In later versions of the piece, I have tried to broaden the application of its approach, emphasizing overlooked questions of genre. Thierry Prat and Thierry Raspail commissioned one revision, "Une vie plus simple: Essai sur la pastorale dans l'art d'aujourd'hui," as a commentary on the Lyon Biennale exhibition in 1991. That gave rise in turn to the version published here, "The Simple Life: Pastoralism and the Persistence of Genre in Recent Art," reprinted substantially as it appeared in the journal *October* in 1993. Editors Benjamin H.D. Buchloh and Hal Foster, along with Rosalind

Krauss and Annette Michelson, were generous with space and advice in allowing me to sort out my thoughts in print.

Over that period of evolution, I tried to make the essay a pendant, equivalent in scope and substance, to "Modernism and Mass Culture," and the two essays function as beginning and concluding brackets to the main body of this book. For the momentum that produced the work in between, I owe a great debt to my continuing association with *Artforum*. Editor Jack Bankowsky first drew me into more topical writing about recent art and exhibitions, and I very much relied in the beginning on Deborah Drier's editorial acumen. Repeated deadlines make for greater discipline in any writer; David Frankel, Sydney Pokorny, and Stephen Ellis made them easier to meet and improved the results. This collection includes one piece, "The Graying of Criticism," that was commissioned in 1993 for the commemorative, thirtieth-anniversary issue of *Artforum*, as well as another contribution to the magazine from the same year, "Profane Illuminations: The Social History of Jeff Wall," which Jack rightly saw as an opportunity for me to bridge my historical and critical commitments in an explicit way.

"Hand-Made Photographs and Homeless Representation" owes its existence jointly to the Tate Gallery and to *October*. Richard Humphries and Sean Rainbird of the Tate extended the invitation to speak at the symposium devoted to Gerhard Richter's 1991 retrospective exhibition. Benjamin H.D. Buchloh then included the paper in a special issue of *October* devoted to Richter and based on that symposium. Benjamin also brought me into his session on approaches to the painting of the New York School at the Berlin International Congress for the History of Art in 1992. "Fashioning the New York School: Jackson Pollock and Peggy Guggenheim's *Mural*," written for that panel, provided this collection with one detailed case study from the formative period of the American avant-garde. Another conference paper gave rise to the one essay included here that has seen no previous publication. "Site-Specific Art: the Strong and the Weak" came from an invitation by Lewis Johnson to speak in his session, "Disfiguration in Art," at the 1992 conference of the Association of Art Historians. The theme offered an obvious and welcome opportunity to talk about the work of the late Gordon Matta-Clark.

The two most recent essays were both written in the summer of 1994 and came from invitations to contribute catalogue essays on individual artists. Lisa Dennison of the Guggenheim Museum, in planning her 1995 retrospective exhibition devoted to Ross Bleckner, encouraged me to address issues raised by his painting; "Surface Tension" was the result,

and it seemed to make a natural pair with "Hand-Made Photographs" in the arrangement of this collection. Deborah Drier, who edited the catalogue, showed once again why she remains one of the best editors in contemporary-art publishing.

Sherri Geldin of the Wexner Center for the Arts commissioned the essay that provided the last word I was looking for, something more current and open-ended to follow on from "The Simple Life." "Unwritten Histories of Conceptual Art" first appeared in the catalogue of the Wexner exhibition devoted to Chistopher Williams and Albert Oehlen. Its editor, Catherine Gudis, along with Louise Lawler, Allan Ruppersberg, and William Wood offered invaluable advice and information. I tried out the core of the piece as a talk in a panel organized by Knight Landesman for *Artforum* at the Drawing Center in New York; the published version greatly benefited from points raised in discussion by my co-panelist Rosalind Krauss.

In addition to the people named above, I have to include a number of others whose conversation over the years has given me much of my education in recent art practice. An incomplete list would include Iwana Blazwick, Yve-Alain Bois, David Batchelor, Chris Burden, T.J. Clark, Stephen Eisenman, Briony Fer, Campbell Gray, Robert Haywood, David Mellor, Sandy Nairne, Molly Nesbit, the late Craig Owens, Dennis Parks, Alex Potts, Anne Rorimer, Martha Rosler, Lisa Tickner, Anne Wagner, Erica Wolf, and Paul Wood. For all of their interest and help, I owe an enormous debt to artists Michael Asher, Ross Bleckner, Dan Graham, Andrew Holmes, Martha Rosler, Sturtevant, Jeff Wall, and Christopher Williams. Patrick Painter, representing the estate of Bas Jan Ader, also responded readily to every request for assistance, as did Jeri Hollister. At Yale University Press, Sheila Lee pursued photographs and permissions with her customary resourcefulness and good humor, while Gillian Malpass, as commissioning editor and designer, gave to this project all of the skill and personal commitment that I have come to rely upon over the years.

I cannot conclude these acknowledgements without repeating the names of Benjamin H.D. Buchloh, Hal Foster, and Serge Guilbaut, with whom I feel I have lived the issues and events touched on in this book. And to those names I must add Charles Harrison, who further offered his acute and exceedingly helpful criticism as a reader of the completed manuscript. William Wood also read the entire text with the most intelligent and informed eye for lapses in accuracy, argument, and style. Catherine Phillips did the same, and as usual she eloquently spoke up on behalf of the readers I most want to reach.

Photograph Acknowledgements

Index

269

273